OUT OF ITALY

Fernand Braudel

OUT OF ITALY

*Translated from the French
by Siân Reynolds*

Europa
editions

Europa Editions
214 West 29th Street
New York, N.Y. 10001
www.europaeditions.com
info@europaeditions.com

Copyright © Flammarion, Paris, 1994
First published by Arthaud, 1989
First Publication 2019 by Europa Editions

Translation by Siân Reynolds
Original title: *Le Modèle italien*
Translation copyright © 1991 by Flammarion

Library of Congress Cataloging in Publication Data is available
ISBN 978-1-60945-534-7

Braudel, Fernand
Out of Italy

Book design by Emanuele Ragnisco
www.mekkanografici.com

Cover image: Album / Alamy Stock Photo

Prepress by Grafica Punto Print – Rome

Printed in the USA

CONTENTS

OUT OF ITALY

Between 1450 and 1650, for two extraordinarily eventful centuries, one country—dazzling, multicolored Italy—beamed a radiance out beyond its own frontiers, a light that spread to every corner of the world. That radiance, that distribution of cultural goods from Italy, can be seen as the mark of an exceptional destiny, evidence so overwhelming that it gives the true measure of a multidimensional history, the details of which, when seen from inside Italy itself, are too varied to grasp. To view Italy—the many Italies—from a distance, is to gather together into a single narrative a history that has been fragmented into too many stories, too many states and city-states. It means presenting a version that departs from usual practice, a quest for the truth, one might say, or at any rate a particular way of trying to understand Italy's greatness, the better to do it justice.

As a witness from quite outside the national scene—so perhaps better qualified than some to consider Italy's claims to greatness with an open mind—I shall not on that account seek to stifle the undisguised sympathy that all French historians, from Michelet onwards or even earlier, have felt toward Italy. The objectivity and impartiality at

which I shall aim as best I can are virtues to which any historian must aspire, though without ever claiming to possess them from the start. As I relate (from some distance and with the urge to see it from a particular perspective) this long chapter in Italy's history, I shall concentrate on what seem to me to be the essential questions, without hesitating to follow any ideas to their logical conclusion. That is no doubt what is being asked of me on this occasion.

But since every essential question raises another, and that one another again, I shall be led to re-examine all the problems opened up by these two centuries of Italian history.

INTRODUCTION
ITALY'S SEVERAL AGES OF GREATNESS

Over the centuries, there have been three obvious and unquestionable ages of greatness in Italy: first, Roman antiquity; then the period from the early twelfth century to the middle of the fourteenth, the first, or according to Armando Sapori the *true* Renaissance; and lastly the second Renaissance, in the usual, broad sense of the word, running from the mid-fifteenth century to the early or possibly the middle years of the seventeenth. Perhaps the last two should, in fact, be seen as a single continuous movement, from the twelfth to the seventeenth century.

Later, in the nineteenth and twentieth centuries, was to come that important but obscure phenomenon, somehow concealed behind the distracting hubbub of political history, that great drain on Italy's human resources: emigration overseas, with effects not greatly beneficial to the peninsula itself. Toward the end of the nineteenth century, Italian emigration replenished the human resources of the various Americas—Spanish, Portuguese, and English-speaking—and helped them launch their modern careers. On a world scale, this was no mean contribution. Was it merely the beginning of something? The question remains open. I am one of those who are impressed by the vitality

of *present-day* Italy, by the lively upsurge in Italian art and literature and by the marvellous Italian cinema. But it is too soon to pass long-term judgment. And we should in any case always remember that *greatness* is a very particular kind of measurement, not really applicable either to the Italy or the France of today. A united Europe might perhaps lay claim to it, for greatness can be founded only on influence and supremacy in relation to others. There is an obvious and necessary relativity to be observed.

All the same, there can be no doubt that a study of Italy's greatness between 1450 and 1650 would be illumined by serious comparison with those other experiences encountered in the course of a many-centuried history, however different or distant in time they may be. What we would be judging, taking Italy as an example, would be "greatness" in itself, that many-sided and diverse phenomenon, which is so much more mysterious and complicated than it seems at first sight, although we have many modern examples before us: the greatness of sixteenth-century Spain, seventeenth-century Holland, eighteenth-century France and Britain, not to mention more recent cases of which we will all be aware. In such examples of greatness, strength has joined forces with intelligence, power with culture, in combinations that are never quite the same, either in their causes or their effects, while they nevertheless remain comparable to each other. The vitality of a society, an economy, a civilization, or a state is at once concentrated and exhausted in such episodes. For although the time span may vary, the end of the story is always "decline,"a word as complex as it is convenient. It seems to set the final seal on

the episode—yet we know that the wheel of history keeps on turning. Who would these days dare to echo Gobineau when he said, "All human societies have their decline and fall, all, I tell you."[1] True perhaps but a Renaissance is always possible.

The Dialectic of Internal and External

We can now move on from these broad considerations. It is enough to have evoked them in order to shed a clearer light on our particular area of concern, the period 1450–1650. From the outset—and this is important—we shall at least have registered that this age of greatness was not a unique episode.

Our period, like that of Roman antiquity, was an age of vigorous expansion, an age of active exploitation of the Mediterranean, the *Mare Internum*, by shipping, by regular traffic, by a form of capitalism already versatile and far-reaching, with strings of solidly established trading posts. There was even a Genoese empire on the Phoenician model,[2] and a Venetian empire too—the latter destined to last (since Cyprus did not fall until 1571 or Candia until 1669), the former being toppled earlier, since Kaffa (a second Constantinople as some dared call it) was lost in 1475, and Chios in 1566. The cities and merchants of Italy even managed to establish their long-lasting supremacy vis-à-vis Byzantium and Islam, and more clearly still vis-à-vis western Europe.

At the same time, there was a steady flow of emigration

from Italy. But with certain exceptions—and here I am thinking of the Italian soldiers who fought so often abroad, at Mühlberg for instance, under the banner of the Duke of Alba in 1547; at Lepanto, under the command of Don John of Austria in 1571; the soldiers who formed the nucleus of Alessandro Farnese's army in the Netherlands; and who continued to fight so frequently during the seventeenth century in the service of the King of Spain, a ruler well known for his readiness to draw on Italian manpower, supplies, and credit and to exploit Sicily, Naples, and the Milanese quite shamelessly—with exceptions then, such emigration was not of massive proportions. It amounted to a few boatloads of people, almost all persons of note: engineers, skilled craftsmen, carrying with them the secrets of specialized technology; merchants (in large numbers); churchmen, and, even at this early date, political "technocrats" from Concini to Mazarin or Alberoni; humanists (some professors and some not), and lastly artists: musicians, architects, painters, sculptors, goldsmiths, theater companies, directors, dancing-masters, and astrologers. This stream of emigrants—the export of the luxury trades one might call it—is itself proof, if any is needed, of Italy's long-lasting supremacy.

In short, we have here a complex form of influence, compounded of adventurism, of every aspect of culture, and of every kind of financial expertise. Italy during these two centuries of the early modern era was not unlike France in a later period or the United States today.

The glory born of material wealth was the long-effective secret of the power of Florence, or indeed of Venice,

Milan, and Genoa—the last being perhaps the most extraordinary. The belated but fantastic financial mastery of the Genoese, starting in the second half of the sixteenth century, is beginning to be realized, at least by specialist historians. Between roughly 1550 and 1650, there was an "age of the Genoese bankers" as striking as the "age of the Fuggers." The Genoese succeeded, for a long moment, in imposing their rule on the wealth of Europe, and by extension on that of the rest of the world.

The glory of the intellect may appeal to us more than the glory of wealth. For century after century, Italy provided a living example, a spectacle of intellectual prowess, agility, and originality, a series of contradictory cultural revolutions, as freedom was followed by order, progress by interruption, radiance by obscurity. On this great stage, the light was always shifting, the colors were always changing: the Renaissance, Mannerism, the Baroque—here was one of the most dazzling sequences of displays of intelligence since the world began.

The inventive spark leapt in fact from one city to another. Each had its hour of glory, beginning with Florence's "balancing act" of supremacy. The movement then flourished briefly in Rome, under Julius II and Leo X. Much later came the days of Venice and Bologna. Then the balance shifted decisively back to Rome which, like a tyrannical and demanding heart, attracted the lifeblood of Italy and the attention of the whole world. After the Council of Trent, Rome's agenda consisted of the reconstruction of traditional civilization in the name of the Church triumphant, making it once more competitive and predominant, with a

transformation of its style and modes of expression. And in a very short time that civilization spread to cover almost all of Europe, the Catholic and indirectly the Protestant as well: curious evidence of the unity of a world divided—perhaps falsely—against itself. In terms of civilization, the Italy with which we shall be dealing runs from the beginning of the Renaissance to the triumph of the Baroque. It covers a twofold or even threefold pattern of influence, but perhaps a single experience of superiority.

Whatever the images or words in which our arguments are expressed for want of better ones (influence, cultural diffusion, model, example, enlightenment) they all relate to a single problem. This may seem obvious but once one starts to analyze the problem, it immediately becomes more complex. There are too many landmarks, all of them uncertain: and too few firm, clear, and incontrovertible conclusions. Every fact, every event, has been minutely studied by generations of devoted historians, but none has illuminated more than a corner of the stage, of the huge system within which Italy's exceptional destiny has been inscribed and elaborated.

That destiny was in fact the prisoner of a kind of external *structure*, one that was slow to change, although in the long run it was to be radically transformed. One has constantly to be aware of both the detail and the overall picture—or more precisely to challenge the dialectic of internal and external factors, and seek a single unifying truth. Indeed, that wider stage on to which Italian life was projected makes sense only if it is constantly related to and set alongside what was happening inside Italy on home ground, at the heart of the system. It is sometimes said that

light shed from the margin is the best, that a complex whole may best be apprehended from its outer limits. That may well be so, but we nevertheless have to deal with two separate geometries, two realities: core and periphery. Their contrasts and coincidences, and even more their failure to coincide, are the *raison d'être* of the debate we shall be following. But what a bundle of difficulties and dilemmas is contained within the enormous mass of history to be subjected to this double analysis. Relations between Italy and the countries and coastlines of Islam and Byzantium were by no means simple. And as for the privileged zone of western Europe, in which Italy played an essential role, that was a jigsaw puzzle, fragmented and torn apart by the rise of the territorial state. It was a world full of vigor and contrasts, with instances of powerful originality, which even today allow nationalist historians to champion the rights of their respective homelands against the more generally recognized superiority of Italy. Louis Courajod (1841–1896), an admirable art historian, claimed that the true origins of the Renaissance lay in France, no less![3] Fortunately this war of words between historians is becoming a thing of the past.

Beyond the Anecdotal

This great mass of knowledge and scholarship in the end becomes a burden. Too much detail has accumulated and we need to move beyond it, to adjust its true weight and restore its meaning if it has any. Too much detail: by

which I mean too many events and happenings, however important, too many biographies, however exemplary. For this is the familiar harvest gathered, in no particular order, by the splintered world of scholarship. Each detail restores, but only for a moment, a fragment of space and time which we need to perceive with accuracy and precision.

Suppose for instance that we wanted to find out about the first Italian merchants to settle in Languedoc: we would have to go back to the beginning of the Crusades. To note the presence of Petrarch in Avignon on his first visit in 1326—Petrarch who converses with Cicero and Virgil as if they were flesh and blood sitting before him—is to register the beginning of an influence from which French humanism would eventually emerge, not transformed perhaps but strengthened. If we count the Italians whom Charles VIII brought back with him from his rapid expedition to Naples, that takes us to 1495—but there were probably more marble-cutters from Carrara and Genoese shopkeepers among them than genuine artists, sculptors or architects. Perhaps too the marvels of the "Italian Campaign" have been a little exaggerated. Take another detail: when the Venetian Jacopo dei Barbari met Albrecht Dürer, the year was probably 1490; on April 8, 1500, he was appointed painter to the Imperial Court by Maximilian; later he entered the service of the Duke of Saxony, Elector of Brandenburg, traveled to Frankfurt-an-der-Oder, and eventually left for the Netherlands with Margaret of Austria in 1510:[4] it seems like a satisfying illustration of the way one branch of the Italian Renaissance eventually met up with the other pole of Europe, the Netherlands, in

which Charles of Ghent (the future Charles V) was grow-
ing up. When Leonardo da Vinci accepted the invitation of
François I to take up residence in the Château of Cloux,
bringing with him the *Mona Lisa*, *St. John the Baptist* and
the *Virgin and St. Anne*, that takes us to 1516, and France
is about to undergo a wave of Italian influence.

This much is clear, well known and documented. But
how easy would it be to situate in time and space the pow-
erful influence of Machiavelli and his *Discorsi*?[5] From the l
540s, when his work was taken up and widely diffused (he
had died in 1527) there would hardly be a moment when
his writings were not being read, reread, and reinterpreted
by a variety of commentators and followers. What this dis-
turbing Florentine was providing for all of them was a tool
kit, a vade mecum of political manœuvre, a certain "virtù,"
that strength which leads to power of all kinds. The
Spaniard Ginés de Sepúlveda defined *virtù* as "the force or
faculty enabling one to achieve any goal one has set one-
self" *(Vis enim seu facultas insita ad finem qualemcumque
propositum perveniendi virtus solet appellari).*[6] We would
call this way of behaving, as if nothing else mattered but
the interests of the Prince, *raison d'état*. This expression,
which had such a successful career, was in fact invented
not by Machiavelli but by another Italian, Giovanni della
Casa, in an address to the Emperor Charles V in 1547.[7] But
in any case, only Italy, with its diverse and highly devel-
oped political forms, with the wealth of events and lessons
to be drawn from its history, could possibly have aspired to
this degree of political sophistication, at the threshold of
modern times. And it must surely be this political maturity

that explains the steady success of so many famous Italians in the political sphere. How else are we to understand how they climbed the ladder of power on so many occasions, in other countries? Consider, however briefly, the short-lived career of Concini, Maréchal d'Ancre, a less successful version of Mazarin: it takes us to April 24, 1617, the date of his assassination. Similarly, the dates of the dazzling, improbable, indeed scandalous success of Mazarin himself are landmarks not to be overlooked. His death in 1661 tolled the knell for the colonies of Italian merchants—it was the end of "Tuscany in France."[8] But before long, in another country, an equally amazing career began, that of Alberoni (1664–1752), the humble gardener's son from Parma, who was to govern Spain under Philip V and the restless and disquieting Elisabeth Farnese—proof, if it were needed, that the Iberian peninsula in the early eighteenth century was, in spite of appearances, open to influence and adventurers from Italy.

Another essential task is to trace and map the spread of the Italian language, that constant presence in all European culture. But who would have the patience to fit together all those tiny pieces of evidence, those fleeting but significant images? On a spring day in 1536, the French King François I, greeting the Venetian ambassadors, quite naturally spoke Italian when he told them he was glad to see them and expressed his anxiety and perpetual resentment against "Caesar," Henri III of France must also have understood Italian, since as a lover of literary disquisitions and anxious for some respite from political debate at his table, towards the end of what he

considered the peaceful year of 1576, he gladly gave the floor to the Queen Mother's Italian doctor, Filippo Cavriana, a man of great learning, who "said his piece" in his native tongue.[9] Even more significantly, the audiences who went to watch the *commedia dell'arte* performed and improvised by Italian companies, in Vienna, London, or Paris, must have been able to understand the actors' words. It was only after 1668 that a few scenes in French began to be inserted into the Italian performances. At the end of the century, performances still combined the two languages.[10] The roles were of course always the same, the characters were stock, and mime helped people to follow the story, but they must also have been able to pick up a few words here and there. One last detail: Mme de Sévigné, traveling to Grignan and stopping overnight at Auxerre on July 16, 1672, passed the time by reading the *Aeneid* in the Italian verse translation by Annibale Caro.[11]

If one were to undertake a systematic search for the Italian merchant abroad (a most worthwhile project) one would have to mobilize all the scholars and historians in the world to do it properly. For in one's reading or in the archives, one is always coming across this remarkable, determined, and intelligent character, often hated, always suspect, but indispensable. After all, his shop had the finest goods the world had to offer. And he had mysterious means at his disposal. With just a pen and a sheet of paper, he could dispatch money abroad, and equally miraculously could receive it back himself, or deliver it to those who paid a fair price for his services.[12] He was

indeed an astonishing figure, and one who remained privileged by his technology well beyond the sixteenth century. Even after 1650, his reign was not over, his superiority remaining intact in eastern and central Europe. He was still to be found in Poland, for example, actively busying himself, attending the fairs, selling endless quantities of fabric from Lucca, Florence, Milan, or even Venice[13]—evidence that industry continued to thrive in these famous cities and that Italian trade was still flourishing in the backward zones of central and eastern Europe. Note too that the spread of trade was accompanied by that of the arts, and that Italian artists, architects, and writers thronged to eastern Europe in the seventeenth and eighteenth centuries. Metastasio (1698–1782), who was summoned to the Viennese court in 1730, would be its official poet until his death. For Italians, the north-northwest sector of the compass long remained a worthwhile direction for travel. And yet by this late date, according to the history books, Italy had ceased to exist or at any rate to have any external presence!

How is one to set down a coherent account of all these thousands of details, of all these sound waves bouncing back and forth, jostling and interfering with each other? Above all, how is one to hazard an overall diagnosis on such a foundation? How is one to extract a meaningful history from this succession of short-lived pictures, some of them mere mirror images?

Proceeding by Cross Sections towards a General Analysis

Possibly the best way to try to grasp the extent, the nature, the force, and the duration of Italian influence abroad is to proceed by taking a series of cross sections over time, at different dates between 1450 and 1650. When juxtaposed, these successive maps of Italy's foreign presence should combine to create a history of Italy outside Italy, covering an area far greater than the peninsula itself. The greatness of Italy was one of the dimensions of the world, as it is important to point out—and to keep pointing out.

We shall then have to analyze and dissect these successive stages of greatness. Did they obey some inner destiny? Do they form a logical sequence? We shall see that power and culture do not always mingle in equal proportions, nor necessarily go hand in hand, and that Italy's foreign influence is not from start to finish a simple matter of the diffusion of precious goods. And this finding bears witness both to the singular destiny of Italy during these centuries of the early modern period, and to other examples where greatness of a similar order can be recognized.

A Series of Overall Perspectives

Contrary to assumptions sometimes made in the social sciences, there is no such thing as a straightforward synchronic cross section, springing unproblematically into view the moment one's argument requires it. A single snapshot, outside time, without a degree of chronological depth, would be lacking in life and therefore in usefulness. If I present a series of perspectives, as I intend to, from about 1450, 1500, 1550, 1600, and 1650, it is not with the idea that on each occasion I shall be able to give a precise picture of the "situation" immediately discernible at these precise dates. Rather it is to assume a convenient set of vantage points from which to look both forward and backward, according to the disposition of time, the landscapes, and the realities before our eyes.

How can one gauge or comprehend life in progress without enlisting the passage of time as an accomplice?

WHAT THE WORLD LOOKED LIKE
TO AN ITALIAN IN 1450

To take 1450 as our starting point is of course to make an approximate choice. For greater precision (though it would in fact be misleading) one might have taken the fall of Constantinople (May 29, 1453) or the Peace of Lodi (April 9, 1454) which saw the opening of a long period of peace in Italy—a restless and suspicious peace perhaps, but peace all the same, which would last broadly until the French invasion of September 1494. Lodi set the seal on a balance of power in Italy of which the European balance of power would afterwards be but a reflection and extension.

I need hardly say that the "Italian" of my title is also a convenient fiction for the purposes of exposition, and indeed an anachronism. Fifteenth-century Italians did indeed feel different from other peoples in Christendom, but they were divided among a series of tiny states, little Italies, lively, jealous, and sometimes violent units, not unlike the nation-states of Europe in the recent past, whose "greatness" lay only in the eyes of shortsighted beholders. For the divisions of Italy, in that age at once so far from the present and so near to it, offer an image of the recent history through which we Europeans have all lived and indeed continue to live. So to say "Italy" or "an Italian" is to use a

misleading singular. An obvious remark, but one so easily overlooked that it has to be made at least once.

The Subjugation of Three Civilizations

In about 1450, the world influenced by the teachings, the various economies, and the intellect of Italy covered Europe in the wide sense, plus the Mediterranean—although in the non-Christian countries it was usually confined to coastal strips with no access to the hinterland. But the entire sea, that is its waters and surface area, depended in some degree on the narrow Italian peninsula, which cut it in two the better to control it, as if geography had sympathetically connived with Italy's predominance.

The whole can be seen as an immense echo chamber, a zone of diaspora and influence, spatial evidence of domination (or perhaps we should call it "imbalance"), of a very special kind—and all this had been achieved well before 1450, in the course of a long history of effort, renewed endeavor, patience, and strategic victories. A few words must be said on this score, otherwise the "present"—1450—cannot be explained. How did Italy, or rather a handful of Italian cities, a few men in all, succeed one day in acquiring and holding on to a position of domination vis-à-vis Byzantium, Islam, and western Europe? The last had been a slow developer, but the first two had long been worlds of splendor and superiority. Only an exceptional breakthrough could have overcome them. We need not linger over the details of these struggles,

whose outcome long remained in the balance. We shall approach them only at the point where success seemed to be within grasp.

Byzantium: A Civilization Worn Threadbare

The decisive blow against Byzantium was struck in 1204, with the diversion of the Fourth Crusade, during that "orgy of capitalism,"[14] which led to the fall of Constantinople, and was even more pronounced after its fall. Until 1261, the great city was the capital of a Latin empire. The reconquest of the "citadel" by the Palaeologi of Nicaea in 1261 did little to alter Byzantium's fate: its decline was slow until 1453, since it remained both on the route to the wealth of Asia, and on that taken by goods exchanged for this wealth. So its prosperity endured. But that prosperity had in reality been appropriated by Italian merchants, mostly Venetian and Genoese, for their own advantage. In 1348, the Genoese customs post at Pera collected revenue to the tune of 200,000 gold *solidi* while the imperial customs of Constantinople received a mere 30,000![15]

Constantinople was to thirteenth-century Italians what Shanghai was to the Europeans of the nineteenth and twentieth centuries. Sooner or later, everything fell into eager foreign hands. Genoese merchants settled north of the Black Sea, at Kaffa in the Crimea, in about 1290; much later and this time in league with the Venetians, they reached La Tana, on one of the mouths of the Don estuary, on the Sea of Azov; and at about the same time, Trebizond,

on the route to Tabriz and Persia. Venetians and Genoese often came to blows over these distant markets, so much wealth was there at stake. But after 1395 and the devastating advance of Tamerlane, the Black Sea route to Asia lost much of its appeal to long-distance traffic. One of the stages in and reasons for the decline of Byzantium was the shift southward to Syria and Egypt of the major trade routes to Asia, in particular the pepper and spice trades. The Black Sea now had only its own produce to offer: timber, grain, Caucasian slaves, dried fish, and caviar.

But this trade was not inconsiderable—and it was certainly enough to make the Genoese of Kaffa and the Venetians of La Tana hang on to their distant outposts. How determinedly the two republics protected and patrolled these remote colonies! From Venice, the Arsenal sent the posts, scaling irons, nails, arrows, longbows, and crossbows needed to defend Tana,[16] for the little town huddled by the marshes was on perpetual alert against constant attacks by the Tartars, a people forever on the move with their herds of horses, sheep, and oxen and their covered and open wagons. The inhabitants of Tana watched the enemy from their ramparts for days on end, fascinated by this tumultuous spectacle of men, women, children, beasts, and wagons on the move. *"La sera,"* writes one eyewitness, *"eravamo stracchi di guardar"* ("By nightfall we were exhausted with watching").[17] Historians have marveled, not without reason, at the saga of the building of the fortress of São Jorge da Mina by the Portuguese on the coast of Guinea in 1475. Every stone to be transported to Africa was cut and numbered in Lisbon. But much the

same had been accomplished by Venice and its painstaking Arsenal on behalf of La Tana, years before.

After 1395 then, Constantinople was being exploited by foreign merchants, and no longer stood on the busy route to the gorgeous East. Things began to fall apart in Byzantium. The population dwindled, those who remained were poorer, buildings crumbled. And the currency was in a perpetual state of depreciation, as Italian gold coins became more sought after than the *hyperperum* (despite its name, which originally meant "purer than pure"). What was more, Genoese and Venetians not only coined false money (so-called *hyperpera* from Pera, Crete, or Negroponte) but appropriated public revenue, and controlled the gold and grain markets. How could the emperor mint sound currency when he had no access to the gold mines of Macedonia? Half-empty streets, and a population "ill-clad, miserable and poor"—such was the impression of a traveler to Constantinople in 1438.[18] There was no more trade, no more industry. The acclimatization of the mulberry tree and the silkworm in Italy, and the valuable textile industry that resulted, ended the ancient and profitable lead in silk manufacture on which Byzantium's fortunes had been founded. The decline of Byzantium could be glimpsed, in early symbolic form perhaps, in the fashions adopted by the still-gilded Byzantine youth, which now, however, wore "headdresses in the Latin style with Persian and Turkish costume."[19]

The Byzantine empire, assailed from far and near, withdrew into itself. The *basileus* scarcely controlled more than the two cities of Constantinople itself, contained by mighty

ramparts now too vast for it, and Thessalonika, where no more was now heard of the fabulous St. Dimitri markets held in front of the city's Golden Gate.[20] It was a virtually deserted town when the Venetians annexed it without compunction in 1423 only to lose it seven years later to the Turks. Byzantium by this time consisted only of the capital city, the miraculously still-beating heart of a great body that was now long dead.

That the Italians should not have been more sensitive to this distress, which was to their initial advantage but would also shortly lead to their downfall, is rather curious. But there are plenty of curious things in history. To the merchant, the potential two birds in the bush mattered less than the one in the hand: business, markets, control of key routes—whatever the political and economic disarray of the Black Sea, the Balkan peninsula, Asia Minor, or the Greek islands. Genoese and Venetians, warring brothers, never found far apart, still controlled the Black Sea and had established themselves in the Aegean: Venice already held Negroponte (the island of Euboea) from which Venetian "settlers" were exporting grain, and Candia; before long, after 1479, she would hold Cyprus as well, partly by agreement with the Genoese businessmen. Genoa possessed the island of Chios, the most remarkable of these western colonies in the Levant.

Eventually, the wholesale and extraordinary decline of Byzantium enabled the Turks, who now controlled Asia Minor, to advance through the Dardanelles (1356). Having established themselves at Adrianople, they pressed their advantage across the Balkans, and a century later, in 1453,

they took Constantinople. Too many historians have under-played this event—but it would be the foundation for cen-turies to come of the great might of the Ottoman empire, as Italy would before long find to her cost. But was there any reason to be apprehensive at the time?

In those days, ships and galleys were valued in terms of the number and quality of the troops they carried (slingers and archers) and the skill of their crews. On May 29, 1416, Piero Loredano and the Venetian fleet had won a crushing victory over the Turkish navy at Gallipoli. It was but a short step from there to underestimating the enemy. True, the conditions of naval warfare were about to change, with artillery being loaded directly on to ships. And Constan-tinople, a city shaped by the sea, would help the Turks in their pursuit of maritime strength, as Venice was to realize during the first Turkish war (1463–1479), which turned to her disadvantage.

In 1453, however, all that lay in the future. Venice had been kept informed by its "secret services" and knew about Turkish designs on Constantinople ahead of time. As early as February measures had been taken, which were later to be extended, to protect the Byzantine capital, "of which it might be said that it belongs to us," as one reads in the debates of the Senate.[21] Yet, in the event, Venice's warships and galleys did not venture beyond Modon and Negroponte respectively. The speed of the Turkish victory had rendered any intervention futile. A deal had to be struck. A Venetian "orator," Bartolomeo Marcello, was sent to Constantinople, where he obtained the release of 117 Venetians, 47 of them patricians, all of them merchants, and

some of them compromised in the heroic defense of the city. He also recovered their property, and all for 7,000 ducats.[22] So it was perfectly feasible, and certainly worth trying, to coexist with the infidel victor. In any case, how could Venice live without the Turks, without their cheap raw materials and the huge markets they represented? By April 1454, the Signoria was coming to terms with the Sultan. The instructions given to the Venetian ambassador were quite clear: *"Et dispositio nostra est habere bonam pacem et amicitiam cum domino Imperatore Turcorum"* ("Our intention is to have a good peace and friendship with the lord Emperor of the Turks").[23]

Italian Footholds on the Coast of Islam and Ventures Inland

The Crusades had apparently ended with the defeat of the West and thus of Italy. St. Louis was taken prisoner in Egypt in 1245 and died outside Tunis in 1270. Constantinople became a Greek city again in 1261 and, with the fall of Acre, Christendom lost its last significant position on the Asiatic mainland. But the waters of the Mediterranean, especially the eastern reaches, were still held by Christian sailors and traders. And this victory canceled out everything else.

In practice, in economic terms, ancient privileges persisted unaltered, in particular those of Italian shipping and trade. In the late fourteenth century, the Italians still came and went as they pleased in the ports and markets of Syria and Egypt, where the Levant's outlets to the Mediterranean

and western markets were now established: Tripoli in Syria, Aleppo, Beirut, Damascus, Alexandria, and later Cairo. Whether along the coast, or in the great caravan rendezvous further inland, Italian and other western merchants, while they might not always get their own way, certainly made their presence felt, buying up the goods of eastern merchants, whose monopoly stopped at, or near, the coast. Thus they obtained drugs, dyestuffs, pepper and spices, cotton thread and fabric, silk, rice, and beans. Since interest and curiosity had very quickly been aroused about the source of the most valuable of these goods—pepper and spices—an expedition was launched by the Vivaldi brothers from Genoa, out beyond Gibraltar and into the Atlantic, but it ended with obscure loss of life and possessions, somewhere on the African coast. Their attempt was made in 1291, the same year as the fall of Acre. Were they searching for the route discovered two hundred years later by Vasco da Gama?

The Italian presence in North Africa followed a similar pattern. All the coastal towns were involved: Tripoli in Barbary, Tunis, Bône, Bougie, Algiers, Oran, and Ceuta. Inland, there were Italian merchants to be found alongside Marseillais and Catalans in a major center like Tlemcen. In all these places, there were thriving merchant colonies. It was child's play to buy in Genoa a bill of exchange payable in Oran or Tunis.[24] North Africa yielded a constant flow of products: hides, wax, grain, as well as goods from the Saharan trade; dates, black slaves, elephants' tusks, ostrich feathers, gold dust from the Sudan. Gold belonging to Venetian merchants was shipped from Tunis in Venetian

galleys for greater safety,[25] and taken to Corfu. Occupied since 1385, this was a vital base from which Venice could control the entrance to the Adriatic and patrol the entire sea, a vantage point almost at the juncture between the east and west basins.

Thus Islam, although in control of the hinterland, was open to foreign penetration via the insidious sea on which, with few exceptions, all the ships were Christian. And in order that the pattern established in the Middle and Far East be more or less reproduced with regard to North Africa and the Sahara, the Genoese Antonio Malfante in 1447 advanced as far as Tuat, in search of the source of the gold of the Sudan.[26] By this time, Portuguese caravels were already venturing down the African coast as far as the Gulf of Guinea. Which would triumph, the men of the sea or those of the land route; the Portuguese or the Genoese?

The question of overland travel having been raised, we should bear in mind that many journeys to the interior, across sand, mountain, and desert, still remain completely unknown. Records of Malfante's trip have survived only by chance. Islam had certainly been crossed from end to end by western travelers. To take but one example, without going back as far as Marco Polo, Niccolò dei Conti, born at Chioggia in the Venetian Dogato, made long visits to India and the East Indies between 1415 and 1439.[27] Vasco da Gama did not "discover" the Indies: he simply discovered an entirely maritime route by which to reach them. And according to Sanudo, when he got there, he found Venetian merchants already in residence. I like the following anecdote: on May 21, 1498, as Vasco da Gama's ships were

at anchor in Calicut Bay, there arrived to meet his emissaries two Moors of Tunis, who spoke Catalan and Genoese. "How the devil did you come here?" they exclaimed. The Portuguese reply is revealing: *"Vimos buscar cristãos e espe-ciaria"* ("We have come in search of Christians and spices"), they said.[28]

It would be both exaggerated and misleading to imagine that the travels and initiatives of Italian merchants had been helping to weaken Islam from before the days of Vasco da Gama. The Italian merchants had in fact respected Islam's role as intermediary between East and West. And it was not until 1516–1517 that the Turks took over Syria and Egypt—without, in the event, forbidding Christian traders to use these staging posts. Only in 1518 (Algiers), 1551 (Tripoli), and 1574 (Tunis), did the Turks move into the Maghreb, and then it was in response to the brutality and success of the Spanish "crusade" more than to any supposedly damaging activity by Italian merchants.[29] In fact, "Italian North Africa," if one may call it that, was already on the wane before the Turkish invasion. It had started to decline in importance soon after the Spanish advance by Pedro Navarro between 1509 and 1511.

Western Europe, Italy's Land of Opportunity

One should not leap to the conclusion that "backward" western Europe was simply dominated by an Italy that was if not inimitable certainly consistently superior. Western Europe should not be regarded as undeveloped or more

rustic than it actually was. Indeed, if Europe was a land of opportunity for the Italians, it was because it represented an up-and-coming economy and civilization on which it was possible to base profitable superiority.

Italy and Europe at the time of the Renaissance should not be imagined like a painting by La Tour, with the light concentrated on a single person and the rest of the picture—Europe—remaining in shadow. Everything was shared. Each time Italy embarked on a period of prosperity, the rest of Europe followed suit—or sometimes even preceded it. Even in the sensitive area of art, where it might seem that the influence was all one way, reciprocity of perspective was in fact the rule. It was at exactly the same time that an identical fashion for painted portraits appeared in both Italy and the Netherlands. There was a clear "bipolarity" in the West as a whole: the southern pole was Italy, the northern one Flanders. The time would of course come when Italy would be considered "the mistress of complete art."[30] But that moment was not reached until a rather late date. It had not yet been reached in 1434, when the Lucchese merchant Arnolfini and his wife had their portrait painted in Bruges, by Jan van Eyck. And when the pattern of influences really began to operate in the second half of the fifteenth century, it would always work both ways. Flemish painting, with its powerful realism, most apparent in portraits and landscapes, had more impact than one might think on the painters of Italy. Enough anyway for Michelangelo later to express irritation at Flemish painting, which he is supposed to have described as nothing but "rags, hovels, green fields, shadows of trees, bridges, and

rivers which they call landscapes, with many figures here and there . . . without reason or art, without symmetry or proportion."[31]

But are *bipolarity* and *dialogue* adequate words to convey the variety of Europe in this period with its many talents and the surprises it held in store, ready to surface at moments throughout its history? After all, Portugal had invented the caravel and navigation on the high seas—in other words the key to the world. Flemish painters, notably van Eyck (1400–1441), had developed the technique of oil painting, and Flanders was neck and neck with Italy, if not a little ahead, in discovering linear perspective. Germany rediscovered gunpowder, and invented the blast furnace and the printing press: the first printers in Italy were all Germans. The Swiss cantons, in their struggle against Charles the Bold, reinvented the foot soldier, the infantryman who was to dominate future battles. Spain in the course of the conquest developed the famous *tercio*, the infantry regiment that would give it supremacy in battle (and therefore in Italy) until at least 1643, the date of the battle of Rocroi. France under the Capetians in the thirteenth century had gained such preeminence— thanks to the growing importance of the Champagne fairs, the widespread influence of Gothic architecture, which, like the Romanesque, had originally been a "French style," the fame of the university of Paris, and the success of the monarchy—that an Italian historian, Giuseppe Toffanin, saw European thought as being centered on France and its capital city. He regarded the thirteenth century as *il secolo senza Roma*, the century without Rome, the title of one of

his remarkable books. So Europe was by no means a docile pupil content merely to sit at the feet of a venerated master. The history of Italy in the end comes to mean the entire history of western Europe, the totality of its relations, legacies, and acquisitions: a history of partnership in a common wealth, to which all contributed and from which all received something. Without this shared wealth, as the historically minded sociologist Alexander Rustow rightly argued, "without that shared development of the urban culture of the Middle Ages, fragmented into a multiplicity of national units, of which France and Burgundy [i.e. the Netherlands], not Italy, would [long] be the leaders, the Renaissance would not have been possible."[32]

The Renaissance, according to this view, was the collective achievement of the West. But Italy, which in the fourteenth century was still only a face in the crowd in the newly diversified Europe, soon afterwards began to emerge, to move ahead and to demonstrate its superiority. For Italian superiority is something else without which the Renaissance cannot be conceived. The emergence of Italy was indeed the key question.

The West Encircled

It was not a question purely of intellectual eminence or cultural prowess. Underlying Italian predominance, there very soon stood revealed economic sources of superiority. To neglect these would mean failing to understand a crucial process. The heyday of the Champagne fairs may indeed

have corresponded to a "century without Rome." But those fairs were entirely dominated by the merchants, money-dealers, and carriers of Italy.

In similar fashion, even before the long sequence of political, economic, and social crises brought by the Hundred Years War, which so dislocated the West, the Italian economy had already thoroughly succeeded in penetrating and encircling Europe. As early as 1297, the Genoese had established a direct and regular shipping link between the Mediterranean and the North Sea. From Cape Finisterre in Spain to the mouth of the Channel, their ships had a straight run, so none of them needed to put in at French ports.[33] By about 1317, Venice had also organized the same pioneering maritime link, and before long all Mediterranean vessels above a certain tonnage were able to reach Bruges and the English ports. Thus was achieved one of the great feats of long-haul trade (*di largo respiro* as the Italians called it): a direct meeting, thanks to the Italian merchant, between those ideally complementary kinds of merchandise, the woollen cloth of the Netherlands and the rich products of the Middle and Far East: pepper, spices, sugar, perfumes, silks, mordants for dyeing fabrics, and dye plants. Thus was inaugurated the long round trip from Bruges to Syria and Egypt. To the west, the major ports on the route were Aigues-Mortes, Barcelona, and especially Valencia, Seville, and Lisbon, from where the ships sailed directly to England, putting in at Southampton and London before going on to Bruges, where Hanseatic shipping from the Baltic and the North Sea met up with traffic from the Mediterranean.[34]

During the same period an active stream of carters and

carriers was moving to and fro over the great Alpine passes—the Brenner and the St. Gotthard—linking the Netherlands to Italy, and animating a string of already thriving towns just outside France: Cologne, Nuremberg, Baste, and before long Augsburg, which mining entrepreneurs were to turn into the capital of silver extraction. In short, an unparalleled volume of traffic was now circulating round the edges of western Europe—bypassing its temporarily less accessible heartland, but benefiting the regions it brought into contact with one another: the cities of Italy, Flanders, and England, or the "free" towns of Germany with their southern extension, the *Fondaco dei Tedeschi*, the great goods depot, almost a town in miniature, that stood near the Rialto in Venice.

So even before that many-sided crisis we know by the convenient but misleading name of the Hundred Years War, Europe was already enmeshed in an unequal system, "loaded" so to speak in Italy's favor. The Italians were able to manipulate the Geneva fairs, which they had helped to create in the early fifteenth century, and where the regular European trade deficit resulting from the balance of trade was settled to their advantage. From the start they had made the necessary—and considerable—effort to gain control of these fairs, which indeed became very successful as a result.[35]

Venice's Galere da Mercato

This long-distance view from outside requires some conclusion before we move on to tackle the important

internal questions. But a graphic image may be more helpful than an extended commentary. One is provided by the cumulative picture of the sailings of the Venetian *galere da mercato* that emerges from the series of maps worked out for the years 1332 to 1534 by Alberto Tenenti and Corrado Vivanti (1961).[36]

Venice was not, of course, the only city responsible for this geographical Italian predominance, but Venice was certainly central to the prosperity built up to the detriment of others, and in this respect can be seen as exemplary. As early as the fourteenth century, the Signoria had placed its ships, built at public expense, at the disposal of the patricians who controlled both commerce and government. These galleys (galleys by design, but using oars only for entering and leaving port, and traveling mostly under sail), originally of about 100 tons and later reaching 200 or 250, were put up for auction every year and hired out to the highest bidder. Those who received them negotiated deals with other merchants to assemble cargoes. Freight rates and sailing dates were arranged by the vigilant city authorities.

Neither the details of the operation, nor the methods whereby Venice determinedly sought to foster trade links and to protect its ships from any competition (which included a form of long-term dumping, with state subsidies to private individuals) need concern us here, however. The important date in the establishment of the system is perhaps 1346 (the same year as the battle of Crécy), when for the first time, we find references to the so-called "Flanders" galleys: these, as we saw earlier, were the major

link between the Italian economy and cloth from the Netherlands or wool, lead, and tin from England.[37]

By 1450, all the routes were in operation: the Romanian galleys that went to La Tana and Trebizond; the Syrian and Alexandrian galleys; the Aigues-Mortes galleys; and from 1436 the Barbary galleys (which had by 1442 added Egypt to the coasting voyages they made from port to port along the North African coast). All these convoys, of three to five ships, were interlinked: goods brought by one would be picked up by another, at more or less regular dates, in the warehouses of the *Dogana da Mar*. So Venetian shipping made up a living system, each part connected to another. The *galere da mercato* did not of course rule out private shipping, of which the most important examples were the great roundships, the enormous vessels that made the *mude* (voyages) to Syria to fetch bulky bales of cotton. The round trip of the *mude* (about six months all told) represented the fastest available return on merchant capital, since the operation consisted simply of sending money and reselling the cotton. The least wealthy and the most prudent merchants tended to prefer this brisk trade, which did not tie up their assets for too long.[38]

By 1450, the itineraries of the state galleys alone, that is Venice's official shipping, would if drawn on a map look very like an octopus, with tentacles reaching into the entire area penetrated by Italians outside the peninsula. Venice and other Italian cities following her example were thus dispatching goods and money far overseas, in order to receive in turn even greater riches. This map of the Venetian shipping routes gives a better idea than anything

else could of the co-ordinated effort, the calculated penetration of space, and the superior command of the crucial transport sector that provided Italy for so long with its livelihood.

The Rise of the Italian City-States

Let us now return to the heart of the story. At the center of the system organized to its own advantage, Italy was far from being a completely peaceful zone.

This was an age of more or less rapid growth throughout Europe. Outside Italy, after some delay, there appeared in the latter part of the century the first modern territorial states: France under Louis XI (1461–1483), Spain under Ferdinand (1479–1516) and Isabella (1474–1504), England under Henry VII (1485–1509). Appearances notwithstanding, we should not be too ready to believe that such states were the achievement of truly outstanding individuals. A general movement favoring the growth of the monetary economy encouraged relations, multiplied exchanges, and rendered political units that were too small more vulnerable, creating at the same time entities marked out for success—"universal spiders' webs."

The history of Europe had long been a race: city against state, or perhaps one might say hare versus tortoise. The hare, the nimble city-state, seemed, logically enough, to be winning all the prizes at first. But the fifteenth century was the period in western Europe when the slow but steady tortoises began to reach the winning-post. The territorial state

triumphed, we may note, in the extreme west of Europe, bordering the Atlantic, an ocean that had not yet made its fortune: Columbus did not set sail until 1492. In fact the territorial state became established in precisely those regions that had not yet been taken over by the swift-moving city-states. It had scarcely any cities to contend with: very few of them were powerful, and those few were often isolated. This was a stroke of good fortune for the modern monarchies—the near absence of any serious urban obstacle to their ambitions and to the "state bureau-cracies" that encouraged the "horizontal" development of the major political units. How could "Germany" in the broad sense and how could Italy in particular ever have achieved unity? Both of them were bristling with city-states. Elsewhere, the isolated city tended to capitulate in front of the modern state: Barcelona in 1460, Granada in 1492, and one might even include Constantinople in 1453, for the Turkish empire had grown up for precisely the same rea-sons as the kingdoms of the Atlantic seaboard, in an eco-nomically backward area. The same would be true of Muscovy and later of Poland.

Italy was, however, additionally prey to an acute politi-cal crisis. Before the European tortoises had really started moving, Italy had been undergoing a profound transfor-mation of its political structures since about 1400, a good half-century in advance of the rest. Its territorial states— the Papal state, and the Kingdom of Naples, seized by Alfonso the Magnanimous in 1442 and united to Sicily—had become consolidated without any spectacular upheaval. They represented in fact an archaic, feudal, and seigneurial

Italy, one that was "underdeveloped." On the other hand, a major transformation was taking place among the richest and most active city-states. They were taking over smaller towns and subjugating them, in the course of wars that were sometimes no more than military parades, sometimes more destructive. Venice moved into Padua, Vicenza, Verona, Brescia, Bergamo, and Udine, and expanded into their territory; Genoa destroyed Savona; Milan became the Milanese; Florence defeated Pisa with savage exultation in 1406—witness the cold and scornful account by Gino di Nero Capponi, one of the architects of this victory over the old enemy, for the seaport of which he would be the first Florentine governor.[39]

So a new map was being drawn and a new political fabric woven, in which the cities, by now truly city-states, found themselves jointly engaged, the Italy of outstanding economic achievement. They did not allow territorial states to insert their bulk between them, as happened in Germany for instance, where the cities were surrounded, stifled, or at the very least jealously watched. Even when transformed into principalities, the Italian cities remained cities, units of a special kind: the Milanese was still essentially Milan, Tuscany, even after 1434, was still really Florence. So, as cities and as states, they derived from their hybrid nature both their strength (their economic dynamism) and their weakness, now that the threatening reign of large states, with large or comparatively large armies, was approaching.

Italy in 1450: On the Brink of an Industrial Revolution?

We need not dwell on this founding crisis of the Italian city-states, nor on the details of the fratricidal wars and the series of changes that accompanied them. It is certainly clear that the early fifteenth century did not see any major economic decline. It was perhaps a far cry from the high point reached in the mid-fourteenth century. But the critical questions are first whether Italy, in its new form, would take the lead in the rather uneven competition between European states—something of which there seems to be little doubt, even among economists—and secondly whether the new Italy would continue to forge ahead, which seemed highly probable. In fact all these conflicts and transformations, as in a chemical reaction, could hardly have taken place without some loss of heat and energy; and this does indeed seem to have been the case, though hard evidence is difficult to come by. What had been taking place, it seems clear, was a general putting of the house in order, a reinforcement of those "poles" of growth constituted by cities that were enormous by the standards of the time: Florence, Genoa, Venice, Milan. Their wars were not always mere shadow play or confined to verbal insults, but firearms did not yet exist. A city could be captured only by a long siege that starved its defenders out, by trickery, or by treason: a single gate had to be forced or opened. The *condottieri* were the technicians of wars that were often ingenious, but in which comparatively little blood was shed. At worst, a few horses might get away or follow a fleeing enemy, a few villages might be burned or threatened with burning. Gian

Galeazzo Visconti complained (was he sincere?) that "the pen of Coluccio Salutati—the humanist and Chancellor of Florence, a fierce polemicist of the latter fourteenth century—had done him more damage than thirty squadrons of Florentine cavalry."[40] These were to some extent—and in retrospect one is relieved to hear of it "phony wars."

It has in any case been established beyond reasonable doubt that the new Italy was steadily progressing or reviving, gaining that lead which would be essential to its greatness. Renato Zangheri has even argued that, between 1400 and 1450, Italy was on the verge of an industrial revolution,[41] or at least was moving in that direction. There had indeed been an agricultural revolution, particularly in Lombardy with the development of forage crops, irrigated fields, and new plants (rice and mulberry trees), while important progress had been made in livestock farming. In Milan and elsewhere, Florence in particular, there were concentrated what were (for the time) huge numbers of artisans. Milan and Lombardy between 1300 and 1500 give one the impression of a region living a charmed life, free from the recession affecting other parts of Europe at the time, an "impression of major constructive and innovating activity."[42] What was more, at the very same time as the Portuguese shipping ventures and the exploits of Henry the Navigator, Italian shipping was building up an intensive network of regular services—one of the major revelations of the extraordinarily rich Datini archives.[43] For instance, between 1394 and 1407 Polo Italiano's ship made the run from Genoa to Bruges fifteen times, as well as making five voyages in the Mediterranean, one of them to Chios, from

which it sailed directly to Bruges—and this is but one example among many. These merchant voyages became more frequent and more regular and opened the door to a wider range of cargoes: goods paid freight according to their value, which made it possible to carry the bulkiest and least expensive commodities over a long distance: grain, salt, timber, wool, hides. This was the "transport revolution" described by Federigo Melis.[44] The seas now saw the appearance of some very large Italian vessels. Genoese carracks could weigh as much as 1,200 to 1,500 tons—probably the limit for wooden sailing ships; the English Indiamen of the eighteenth century that sailed to China were of barely larger tonnage, and for the fifteenth century this was colossal.

On St. Martin's Day 1495, two of these Genoese merchantmen, as tall as houses, were lying off Baia near Naples, just as the French were hastily evacuating the city. According to Commynes, if they had sent their crews ashore, they might have reversed the situation, "for those from the two ships would have been enough to recover the city of Naples for the present."[45] Unfortunately for the French, the Genoese did not risk it.

But the industrial revolution did not after all take place in the advanced and go-ahead Italy of the fifteenth century. What was lacking? Was it simply that the population was not big enough or, as some have suggested, that Italy did not possess a "national market"? Such a revolution would also have required the unity of the peninsula—under the leadership of Milan what was more, with Filippo Maria Visconti (1392–1447) succeeding, for example, in his major advance

into central Italy. In retrospect, we might be drawn into deploring, in the name of the economy, the liberal and republican resistance of Florence, a reaction that usually receives the sympathy of historians. But even if Italy had been unified, and capable of standing up to the political giants surrounding her, would she have been equal to developing the new structures of an industrial revolution several centuries earlier than Britain? It is hard to give a short answer to such questions, which are nevertheless of prime importance since they force us to think about what the industrial revolution really meant. I believe that it implied a *set* of circumstances that were not available to Italy. But the fact that the issue has been raised at all is evidence of Italy's precocious vigor and of the thoroughgoing nature of the upheaval experienced during the first half of the fifteenth century. What was vanishing was a seigneurial and communal history, one that had nevertheless been characterized by a degree of liberty, a certain way of life within a small radius, a civilization that included the free organization of the *Arti* (guilds). To speak of an ancient popular culture is perhaps to go too far. But what would come afterwards was entirely aristocratic and princely in nature, transplanted from an ancient context. Civilization rose to the top of society, as a diver rises to the surface of the water.

Merchants as Ambassadors Abroad

The Italy of the early Quattrocento was a force within western Europe, but its writ ran no further. The doors of

the civilizations of Byzantium and Islam remained closed to it. This was a matter of mutual incomprehension, some historians say, and there is an element of truth in that. But from as early as the eleventh century, to go no further back, Italy had been visiting Byzantium or the cities of Islam, civilizations which were richer than its own. Here Italy was the pupil who listened and borrowed. The famous medical school at Salerno reproduced the teachings of Arab medicine. And literary critics have conclusively demonstrated the borrowings Dante and his contemporaries made from the Arab authors whom they took as their models on account of their philosophical and scientific superiority. So there was never any question of Italy trying to influence those who were richer and more brilliant than itself. On the contrary, Greek scholars were being received with much respect in Venice and even Florence by the late fifteenth century. Indeed when Constantinople fell in 1453, the exodus of Greek intellectuals to Italy—however intolerable some of these refugees later turned out to be—represented an enormous cultural transfer. It was as if Aeneas had once more brought to Italy "the gods of Troy." Cardinal Bessarion (1403–1472) was the most famous of these expatriates. In Venice, "his library became the famous St. Mark's library," and without him "the Aldine family would never have been able to publish their first great editions."[46] A second wave of humanism was launched, with Greek as its vehicle. Its architects were many, among them a refugee this time to Florence not Venice, Johannes Argyropoulos, who would teach Aristotle's natural philosophy in the *Studium Generale.* His name is mentioned in Leonardo da

Vinci's notebooks though we do not know whether the painter attended his lectures.

To receive is one thing, to give another. Italy would exert *lasting* influence only in western Europe, within a civilization related to its own and welcoming toward it. Even in this important direction, however, it seems that Italian superiority long took a purely material, commercial, and financial form. The Italians scattered throughout western Europe were either merchants or, more often, moneylenders. Wherever one cares to look, whether in Barcelona, Valencia, Seville, Lisbon, London, Bruges, Bordeaux, La Rochelle, Paris, Rouen, Avignon, Montpellier, or Marseille, one finds these clusters of Italian merchants. The immense amount of material to be found in the correspondence sent and received by Francesco di Marco Datini, the merchant of Prato whose fabulous archives have survived, is as concerned with dispatching bills of exchange as it is with merchandise.[47] An entire sophisticated system of credit, truly a "superstructure" of economic life, had already been established. There was, so to speak, an airmail service linking Bruges to Genoa, Florence to Montpellier, Paris, and London, or Barcelona to Venice. Meanwhile what people noticed most was the physical movement of goods. The most spectacular sight to be seen must have been the arrival in Bruges— the central rendezvous of trade—of Venetian *galere da mercato* (the *galere di Fiandra*), of Genoese carracks, and later of Catalan roundships. Whenever the ships came in, Bruges was transformed into a marketplace, rather as in the seventeenth and eighteenth centuries the great Indies

companies opened their warehouses at carefully selected moments, to put their goods on public sale.

Among the Italians abroad then, merchants were particularly prominent. They were already being accompanied by soldiers, sailors, adventurers, intllectuals, and artists. But the latter did not arrive in large numbers and were certainly not received as revered and indisputable masters. They appeared very early in Avignon, but seem to have slipped in one by one. The Italian goldsmiths there were originally commercial travelers, merchants rather than artists or artisans selling their own craftsmanship.[48] From about 1328 Italian painters began to find work in French artists' studios, but only as subordinates. There was no question of their being seen as having something unusual to offer, let alone a new vision of the world. That day had not yet come. Even later, when the great sculptor Francesco Laurana, Dalmatian by birth but trained in Italy, and having worked in Sicily and Naples, came to the court of King René of Provence from 1461 to 1466 and from 1475 to 1502, he made little impact. In Marseille he sculpted the altar of Saint Lazare at the Major, and the reredos at Saint-Didier; the tomb of Giovanni Cossa in the church of Sainte-Marthe in Tarascon; and probably the tomb of Charles IV of Anjou intended for Le Mans cathedral.[49] But despite the maturity of his style, he did not really exert much influence on French sculpture. At this period, Italian art did not yet have any great prestige and influence beyond the Alps.

Even such a great humanist as Petrarch, when he came to France, was doing no more than furthering an analogous or even older movement there, which was now beginning to

gather strength. Before Italy could become the center of major cultural influence, Italian merchants would have to become, over time, even more refined; Italy would have to distinguish itself more clearly from the rest of the West; Italian nobles would have to make the move to the cities earlier than their counterparts in Europe, and build houses and palaces there. The cities of Italy would have to expand, renew themselves, and embark on great building programs; the Renaissance in its full flowering would have to become indisputably established there; public spectacle would have to be on a scale never seen before; the bourgeoisie would have to become more important and much time would have to pass.

But in the meantime, the other European countries would have asserted their own personalities. The warm welcome they would one day offer to Italian culture would in every case—and in a variety of different ways—be strongly counterbalanced by their own national cultures, by now firmly established and unwilling to give ground to the interloper. Italy did not prevail without a struggle—and that struggle would actually contribute to her greatness.

Italian Humanism: No Breakthrough until the Mid-Fifteenth Century

The word *humanism*, coined by Georg Voigt in 1859, has had a very successful career. With a little encouragement it might even become a slogan of present-day political philosophy: one often hears references today to "the new humanism" or "the third age of humanism." Any inquiry

into human nature comes under this heading, and many things are grist to its mill.

In the following pages, this word will certainly not be used in this new and distracting way, nor will it quite be used in its once usual sense of ancient culture, derived from *humanitas* and *humanae litterae*. What today's historians prefer to mean by this inspiring watchword is no longer simply the return of Western thought to a certain form of classical antiquity, although that remains an essential feature of it, but a more complicated cultural phenomenon, a slightly mythical one perhaps, not unlike what is meant by that other vague term, the Renaissance. "Humanism begins when medieval civilization dies," said one historian in 1935, "and with it the economic and social concepts proper to the Middle Ages."[50] But we know that the Middle Ages were a long time waning.

What is more, the term *Renaissance*, launched by Michelet and Burckhardt, is often confused with the concept of humanism—except that humanism emerges first, as the earliest architect, begetter, animator, and propelling force of that universal transformation (destruction and reconstruction), which goes by the very general name of the Renaissance. Humanism travels ahead of the movement, like a quartermaster finding lodgings for the troops. It is the Renaissance before the Renaissance so to speak. And many historians are quite happy to accept this, being willing to see humanism as something very ancient, something already present in the hybrid thought of the Middle Ages, into which memories of classical Rome were incorporated, despite the confusion they caused by coexisting

with Christianity. In short, humanism dates from long before Petrarch (Francesco Petrarca, 1304–1374), the first man to explain the whole range of its meanings. Augustin Renaudet after all saw fit to entitle one of his books *Dante Humaniste* (1952).

Although long established, humanism took on a new vigor, to become present everywhere in the West, much as science would later, at the crucial turn from the sixteenth to the seventeenth century. All over Europe, there appeared men of passion, versed in the "three languages" (Greek, Latin, Hebrew), brimming with self-confidence, and openly careerist. Sometimes they forced their way into the universities and imposed their ways of teaching. More often, they found doors closed to them and the *humanae litterae* had perforce to flourish outside the privileged and unwelcoming academy.[51] The humanists found it easier to penetrate the chancelleries, found niches in modest livings of the Church, sometimes made their fortunes in the courts of princes (though that was fraught with danger) or founded circles and academies, meanwhile persecuting those of backward-looking mind (of whom there were plenty). Among themselves they quarreled shamelessly; they were arrogant, insufferable, and—in their own eyes at least—indispensable. Humanism was a sort of epidemic sweeping through Europe, although unlike the plague which attacked the entire human race, humanism affected only small groups of people: Latin speakers were necessarily men apart.

The driving force behind humanism was no doubt a more or less widespread sense of crisis. The collapse in the

fifteenth century of both Empire and Papacy, those twin pillars of Christendom, and the series of wars, recurring depressions, and relentless outbreaks of plague all contributed to create a kind of *mal du siècle*, encouraging a latent cultural revolution. Humanism was moreover a means of destroying something already on the point of collapse but still presenting an obstacle and hindrance. It was an "ideology" in search of itself, difficult or impossible to define, since it was constantly changing. Perhaps this was the first attempt in the West to find a lasting form of ideology—unless, as J.A. Maravall thinks, scholasticism was the first to fulfill that function.

To call it an ideology is to identify it as a loose system of ideas, beliefs, declarations, prejudices, connected by a sometimes less than perfect logic, but connected all the same. An ideology cannot but be all-enveloping: its nature is to take over the individual and oblige him to submit to constraint, as he is generally only too pleased to do. In short it is a kind of replacement civilization, designed to repair the holes and fill the gaps in an existing civilization, now perceived as damaged or deficient. Logically it calls for enthusiasm, conviction, the certainty that one is right, and the lure of success. That it should consist of a bit of everything is logical too: the plaster used to patch up the cracks blends with what was already there.

Humanism was in this sense no more a simple return to antiquity than the art of the Renaissance was the resurrection of Vitruvius. Antiquity was an alibi, a dream one might enter to escape the contemporary world, which could not be the world of Cicero and Seneca. Humanism claimed to

offer "progress and a return to the past," which is a contradiction in terms, and to combine "in a single intuition nature, virtue, beauty, reason, antiquity and the Christian religion"[52]—a naïve program perhaps but a revolutionary one. Philology might be a small thing in itself, but the freedom of intellect and the rational criticism it required amounted to a major step forward!

As it was, the *tertium regnum*, the "third force" of humanism, gradually imposed itself throughout Europe, and a network of correspondents made of it a "European republic of letters," a world apart, a nervous system that gradually extended to cover all of Christendom, developing sensitive or ultrasensitive antennae for any event that might happen.

In that world of about 1400, Paris did not lag behind Florence or Rome; Strasburg or Basle were the equals of Padua. A specialist has even written, apropos of Paris: "The time lag [between European humanism and that of Italy] which was until recently thought to be quite established, now seems to be minimal or even nonexistent. In some cases, one might even wonder whether French humanists did not show the Italians the way."[53]

The same might be said of Germany, which was powerfully influenced by the holding in two of its cities of the Councils of Constance (1414–1418) and Basle (1431–1449); humanism was certainly given a considerable boost by these international meetings, by the presence there of men like Nicholas of Cusa or Enea Silvio Piccolomini (the future Pope Pius II)—but already at this stage, the first seeds of the new thinking had begun to germinate there.

As regards humanism then and the cultures coming face-to-face with it, there was for some considerable time a west European equilibrium, in other words exchange took place on a basis of reasonable equality. The imbalance that would make possible the rise of Italian humanism became evident only during the second half of the fifteenth century at the earliest. The heart of Europe, that is to say France, had been ravaged. Italy on the other hand had been protected from the worst, and that was important. Here the uninterrupted succession of generations of humanists encouraged a certain progress, an accumulation of knowledge, reaching down "from Petrarch via Salutati to Bruni"; and Italian humanism, once launched, naturally moved on to reach its peak with the age of Poliziano, Ermolao Barbaro, Marsilio Ficino, and Pico della Mirandola. This was the age of enthusiasm for the study of Greek and Hebrew, the age too of the printing press. The first printer in Italy, a German, is mentioned in 1467. Does the establishment of these pre-conditions explain the great Italian breakthrough? In Paris, which we may regard as a typical example, it does *seem* that the flame of humanism was revived by Italians. Gregorio Tiferna, a native of Rome, was teaching at the University of Paris between 1456 and 1458. Among his listeners were two outstanding students, Robert Gaguin and Guillaume Fichet. About twenty years later came Filippo Beroaldo the Elder, and then his successors— a disputatious group: Fausto Andrelini, Girolamo Balbo, Cornelio Vitelli. The great teachers of later years were, among others, an Italianized Greek, Johannes Lascaris, and Girolamo Aleandro. The latter's inaugural lecture in 1508,

read at top speed, lasted two and a half hours without damaging the author's reputation—it was already too great to be touched.[54] By this time, French humanism seemed to be restored to health: "Guillaume Budé was a French Poliziano, Lefèvre d'Etaples a French Pico della Mirandola."[55] Who could say fairer than that?

But are words like "restored to health," which I have not invented, the right ones to use? The problem can be reconsidered in every detail, but I doubt whether it can be resolved once and for all. If we stay with the French example, which is partly valid for other countries, we should have to identify some kind of gap or breakdown during the difficult time France was experiencing. Such is not to be found before 1418, according to a brilliant study by Ezio Ornato (1969), and most people will agree with him. But, he goes on, "What about after 1418? To prove the existence of a decline after that date, it will not be enough simply to point to the sudden disappearance of the best-known humanists who fell victims to the civil war; we should also have to demonstrate that the milieux in France which ought to have been transmitting the new culture—notably the universities and chancelleries—had been rendered incapable of training a new generation of cultured men able to carry on the tradition. I hope presently to help demonstrate the contrary."[56] Whom are we to believe? In this debate, in which Italy is our chief area of concern, reconciliation seems to be the sensible course to take. All humanism is in a sense twofold, with first a national and then a European component. Pico della Mirandola spent the years 1485 to 1488 in France; Lefèvre d'Etaples went to

Florence, Padua, Rome, and Venice in 1488 to 1489 and again in about 1500. Is it really impossible to reconcile the notions of on the one hand a perfectly healthy French humanism and on the other an *outstandingly* healthy Italian humanism, coming to meet it and maintaining natural links with it? If this could be done, it would mean accepting that the same set of circumstances, the same *conjoncture*, prevailed for humanism in France, Italy, and perhaps elsewhere as well.

The same *conjoncture*? I am inclined to say, yes very likely. And the same structure too, by which I mean the same basic reality. Nonspecialist historians would at this juncture make a more obvious but unanswerable point: humanism was an urban phenomenon, connected with the rise of the bourgeoisie. A priori one would naturally expect Italy to be leading the field: where else in Europe were there so many rich cities, so many bourgeoisies comfortably established? On the question of quality, the debate remains open, but in terms of quantity the immense superiority of Italy is obvious. If we are looking for "critical mass," as Pierre Chaunu would say, this is certainly the place to look.

Once these considerations are made, it becomes clear why Alberto Tenenti does not like discussing humanism in the broad sense until after 1440;[57] not because he believes that no humanism existed before the Italian influence made itself felt, but because it was only then that humanism took on European dimensions, finally finding a firm foundation, and preparing, without it being apparent at the time, to confront the great religious conflicts that would gradually break out towards the end of the century and

more particularly in the next. Humanism—like science in our own time—would find itself facing unexpected responsibilities at about the same time, and in the train of the same movement as the end of the Italian wars. Revolutionary in spirit, humanism would lead to that more obvious revolution that we call the Reformation—a tidal wave that was about to engulf Europe.

Three successive Italies, with quite different political and economic climates and circumstances, can be distinguished with the naked eye, as it were, between 1450 and 1650. They correspond to traditional divisions, with war and peace being the major punctuation marks; but war and peace are often a reflection, as we shall see, of the slower heartbeats of the *conjoncture,* the economic trend, that will often be referred to in this analysis. (The trend was up in 1460–1483, down in 1483–1509, up in 1509-1529, down in 1529–1539, up in 1539–1559, down in 1559–1575, up in 1575–1595, down in 1595–1621, up in 1621–1650—dates approximate to within two or three years.)

The three Italies in question are:

First a peaceful Italy, one that had created peace for itself after the complex and difficult agreement of Lodi on April 9, 1454, and was able to enjoy and preserve it, by some miracle, for the forty years from 1454 to 1494, while the rest of Europe rang with the clash of arms.

Next an Italy ravaged from 1494 to 1559 by war imported from outside, war imposed by others, but to which Italians had to accustom themselves if they were to survive, a war interrupted by pauses but always on the

brink of breaking out again or increasing in severity. The war was the occasion for a flood of undesirable immigrants: the French, *said* to be *bons vivants* and cheery fellows; the Spanish, who arrived wearing espadrilles but turned haughty once they had made their fortunes; the Swiss, who swooped greedily down on the temptingly rich Milanese; the Germans, who returned over the Brenner Pass with their camp followers and their meager booty, pushing in front of them perhaps a horse, a cow, and a cart. Such were the so-called Italian wars—which in fact were wars *over* Italy, directed towards the conquest and occupation of the peninsula.

And finally, an unexpected Italy, following another simple event—the signing of the peace treaty of Cateau-Cambrésis (April 1–3, 1559) which might have been just one more piece of paper. But this time, Italy was to be plunged into a long, indeed *very long* period of peace, as if condemned to remain outside the war zone by some sort of pacific imprisonment. For this uneasy peace, which spread like treacle through Italian life, also came from outside: it was imposed on Italy by many coincidences and by the weariness and indifference, in the end, of foreign powers who had fought too long over the cities and landscapes of the peninsula to want to try it again, and who had more urgent things to attend to elsewhere. Of the savage and devastating Thirty Years War, Italy received no more than "a few splashes." Three Italies then: of which the first had complete freedom of action; the second was dominated by foreign presence; the third was peaceful once more and would have regained the freedom to live undisturbed for a

long time, had the Spanish not still kept garrisons there and continued to occupy the center stage. But were the Spanish perhaps there to provide cover—an excuse, a guarantee, and a good conscience for those established social groups who really controlled Italy? Federico Chabod demonstrated as much when he studied the *Usi e abusi nell'amministrazione dello Stato di Milano a mezzo del cinquecento* (1958). As soon as one penetrates below the thin veneer of Spanish rule, one finds Italian high society holding the levers of power, something that was true not only in Milan, and well beyond the mid-sixteenth century! The bourgeoisie or rather patricians, the nobles or rather feudal lords, came to terms with the Spanish presence, which was nowhere actually welcomed, except in Lucca—no doubt because there it represented less of a threat.

But perhaps we are inclined to view the question of occupiers and occupied in the sixteenth century too much in terms of recent experiences ("collaboration" and "resistance"). I doubt for instance whether the French, who occupied Piedmont from 1538 to 1559 (and were more effective on the ground than the Spanish), ever really dominated it. Venice tended to allow her possessions in the *terra firma* to keep their own institutions and even their former customs regulations, some of which discriminated against Venice itself—those of Padua for instance. Ruling without truly ruling is a problem that often arises in history and is rarely clearly resolved.

Nor should we be too inclined to explain the Spanish presence by the need to confront the Turks, from the eastern coast of the state of Naples to the whole of Sicily. It is

true that the Turks began to threaten Italy seriously in 1480, with the capture and sacking of Otranto, the first incident in the so-called Italian wars; and that they continued to do so off and on for a century, with some long intervals. But that threat had vanished by 1574. And we should remember that Spain usually sent only small garrisons to its Italian possessions; three or four thousand men, for instance, to hold the huge kingdom of Naples. If Italian troops, and the Italian cavalry that patrolled the coasts, had not lent a hand, Spanish rule would have collapsed like a pack of cards.

So there was a degree of complicity and sometimes goodwill on the part of the subject society towards its "oppressor." Yes, people complained about the Spanish, insulted them, and said terrible things about them—witness these anonymous lines quoted by Corrado Barbagallo:

Io quando sento dire—Egli è spagnolo—
Faccio la conseguenza, id est *un tristo,*
Un sodomita, un furbo, un mariolo,
Un luterano, che non crede in Christo.[58]

("A Spaniard"—when they tell me that,
I reckon he's no good:
A sodomite, a cheat, a brat,
And a Lutheran to boot.)

But that was simply a little literary letting off of steam. In practice, no resistance was organized against the arrogant occupier.

Any reader interested in following up the military details of the Spanish occupation would frequently find himself surprised and disconcerted. Take for instance the memoirs of the Spanish soldier Miguel de Castro, hardly more than a boy, and although already inclined to show off, a sharp-eyed observer and an excellent narrator.[59] Read the account of the moving welcome given by some poor peasants to this *bisoño* ("greenhorn") when he arrived in Praiano, a little village in the mountains behind Amalfi, with his uniform in tatters and his white shirt showing through the holes: the story is too naively told not to be true. Similarly, I never tire of reading his account of his company's march, just after Christmas 1608, across the Calabrese, from Nicastro to Tropea, facing the storm-tossed sea. Darkness fell early, horses slipped into the ravines with their burdens, and the men, ravaged with cold and drenched with rain, were knee-deep in water. Whatever could this handful of soldiers have done in such an inhospitable and nightmarish landscape, if they had actually had to fight?

1454–1494: An All-Clear That Is Hard to Explain

The first Italy we have identified, Italy in the latter half of the fifteenth century, was free, at peace, and, it might be said, happy. War had practically disappeared after the hard-won Peace of Lodi in 1454, a treaty that meant something, since it held firm.

Advantage was taken of the peace by the dominant

social groups. There were stirrings here and there, in Calabria for instance, but the social order was nowhere endangered. The rich and powerful were able to enjoy their privileges and their peaceful and luxurious civilization without guilt; they could bask in the Quattrocento sunshine. All would seem to be for the best and historians would ask no more questions, if research had not revealed that throughout western Europe there was in fact an "autumnal depression" marking the end of the Middle Ages, a fairly long-lived economic depression, which affected more than the very end of the century, the forty years from 1470 to 1509. And Italy was as subject to this change in the economic climate as any other country.

How then are we to reconcile this apparent contradiction? A cultural explosion might seem a priori to be a sign of good collective health; while an economic recession would a priori seem to exclude such achievements. And yet there the achievements undeniably are. How do we resolve this dilemma?

By an effort of the imagination, perhaps, and by a systematic discussion of the elements of the problem, taken one by one. But we shall in the end say no more than R. S. Lopez and H. A. Miskimin have already said in their classic article "The Economic Depression of the Renaissance."[60] The data that have been uncovered are sufficient to raise though not to resolve the major problems. We shall have to be careful not to fall into the trap of relying too much on the theory and concepts of the economic historians, lest we end up like the sorcerer's apprentice entangled in our own reasoning. The only serious

argument in my view is the price recession between 1470–1473 and 1500–1509. These are approximate dates, but on the whole reliable ones, and it is at least firmly established that the century ended in depression, something that may have contributed to the gloom of the last years of Lorenzo the Magnificent (who died in 1492). But if we are looking at the economic *conjoncture*, we should not forget that the cyclical depression noted here was preceded and followed by upward trends, so there were compensations. The key question for us is whether in about 1470 and again in about 1509 the history of Florence, which is central to our story, witnessed visible turning points, first downwards, then in the other direction. Overall, however, the period was unquestionably one of recession.

What would a recession of this type actually have meant, particularly in Florence, which lies at the heart of the problem? It should not affect our arguments that no economic indicators have been calculated for Florence itself (where documents do exist, according to Earl J. Hamilton, but have not been used). By this time, it is clear that the economic trend within Europe was a unified one. What happened in Venice, Siena, or Valencia gave a fair indication of what would soon happen elsewhere.

What we need to know is the kind of effect and social impact such a downturn could or did produce. Who was most affected? Who remained untouched by the depression? In theory, the accumulated wealth of the rich would have been hard to invest, and good placements would have become rare. That said, were the rich likely instead to

squander their money more willingly on luxury, display, and art? The social order encouraged such extravagance, such diversion of funds. When the excitement and profitability of business waned, did the rich merchant play the noble art patron? As it happens, there is a possibly suggestive comparison. If one looks at the late sixteenth and early seventeenth centuries (say after 1595) in Europe, one surely finds the same combination of price recession, financial extravagance, and cultural brilliance. These were the years of the Spanish Golden Age, of England under the Stuart Restoration, of the Archdukes and Rubens in the Netherlands, of the flowering of Holland, and of France during the *style Henry IV* (too often inaccurately described as the *style Louis XIII*).

But perhaps, in the end, we have been drawn into wrestling with a false problem. Historians may become the victims of the very success of their analysis and its instruments. Through their efforts, human history has been caught in the flexible and undulating toils of the *conjoncture*, the trend of prices and wages. Yet as a context, it may not be entirely valid. Economic research informs us that national income, that is, the total of individual incomes, increases or decreases independently of medium-term price movements (if nineteenth-century Europe is a reliable example). Now the connection between the economy and cultural life has as much, if not more, to do with growth as with the medium-term trend. And growth has its own rhythms: a priori it is quite possible to imagine it bearing the weight of a particular cultural expansion, while the *conjoncture* remained of only secondary importance. The

problem in these centuries, when measurement is approximate and difficult, is that growth can be perceived only in a qualitative fashion. Are a few "signs" sufficient to reassure us? With so little light to guide us, it is not easy to get very far, even if we take a leaf out of the medievalists' book and use both prudence and imagination in drawing conclusions on the basis of very little documentation.

Partial arguments of course abound. Some things we can see for ourselves: the cities were everywhere developing and expanding—Florence in particular but also Milan and Venice. In Venice, wooden bridges over the canals were replaced by stone bridges. St. Mark's Square became a perpetual building site. According to Sanudo's *Cronachetta*, written in about 1499, the city remained a splendid sight; the port was busy; the great warehouses of the *Dogana del Mar* were bursting with merchandise; the cost of living was low; the markets were full of produce. What was the reason for all this splendor? *"Questo è per esser tutti danarosi"* ("Everyone has money").[61] And Venice had moreover waged a long and by no means phony war, all on her own, against the Turks, from 1463 to 1479. During the short war of Ferrara (1482–1484), she had held out against the rest of Italy. *"Tu presumi la monarchia voler far d'Italia bella,"* "You presume to make fair Italy your kingdom," said Venice's enemies, though in fact the city managed to seize only the rich but narrow strip of Polesine and Rovigo.[62] What a strange fate was Venice's: turning its back on Italy without being separated from it, fighting the mighty Turkish empire, yet obliged to do business with it. Venice could not live without the Turks, nor the Turks

without Venice, since it was through this city that the Ottoman empire acquired from the West the artillery and naval designs, the skilled workers and the silver it needed to survive. Venice and the Turkish empire made up one of those couples of "complementary enemies" whose incongruous but durable marriages are often arranged by history.

But the question that concerns us here is the economic health of Venice, and consequently of Italy. Gino Luzzatto has rightly pointed out that "at least within the city limits, Venice during the second half of the fifteenth century enjoyed prosperity certainly no less than at the peak of her fortunes."[63] And this remark might possibly be extended to the whole peninsula.

If so, it was because the Mediterranean was still offering a preferential welcome to Italian shipping. Syria until 1516, and Egypt until 1517, remained independent of the Turks, being ruled by the Mamelukes and Sudan, and still on the whole being accommodating towards the West. Even the Black Sea remained accessible after 1475 and possibly until 1550. Germany, moreover, newly invigorated by the revival of the silver mines, was closely linked to Italian markets. France, although inclined to be protectionist, left open the doors of the Lyon fairs, at which Florentines and Lucchese reigned unchallenged. Spain, Portugal, England, and the Netherlands, widely accessible to trade, were also tied to the distant fortunes of the Italian peninsula. Seville and Lisbon were bases for Italian capitalism (Genoese and Florentine) until the sensational events that, as we know, would before long be taking place.

All in all then, Italy was not alone in creating a balance for itself as the Middle Ages came to a close, turning its back on foreign wars, with a peace that would benefit its *apparently* happy existence. All the surrounding countries of western Europe meanwhile were experiencing *internal* wars: they were not for export, nor were they really exportable, a sign possibly of the great recession affecting the West: the Wars of the Roses (1455–1485); the civil war between Louis XI of France and Charles the Bold (1467–1477); and the domestic conflicts of the Iberian peninsula (Castile against first Portugal then Granada). Within Italy, by contrast, peace was carefully preserved by diplomatic negotiations and agreements.

In an Italy now learning about peaceful coexistence, Florence was the instrument of the necessary restoration of equilibrium. Between adversaries watching each other with suspicion, the Tuscan city's geographical position made it a sort of unofficial capital of the peninsula. Everything came into and out of Florence. Despite its manifold divisions, Italy was now in a sense taking shape, despite all the resistance, inertia, and ineradicable local particularities. Meanwhile the artists whom Florence had to spare were in demand everywhere: Rossellino was building the Palazzo Venezia in Rome: Giuliano de Maiano, the Porta Capuana in Naples; Filarete, the Ospedale Maggiore in Milan, and so on. Florence was restoring the balance of Italy, setting the pace. In short, Florence was to Italy what Italy was to the rest of Europe.

High Society

It is not easy to form a clear picture of this center of *Italy—despite* the huge mass of accumulated knowledge. Yet it is from Florence that many things can be perceived and situated. Every civilization is based on a society, whose needs and desires it expresses and whose hierarchies it also reflects. Between the years when Petrarch and Boccaccio were young and those of their maturity and later, which sector of Florentine society counted most, culturally speaking? Who organized and directed the cultural movement? If we knew the answer to this, many problems would become easier to resolve, including that "autumnal depression" we have detected here as elsewhere, marking the end of the Middle Ages in western Europe.

Frederick Antal's fine and uncompromising study (1947) poses the question and proposes an answer.[64] As he sees it, the authoritarian dialectic between artist and client was resolved in favor of the latter. It was the client who commissioned a work of art, chose it, or imposed his tastes—the client, in other words a representative of the upper layers of a restricted society: the nobility, by now residual but still able to set the tone, envied and in some cases given to ostentation; the *haute bourgeoisie*, which was fabulously wealthy by the standards of the time, assembled in the seven *Arti maggiori*, the major corporations of Florence, and firmly embedded in that "coral reef" of merchant companies which was the beating commercial heart of the gigantic urban complex; and bringing up the rear the *petite bourgeoisie*, making up the fourteen minor *Arti*. The

rest of the population, the *popolo*, was not involved. Traditionally in Florence everyone was interested in everything; so ordinary people gossiped, quarreled and took sides—but without leaving any traces. They were excluded from a civilization that they could see and even pass judgment on (from the outside), on occasions such as the completion of the Baptistery or the cathedral dome, but that they could not really perceive or rather understand, when it was a matter of following arguments drawing on Plato and the cabbala, or even the norms supposedly drawn from antiquity, governing the construction of the Pazzi chapel by Brunelleschi.

It was precisely at this time, the age of Masaccio and Donatello, or possibly even as far back as the age of Giotto (although we know that Giotto was actually an object of general admiration in his lifetime), that this deep rift in Florentine society took place, between the very tiny group able to enjoy a refined culture and the great mass of people, relegated to being spectators and rarely asked for their opinion. No doubt they had eyes to see and ears to hear— if only the sermons in church, or the farces and satires of the *poeti di piazza.* But how many people understood (and who has taken the trouble to find out how many understood?) the facetious anti-humanist verses of a Burchiello for example, which we find extremely hard to understand today, so complicated and sophisticated is their sharp humor. We can scarcely catch a glimpse of the ordinary townspeople we are looking for, even on occasions such as popular festivals. Lively and quick-witted but illiterate, they were no doubt responsive to the extracts of the *Divine*

Comedy that were read out to them, or to stories from the old chivalric romances; they might be struck by a satirical song, a sentimental *lamento*, or by the clowning of a Gonnella. But we do not really know what they liked, which is a matter for regret. This popular culture does not appear in the records, and at best we can try to imagine it. One historian investigating the dark avenues of witchcraft in sixteenth-century Italy[65] assumes that it was already present among the ordinary townspeople of Florence in the previous century, or even earlier, since cities recruited labor from the countryside, where magic was still a force to be reckoned with. The ramifications of witchcraft no doubt extended beyond the world of the poor, who had no particular monopoly of this counterculture emerging from the mists of time. Magic can always be found in all societies, even the industrialized societies of today. The interesting thing would be to discover what its real impact was on a given society, and that is precisely what we do not know. We can at least be sure that there were people who were excluded from the highly intellectual civilization of humanism and condemned to silence. One historian recently remarked that "one of the reasons for Savonarola's success may have been the resentment of the average Florentines against the over-exclusive, overaristocratic culture of the humanists in the Medici circle"[66] and he may well be right.

In Florence then, art and thought were determined by and directed toward the top of the social hierarchies. The wealthy bourgeoisie, if left to make its choices unhindered, would have inclined towards the rational, whereas the tastes of the middling and *petite bourgeoisie*

were more sentimental. In 1401, "the emotional and Gothic Ghiberti was chosen to decorate the doors of the Baptistery, instead of the scientific and classical Brunelleschi."[67] But with the rise to power of the Medici, the audience that mattered for artistic and intellectual production dwindled even further. After 1434, the entire architectural, pictorial, and literary discourse of the city faithfully reflected the tastes of a very restricted group of people—a princely court in all but name. If Cosimo de' Medici had withdrawn his generosity, or suddenly abandoned his project (1436) of rebuilding the convent of San Marco for the Dominican friars, Fra Angelico would have had to stop painting frescos on the walls of the cells. This brings us back, if I am not mistaken, to the problem identified by Roberto S. Lopez. Whether we are talking about the economy—in terms either of medium-term trend (*conjoncture*) or growth—or whether we are talking about culture and (why not?) intellectual trends and growth, sooner or later we are brought back to consider the internal workings of society. If, during a period of crisis, the rich remain rich while the poor become poorer, if the cost of labor falls to a comparatively low level, then our problem may be, if not solved, at least on the way to solution. The extraordinary achievements of the Renaissance can be explained only by the colossal difference between the wealth of the rich and the destitution of the poor.

It is not so much the economic situation in Florence (from which it cannot of course be separated), but the personal situation, the personal *conjoncture* of the Medici that matters here. It is of no great importance whether the

Medici had fewer employees in their service and less capital at their command than the Peruzzi had had in the previous century: for once what counts is not the past and the present in general, but the immediate past and present. And this leads me to be more optimistic in the end than Roberto Lopez. There certainly must have been some kind of a depression, if we can trust our price indicators and orders of magnitude. But we do not know quite what its impact was on Florentine reality. What more than any other factor makes me optimistic is that between about the 1550s and the 1570s northern ships were visibly beginning once more to invade the Mediterranean. To my mind (as I have explained at greater length in the second edition of *The Mediterranean*) this was a good sign for the *Italian* economy.[68] At any rate, as long as shipping in the Mediterranean was busy, Italy's economic health was probably not giving great cause for concern on the eve of the Italian wars.

1494–1559: *The True Cost of the Italian Wars*

In considering the so-called Italian wars, a good starting point even today is Eduard Fueter's still-reliable judgment of 1919:[69] the cyclone raging in the peninsula was to govern the political weather for the whole of Europe until the middle of the sixteenth century. Its cause was obviously the fragmentation and political weakness of Italy. Having failed to establish its unity, Italy looked like an easy target. Large states prepared to swallow up smaller ones, and everyone

marched on the prosperous peninsula: the French, the Spanish, the imperial armies. Under their banners marched mercenaries from the Swiss cantons, or from Württemberg, Gascony, the Dauphiné Alps, and the mountain regions of Spain. War was in a sense the revenge of the poor against the rich. Already in the time of Colleoni (1400–1475) the *condottieri* had been recruiting men from the poor districts of the Italian mountains.

But after 1494, warfare ceased to be the ingenious and slightly theatrical affair of the past. Artillery, although not unknown in the peninsula, arrived there with a vengeance with the army of Charles VIII. Europe reacquainted Italy with the savagery of war: the sack of Brescia by the French (1511); the sack of Rome by the assorted troops of the Connétable de Bourbon (1527); the sack of Pavia, captured by the French in 1528 in revenge for their defeat of 1525; the sack of Genoa (1532) by the Spanish (who spared only the bills of exchange seized from the merchants)—such horrors indicated clearly enough the inhumanity of the new age. That said, should we imagine a continual string of horrors? There were, as we have seen, pauses. Some troop movements did little harm: certain armies pillaged but others knew the experience of empty stomachs. Above all let us venture to say that the Italian wars did not seriously disturb the economic health of the peninsula. Yes, there was suffering, but it was spread out over a long period (1494–1559). Depending on the date, one region might be devastated, another untroubled. And, lastly, the armies in the field were not large: perhaps ten thousand men or less on either side: life went on while they fought.

New buildings continued to go up in Rome in any case, during the pontificates of Julius II (1503–1513) and Leo X (1513–1521). Everything contributed to the fortune of the Eternal City: in the first place there was the eloquent example of the ruins of antiquity; then the patient and efficient continuity of papal policy: the state's revenues doubled between 1492 and 1525; cities such as Perugia and Bologna were brought to heel; soon the papal finances were appealing for credit. What was more, a nonviolent army, that of the pilgrims, invaded and enriched the city: 200,000 of them gathered in St. Peter's Square for the jubilee of 1500. And anyone who mattered among artists, writers, and humanists naturally hastened to Rome, especially after the election in 1513 of Leo X, the Medici Pope, indulgent, pacifist, and a patron of the arts. His "age," to paraphrase Voltaire, lasted only a few years, but to what brilliant effect! His pontificate opened almost at the same time as the fifth Lateran Council (1512–1517), the great spectacle and hope of the century, although in the end nothing came of it. Leo X also had the good fortune to inherit the projects and enterprises of his predecessor, and took them up on his own account: the new St. Peter's, which had been building since 1500; the *Stanze* of the Vatican, of which Raphael laid the first brush strokes in 1508; the ceiling of the Sistine Chapel, on which Michelangelo began work in 1512. In view of the magnificence of these already initiated projects, some historians have not unreasonably called this the age of Julius II.

Rome then was a culturally dominant city as the sixteenth century opened, but it was not the only one. Take

Venice for instance: sheltered from attack, a miracle of nature and human ingenuity, Venice struggled and prospered, erected fine buildings, and sometimes benefited from the misfortunes of other powers. The Tuscan Jacopo Tatti, known as Il Sansovino, in 1559 designed the fine staircase in the Doges' Palace, the *Scala d'oro*, reserved for patricians, and would also sculpt the two colossal statues which gave their name to the *Scala dei Giganti*. Titian had already embarked on his illustrious career. Meanwhile, elsewhere, several princely courts, founded by successful soldiers of fortune, were particularly lively: examples are the Gonzagas of Mantua, who loved fine horses, game birds, pedigree dogs, and pictures, and built the palace of Tè (1525–1535) designed by Giulio Romano, as was the rest of the nearby town; the Montefeltro of Urbino; the Este of Ferrara. It was for the court of Urbino that Baldassare Castiglione wrote *Il Cortegiano*, a manual of courtly behavior for the perfect knight; Ariosto lived in Ferrara.

Fair Stood the Wind for Italy?

After 1509—the year of Agnadello—the economic climate took a turn for the better and remained fair until 1529, the year of the Paix des Dames (or Peace of Cambrai) which brought to an end the first great conflict between the Valois and the Habsburgs, at the same time ending the first, crucial stage of the Italian wars. Logically, these years saw an underlying revival of business, with livelier circulation of goods—very similar to the situation at the other end

of the century, in the France of the Wars of Religion (1562–1598), when, after 1575, the economic upturn reached most of Europe, giving fresh impetus to this fratricidal combat. One may guess that something of the same order occurred during the age that saw Agnadello, Ravenna, Bicocca, Pavia, the sack of Rome, and the expedition of Lautrec.

We would certainly do well, in most cases, to be wary of these suspiciously neat coincidences, which are so satisfying to the historian who sees the economy as conveniently explaining not only politics but culture as well. In our case, however, the economic downturn of 1529 seems to come just at the right moment to explain both a political turn for the worse and, we should note, the almost complete cessation of activity in the Mediterranean by the small all-purpose ships from the still very poor Atlantic seaboard. English ships had been present in the Mediterranean since the beginning of the century or perhaps earlier. They often sailed as far as Cyprus where they kept a consul for many years, and took on cargoes of red or white malmsey and *uve passe*, raisins. But the English stopped finding such voyages worthwhile after 1534, and would soon disappear from the Mediterranean. The appearance of their small cargo ships in these waters had always been a sign of good times: essentially they came when there was work to do. They would not be seen there again, for reasons determined by the economic climate, until about 1575. This is an indicator one might reasonably regard as reliable.[70]

But there are other, even clearer signs, although they tell a more nuanced story. The many letters exchanged

between merchants almost all show, by the range and number of transactions handled and by the connections they were using, that the networks of economic activity still survived and favored Italy. The crisis existed but did not affect Italian superiority. On this score, nothing had yet changed, if we are to judge by the letters exchanged between the Capponi of Antwerp, the Guicciardini of Pisa, the Martelli of Valladolid and Lyon, and no doubt many others too. The economic climate in general appears to confirm this impression. The Italian economy seems to have held up well during the crisis and depression of 1529–1539, and was able to turn to its advantage the *slight* improvement that followed between 1539 and 1559. Real problems began for it only after 1559, with the general depression that was to last until 1575. The return of peace in 1559 had little effect. So we may assume, with all the prudence always required in this area, that the commercial economy of Italy enjoyed an extra half-century of comparative prosperity.

Federigo Melis goes even further than this.[71] It is true that he was writing just after becoming acquainted with the rich documents of the *Carte Strozziane*, in the Archivio di Stato in Florence, and having been dazzled by the extraordinary personality of Filippo Strozzi. The son of Filippo the Elder (who had commissioned Benedetto da Maiano to build the Strozzi palace), Filippo was a businessman of international stature who died in 1538 during the fateful upheaval of Florentine politics, from which he had long stood apart. Among his papers were found the records of a Florentine "company," established at Cadiz and Seville between 1533 and 1537 and managed locally by another

Florentine, Francesco Lapi. For us it provides an opportunity to glimpse the extraordinary texture of Florentine commercial society, an amazing conglomerate of trading firms linked to one another by multiple connections both horizontal and vertical, their chief concern being to avoid on the one hand the problems native to the national economies in which they set up branches, and on the other the consequences of political upheaval in Florence, which all too often threatened to bring the whole edifice tumbling down. It was the role of the *maggiori*, the heads of firms, the most highly placed managers, to take precautions and to have ready in advance the alibis and sleeping partners one might suddenly need.

Florentines were to be found firmly ensconced everywhere at this time, and the Quattrocento proverb was still valid: *Passeri e Fiorentini sono per tutto il mondo* ("There are sparrows and Florentines all over the world"). And they were there to command, to control, and to make their fortunes. To this end, they even used the slow but profitable trading links between Spain and New World. So Federigo Melis feels justified in concluding that in the late fifteenth and early sixteenth century, "Florence was still a world leader, not now in terms of the market, but of enterprise."[72] It is a qualified judgment, since things were not simple. Florence was not (had it ever been?) a center for world markets, a rendezvous for the rich routes along which heavy and precious goods traveled. It was by sheer superiority that it imposed its leadership, through its industry, by pulling the strings of financial control, through wise investment and through the superior organization of the

aziende. These trading firms could operate either jointly, if required, or as quite separate concerns if that was more advantageous, either mutually supporting each other or, in times of danger, cutting communications so that none dragged others down in its fall, but left them to fight another day. What Florence possessed in short was technical superiority, and we shall need to return to this point in our conclusion.

One last remark, borrowed from the same writer: Florence would play this leading role only as long as the Lyon fairs remained the unshakeable foundation of the European economy, that is (according to Richard Gascon) until the middle of the sixteenth century.[73] After that the Genoese took over, once more at the highest level possible within the economic constraints of the time. In short, the wealth of the world took a long time to make its controlling center the North Sea, that smaller-scale Mediterranean framed by the flat, sandy shores of northern Europe.

Italian Merchants in the Atlantic

That the Atlantic Ocean should from the very start, the time of the great discoveries, have been dominated by the Italians may look like a paradox. But the evidence is there. In the past, historians tended to oversimplify the debate. According to received wisdom, no sooner had Columbus sailed the Atlantic in 1492 and Vasco da Gama made his voyage in 1498—the latter with particularly electrifying effect—than the major trade routes were immediately reorganized,

leaving the Mediterranean marginal to traffic. As a result, the fortune of the Atlantic meant the end of Italian supremacy.

But this was not what happened. The reorganization of the major world trade routes brought about its inevitable consequences only slowly. The "façade of the West," having been Mediterranean for millennia, did not become Atlantic overnight. There was indeed a "right-angle turn"[74] but it was so slow that contemporaries did not at first realize what was happening. In spite of the collapse of the pepper and spice trade, which was strongly felt in Venice from the early sixteenth century (but which revived again in about 1540 or 1550) neither the Mediterranean nor, *a fortiori*, Italy, were hit immediately or devastatingly. Historians should have realized earlier how slow such developments usually were, how great the force of inertia, the weight of established trade links, the already great sophistication of capitalist enterprise, now concentrated in certain key points in the world, most of them Italian cities. Armed as they were with capital, credit, tried and tested trading habits, and long-established advantages, how could these cities have failed to defend their putative share in the ventures, both profitable and risky, made possible by the great discoveries?

This was more likely to be the case since such ventures did not begin and end with Christopher Columbus and Vasco da Gama. The Italians had long been active in the field. "People repeat all day long that the Spanish and Portuguese discovered the New World," Bandello wrote in 1515, "whereas it was we Italians who first showed them the way."[75] There is some truth in his protest, and everyone knows the names of Christopher Columbus (Cristoforo

Colombo), Amerigo Vespucci, Ca'da Mosto, and Verraz-zano. But that is not the real point at issue.

The great discoveries were in fact in the making as early as the late thirteenth century, following the first experience of the Atlantic provided by direct and regular voyages between the Mediterranean and the North Sea. These shipping routes sealed the fate, if they did not precipitate it, of the Champagne fairs, the rendezvous that had marked the triumph of the overland routes. A modern maritime civilization was grafted onto the ports at which ships called on these long voyages—as historians have realized since at least 1930.[76] Lisbon, where the "bourgeois revolution" of 1387 brought to power the Aviz dynasty, is a typical case. The Italian example encouraged the city in its maritime vocation. As early as the fourteenth century, the first Portuguese chronicler, Ferñao Lopez, mentions the presence in Lisbon of colonies of "Genoese, Lombards, Milanese and Corsicans."[77] So Italian merchants had already seized key positions even before Europe had become decisively oriented towards the Atlantic: they had simply to hold on to them if they were to have a share in the new trade routes. To my mind, this is one of the major discoveries of historical research. And the examples that support it provide incontrovertible evidence.

Towards the end of the fifteenth century, the Italian merchants in Lisbon formed a thriving colony, of whom we know all the leading names. We also know that Christopher Columbus went to Portugal in the service of the Centurione, Spinola, and di Negro firms, all Genoese merchants. The richest of these merchants had created the

sugar-based economy of Madeira, and they would finance entire ships, as did the Vanni, the Gridetti, and particularly the Marchioni firms for Alvarez Cabral's expedition of 1501–1503. Some of these merchants eventually made their way across the Atlantic, ending up in Brazil, where they settled.

The example of Andalusia is also a convincing one. Italian merchants had followed closely on the heels of the Christian reconquest, the Genoese leading the way from the start, both into Christian-held territory and onto the Muslim-held shores of Morocco. The Florentines also took advantage of the opportunity. Every kind of useful commodity was pursued by both: sugar, cereals, hides, wool, copper, mercury, lead, and lastly gold, which came across the Sahara from the Sudan to North Africa, and then on to Spain. In the fourteenth century, Spain was El Dorado. In 1340, certain large coins, doubloons, were almost as big as ingots, each weighed as much as "100 Moroccan doubloons." During the reign of John II (1406–1454), there were monstrously huge gold coins in circulation, weighing up to 235 grams. Being, like North Africa, a land where gold was plentiful, Spain allowed it to be exchanged cheaply, for six times its weight of silver, whereas the metallic ratio at the time was 1 to 10 or more. Gold coins were shipped from Spain to Genoa: perhaps as much as 200 kilos in 1377, a huge figure comparatively speaking. And the supply seems to have been uninterrupted: a Danzig merchant, who died in Genoa in 1440, left in his will *"140 duplas auri hispanas aut barbaricas,"* "140 gold doubloons of Spain or Barbary."[78] At the same time, Florentine galleys

were also carrying *auro tiberi*, that is, *al-tibr*, gold obtained from river panning in the Sudan. Venice's desire for gold led to the creation of the voyages by the *galere di Barbaria*, which sailed to Spain and North Africa.

But the problem for historians is that we cannot simply invent a "gold-flow thesis," in which everything can be explained by the gold supply.[79] There were always two precious metals, gold and silver, in circulation, and one has to look at their mutual and changing relations. As late as 1506, a patrician and wealthy merchant of Venice, Michiel da Leze, gave his son, who was about to sail with the Barbary galleys, instructions to change 3,000 *mocenighi* of silver for *"tanti boni ari"* in Barbary; then if necessary he could have the metal melted down and minted at the Valencia mint.[80]

It is a curious and intriguing story. But what was to follow was even more significant. As that indefatigable researcher, André E. Sayous, long ago demonstrated,[81] it was the Genoese merchants in Seville who, in the early years of the sixteenth century, were to organize the first regular commercial shipping link with America, something unthinkable without the long-term credit that only they were capable of offering merchants and shippers. This explains the extraordinary business success they enjoyed, success with lasting consequences, ensuring for the Genoese that special place in the economy of the Iberian peninsula that might at first sight seem astonishing. All the names of the great trading families of Genoa figure in the documents of the Archivo de Protocolos, the notarial archives of Seville: either the names of Genoese who had

settled there—names such as Grimaldi, Cattanei, Calvi, Centurione, Spinola, Rivarolo, Lomellini, Garibaldo, Pallavicini, Adorno, Salvago, etc.; or those who sailed to America during the early years of the century: Geronimo Grimaldi for instance, Raffaello Cattaneo, Bartolomeo Grimaldi, and many others.

And Seville was only one example among many of a much-repeated pattern. One would have found the same in Bruges or in Antwerp, whose great fortune, although deeply dependent on the northern countries (woollen cloth from England, German merchants, the Baltic trade), really took off only after the meteoric and powerful rise of Lisbon. An entire book, now a classic, has been written on the colonies of southern merchants in Antwerp.[82] A similar process can be detected in the origins of the Lyon fairs and throughout their career. Lyon had everything in its favor, the goodwill of Louis XI, the proximity of Geneva with its wealth waiting to be captured, the presence of two, or even three waterways: the Rhône, the Saône, and comparatively easy access to the Loire at Roanne. The great north-south route across Europe ran through Lyon, and merchants settling there could deal directly with the King of France, whose power was increasing day by day. All this is perfectly true. And it was also the case that Lyon made an excellent center for Italian merchants to redistribute luxury textiles, cloth from Florence, silk from Lucca, velvet from Genoa. But while Louis XI may have granted the city the privilege of holding fairs, in 1464, it was the Italian merchants who created the meteoric and lasting success of Lyon. "The true point of departure for the rise of Lyon may be placed

somewhere between 1464 and 1466. This was when the Medici transferred their Geneva branch there. One of the most powerful banking houses was by this choice showing faith in the value of Lyon and its capacity to become a major business center."[83] Federigo Melis's intuitive feeling therefore finds confirmation: Italian and in particular Florentine capitalism always operated through the large-scale transfer of resources.

Thus, just at the moment when the "barbarians" were beginning to insinuate themselves in small, aggressive, and much-feared bands throughout the network of towns and regions of Italy, just as Europe was embarking on its first sensational conquest of the world, it was Italy's good fortune to be in advance possession of some important command levers—as well as to have the presence of mind to hold on to old ones and create new ones. It was Italy abroad rather than domestic Italy (over which shadows were beginning to fall) that was unveiling its destiny in these early years of the sixteenth century. But nothing had yet collapsed at home. Renaissance Italy was still alive and kicking.

The Renaissance: A Problem of Definition

We are again faced with the word "Renaissance," a convenient, resounding, and mythmaking word it must be agreed. It simplifies, misleads, and demands discussion. For a start, no historian would today accept that the Renaissance is the exclusive terrain of the history of art and

the history of ideas. Art and literature are but languages for the society that speaks them and listens to them, approvingly or otherwise, and may from time to time modify them. The Renaissance has to be placed in the fullness of time, space, and the overall meaning of history.

Prudence generally advises us to distinguish several different stages: the pre-Renaissance, the early Renaissance (Florence), and the late Renaissance (Rome), culminating at the earliest in the death of Raphael (1520) and the breakdown of strict rules with the *maniera* of Michelangelo. These are the normal boundaries, which certainly seem reasonable—perhaps a little too reasonable. So I am somewhat attracted by the bold stance of Armando Sapori when he argues that the "true" Renaissance began as far back as the twelfth century. We might even allow ourselves to extend the limit back to the year 1000, to make matters even clearer. I also like Georges Lefebvre's sweeping remark that the Renaissance lasted right through to the Enlightenment of the eighteenth century. This was also the view of Huizinga: that one would have to wait until the Enlightenment to see the cultural destiny of Europe significantly change again.

No doubt all three of them are right, in the sense that we undoubtedly need to look at the development of the Renaissance over the very long term, cutting it off neither from its medieval roots (and humanism certainly existed in the Middle Ages) nor from its modern extensions. Broadly defined, the Renaissance was that slow transformation, long in the making, that took western civilization from the traditional forms of the Middle Ages to the new, contemporary

forms of the early modern period, forms still alive in our own western civilization of today, which has scarcely shaken off its old contradictions before creating a brand new set. What was happening throughout these centuries was a slow process of destruction, what modern economists would describe as "non-neutral progress": the progressive breakdown of the old shibboleths, a continuous process of iconoclasm, despite occasional pauses—in short the promotion of humanity: from now on, man would stand at the center of the world. If this is true, all the "modern" activities of the Renaissance, however new they seem, or seemed at the time, are to be relocated within a long-term perspective, or as André Chastel puts it, within "practices already hundreds of years old."

In other words, let us by all means advise historians to use the complex word "Renaissance," but to do so in a way that allows them to clarify appropriately the necessary chronological time span, enabling them to explain, to each other and to us, how and why the civilization of the relatively small European continent finally altered and surpassed other civilizations, bending them to its will. That history as it lies before us is certainly primarily an Italian one, but it is also that of Europe: of the Netherlands, Germany, Britain, France, and the Iberian peninsula, including Spain. (It used to be argued that Spain was "a country without a Renaissance," in other words without modernity—a completely inaccurate remark.)

This *long* view of the Renaissance should not however rule out different views of it, with narrower time limits. It could perfectly well be argued, for instance, that the true,

the only Renaissance (though perhaps we might have to change its name) was that brief period, that short moment in western history, when, in the middle of a series of dark centuries, there was glimpsed the ephemeral and abnormal glow of happiness—an appealing definition evocative of the names and declarations of a whole generation of humanists, Erasmus chief among them, who were conscious of living in the bliss of a golden age.

On the other hand if we extend indefinitely the chronological field of observation, we are talking about the whole of Europe, and that of course means its conflicts and quarrels: the archaic and the feudal, the seigneurial, the princely, and the state-controlled; economies barely yet touched by money, and the zones where capitalism was already well tried; the Atlantic and the Mediterranean; and finally north and south—each an assemblage of countries, destinies, and attitudes. And, of course, currents, countercurrents, ebbs and flows mingled with one another. Cultural influence of necessity speaks with many voices and Italy was not always, though it was often, that source from which all good things flowed, including beauty and wisdom. In fact, from the technical point of view, neither gunpowder nor the blast furnace, neither the printing press nor high-seas navigation, those key discoveries of the age, originated in Italy. Nor did the Reformation, that violent storm that was to convulse and shatter the destiny of Europe, splitting it into two halves from now on foreign to one another, that revival of religious passion that had in the fifteenth century been the privilege and mark of Christendom as a whole.

We have been warned then: European history did not

originate entirely in the Italian south, for all its *dolce vita*, fine living, and high thinking. But since Italian cultural influence certainly did exist, let us move beyond these provisos and concentrate now on that.

Europe Under the Influence of the Italian Renaissance, Before and After the 1520s

Everything has been said, and well said, about the reasons why Italian civilization and a certain Renaissance—the most beautiful—cast its influence beyond the Alps. Much has also been written about the vigorous and kaleidoscopic European civilization of the time, about its many variants, about its strength and obstinacy, about what it welcomed and what it rejected. The problem is to make the two pictures fit together, to explain the narrower sphere—Italy—by the wider one—Europe—and vice versa.

The problem is that no one has yet written, or attempted to write, a systematic history of the spread of cultural goods from Italy, a history that would cast light on the gifts and transfers on one hand and the acceptances, borrowings, adaptations, and rejections on the other. Such a study would still today require an immense amount of research. We still need a dictionary, a grammar, and an atlas of such cultural transfers, and all of them would have to be examined in the finest detail before going any further. We would need to know, for instance, about the products of the bronze-casters' workshops of Padua and Venice, or about the early export of marble from Carrara, either in

solid blocks or in the shape of elementary works of art delivered by the quarrymen themselves, usually modest stone-cutters who might on occasion "exchange their pick for the chisel." The trade in marble was linked to the hire of artisans from all over Italy. It came to be concentrated in Genoa, where it was commercially organized. Louis XII had his own agent there, Spinola di Serravalle, to handle purchases, to commission artworks and make payments on the spot, as well as to have goods shipped to France. For the mausoleum of François II of Brittany, marble from Carrara was embarked at Genoa, sent by boat up the Rhône, carried across to Roanne and sent on down the Loire to Nantes.[84] Such agents, who were themselves active merchants, also naturally sent artists, whom they recruited on the spot. In the early years of the century, Liguria was swarming with marble cutters from Milan and Lake Como (known as the Lake School). With the promise of work and the prospect of making some money, they went on board ship along with the cargoes of marble. So it was on the whole a modest form of Italian culture that carried the first version of the new art, bound for France or elsewhere.

As these details suggest, one needs to pay attention not only to the goods transferred but also to the agents of all kinds, artists but also merchants or mere travelers, without whom the goods would never have moved at all. Who were these agents, how did they act, and why? The questions are often asked, but have not received adequate answer. Only collective research could really tackle the many difficulties. It might perhaps confirm the following suggestion: that until about the 1520s, Italian influence, of which the first

signs go back to the 1480s—before Charles VIII's invasion—expressed itself mainly in minor details. Portable examples, so to speak, of the new art were exported singly, like spare parts, and gradually introduced themselves into the "Flamboyant Gothic" style which still had a long life ahead of it. European art did not change overnight at a touch from the magic Italian wand. It was only after the 1520s, a little earlier or later according to region, that Renaissance art began to appear outside Italy in its true guise, that of a coherent ensemble. It then encountered success in many parts of the world—but not yet on a massive scale.

The Haphazard Arrival of Renaissance Decoration

Such small-scale exchanges, minor borrowings, and modest works of art had not waited for the late fifteenth century: Italianism had begun to filter into Europe very early. To take one illustrious example in France, Jean Fouquet traveled and worked in Italy from 1443 to 1447. At La Minerva he met Fra Angelico and borrowed from him "those decorative motifs—pilasters, garlands, armor and helmets . . . models for which had been provided for him by his friend Michelozzo."[85]

Painters were indeed among the first to adopt elements of Italian decorative style, such as scrolls, arabesques, and grotesques. Italian books, which were widely exported, played a pioneering role in this field, making available on the market many details: "sirens attached to anchors,

dolphins, genies with entwined arms and legs vanishing into spirals, candelabra, bucranes, three-headed female versions of Hermes, priapic forms, little cupolas, winged helmets."[86] But architecture took longer to imitate Italian models.

It was not until the turn of the century, and in general the years after the Italian expedition, that "Italian ornaments conquered the walls of France," as Louis Hautecœur put it[87]—walls that had nothing Italian about them at the time.

In the early days, Renaissance ornament crept surreptitiously into French architecture. In the Chateau of Blois, begun in 1498 by Louis XII, absolutely everything is Gothic. But on the external façade, one finds unexpected details—arabesques, shells, dolphins, Neptune's tridents—straight from Italy. In the Château of Gaillon, for which Cardinal Georges d'Amboise had a fountain, medallions, bas-reliefs, and statues brought from Genoa in 1504, the Italian style is more insistently present, in the palm-frond friezes, the scallop-shell pediments, the fluted columns with composite capitals. And of course examples like this, introduced at the top, were quickly imitated: the new décor can be spotted in the houses built at this period by financiers or rich businessmen, like Semblançay, Robertet, or Thomas Bohier (who bought Chenonceau in 1513). From the houses of the wealthy, the fashion passed to those of the more modest: in Blois, "Dolphins appeared at number 54 rue Foulerie, and pilasters with arabesques at 5 and 7 rue du Puits-Châtel." Everywhere architectural detail—foliated scrolls, friezes, window rails, brackets,

staircases, copingstones and cornices, gables and balustrades—followed the style of the day, that is, where architectural design was not completely altered. It was easy enough after all to put consoles where Gothic architecture had put corbels. But it would be another twenty years before antique styles in the matter of capitals, pilasters, and columns would become acclimatized.[88]

It seems to have been for geographical reasons, and also because the accident of politics linked France to Milan, that the first Renaissance ornaments to reach France came from northern Italy, from the exuberant architecture of Lombardy, itself still very sympathetic to the Gothic and often combining it with the new art. Only later did Florence begin to provide models.

That these first examples should have appeared chiefly in the chateaux of the Loire and that they subsequently spread all over France is significant, since it clearly indicates where the heart of France lay at the time, between Orléans, Blois, and Tours.

We should be grateful to Louis Hautecœur for his painstaking and ultimately revealing study. After reading him, one is not so astonished after all at the manner of diffusion of these early Italian decorative motifs, precocious but widely scattered, as if the seed had been tossed casually into the air. And it seems that France was not alone in being affected by a fashion for architectural detail.

In Hungary, the Renaissance left no monumental traces, since the Turkish conquest (1526–1541) submerged almost everything. But excavation of the Corvinus Palace at Visegrad, near Buda, has revealed that in about 1484, there

were some "offshoots" of Renaissance art in Hungary: a red marble fountain, a Renaissance balustrade—over arcades still in the Gothic style.[89] This much is understandable: only decorative motifs could easily be superimposed on a foreign style of building.

Europe outside Italy—and even a considerable part of Italy itself—was in fact, in the late fifteenth and early sixteenth centuries, still under the influence of very traditional architecture. In 1509, the year when the finishing touches were being put to the Palazzo Vendramin on the Grand Canal—an authentic example of the Venetian Renaissance, along with the church of Santa Maria dei Miracoli (1481–1489) and the Palazzo Dario (1487)—Venice was still overwhelmingly Gothic in style. In 1515, when François I succeeded Louis XII, Paris had nothing but Gothic monuments. It would be 1528 or even 1533 before the French capital could boast buildings inspired by the new taste in art. And the Gothic continued to flourish unconfined. The north steeple of Chartres Cathedral was finished between 1507 and 1512; the Catedral Nueva in Salamanca, begun in 1513, started to go up in Gothic style (though since it was not finished until the eighteenth century, it turned out to be a combination of styles in the end); the cathedral in Segovia, rebuilt from 1522 on the ruins of the previous structure that had been destroyed at the time of the *Comuneros*, was entirely Gothic in inspiration; only the porch would eventually be built in the style of the Escorial. Gothic too was the town hall of Baste, built between 1508 and 1521. In England, "Perpendicular Gothic long continued" its career. In Germany, only princes, or sometimes princes of money,

managed to impose the new architecture and then not without difficulty. In Augsburg, for instance, Peter Flöttner, who had been trained in the Venetian school, was asked in 1519 to design the Fugger Chapel in St. Anne's Church, but its decorations, all in the new fashion, are displayed under a vault in the old Flamboyant style.

Are all these hybrid examples to be regarded as evidence of progress or of resistance to progress? Lucien Febvre long cherished a plan to study (or to set up a research center in Rouen to study) the meeting between the Renaissance and Gothic styles. It would have demonstrated that the choice was not an easy one, and that the debate took a long time to be resolved. Sometimes it was not resolved at all, or only in unexpected ways, as borrowings from Renaissance Italy were absorbed into or swallowed up in ancient local styles, which often proved quite adept at digesting the new elements. This was the case in Bohemia, as we shall presently see.

The Significance of the 1529 Crisis

The year 1529 marks a peak in price history: it is a *crisis* in the true sense of the word. Prices had been rising since 1509. This upward trend had, we have noted, been able to support some of the burden of the Italian wars, until the Paix des Dames (1529). The coincidence of dates is curious to say the least, but as a rule any serious crisis tends to bring belligerents to the conference table ("to their senses" I almost wrote). It happened in 1559, and again in 1598,

1604, and 1609 (the Peace of Vervins, between England and Spain, which ushered in a twelve-year truce).

The rule may have operated in 1529. Once more, Italian influence abroad may have coincided with a period of economic difficulty. As with Florence in the age of Lorenzo the Magnificent, we have to *imagine* what took place. The economic recession was particularly traumatic for a sophisticated country such as Italy, by now used to the experience of capitalism. We have already noted that, in its higher modes of operation, the Italian economy proved capable of maintaining all its positions, at home and abroad, until the middle of the sixteenth century. But that did not rule out the possibility of strain, loss, embarrassment, and even disaster along the way. The crisis was probably less dramatic for those European countries that were still largely dependent on agricultural production and therefore less active, more archaic, and undoubtedly fairly stable. Here, princely courts and seigneurial rents were by and large protected from the crisis. Was the influence of Italian art and thought outside the peninsula the result then of a crisis felt particularly acutely in both Florence and Rome, cities that were moreover subjected in 1527 and 1530 to calamitous assaults?

It is also worth pointing out that Italian influence was very largely the work of a diaspora of artists, teachers, and thinkers. All kinds of reasons might motivate their journeys. But if things were not too good at home, hope of finding high wages and glittering prizes abroad may have been more of a temptation. After all, European academics, engineers, doctors, and painters are often tempted these days to go to the United States. After the Wall Street Crash of 1929, ships

crossing the South Atlantic were carrying employers, fore-men, and industrial equipment to try their luck with the mar-kets of South America, which did not on the whole disap-point them.

True, expatriates have *always* run risks. Foreign paymas-ters might turn out to be demanding—and sometimes bad at paying up. Italian humanists remarked with surprise and dismay that when Latinists and Greek scholars served German princes, they were expected to rub down the horses, on top of their other duties. And then there was the open or concealed hostility of foreign rivals: the mania for all things Greek in France was a veiled form of antipathy towards Italy. After all, the Italians themselves had harbored mixed feelings toward the Byzantine refugees in Italy.

Reflections of this kind are plausible enough. But one cannot simply assume a theoretical partnership between the economy and the history of art. Concrete, detailed evi-dence is what we lack here, evidence not only about the biographies and the works of the Italians who exported their culture, but also about the foreign milieux that invited them in. For their voyage was not simply a depar-ture, it was an arrival too, and each was to some extent gov-erned by the other. The reasons for these adventures and exiles were sometimes to be found outside Italy.

The Reception Committees

In the early decades of the sixteenth century, the Italian civilization being exported abroad was aristocratic and

ostentatious. A priori, therefore, one might imagine that aristocratic circles already well disposed towards humanism—in Augsburg and Nuremberg, London, Antwerp, and elsewhere—would have extended a warm welcome to an art and a way of life whose refinement no one could deny. This was indeed often the case. Cities, because of their wealth and their civic pride, were inevitably the first ports of call.

But the most receptive centers of all were the courts of princes, their reaction tending to be proportionate to their size. "The greatest patrons of Renaissance art were the ambitious and the military,"[90] in other words princes who were obsessed by their own glory, by the desire to escape the common lot of mortals, to survive to posterity, and to have some share in the fame of great writers, historians, and leading artists. They wanted to be sure that after their death the trumpets of glory would still sound in their honor. To believe this was to lend to writers and artists some sort of supernatural power which they themselves, being inclined to self-importance, were indeed sure they possessed. It was the power boasted of by Corneille in his old age, when he wrote the *Stanzas to a Marquise:*

> *Et dans deux mille ans [je ferai] croire*
> *Ce qu'il me plaira de vous.*
> *Vous ne passerez pour belle*
> *Qu'autant que je l'aurai dit.*

> *And two thousand years hence [I will make]*
> *people believe what I please about you.*

If they think you fair,
It will be because I said so.

A hundred and fifty years earlier, Ariosto had been even more confident of his powers. It is the complicity of writers, he declared, that creates the reputation of great men:

Aeneas was not so pious, nor Achilles so strong,
Nor Hector so brave as reputation tells,
And thousand upon thousand upon thousand could bear
Comparison, truly to advantage, with these.
But palaces and castles bestowed by their heirs
Have caused them to be honored in verse sublime
By the happy recipients, great writers of all time.

Augustus was neither as virtuous nor as clement
As Virgil's trumpet proclaims.
But for having loved fine poetry,
He was forgiven his iniquitous banishments.

Renaissance civilization could not but take root in the pomp of the princely courts that appeared almost everywhere in the sixteenth century, for it was itself a civilization based on pride. Giovanni Rucellai was already writing in his diary in 1457: "It is thought that our age, since 1400, has more reasons for satisfaction than any other since Florence was founded . . . [Today] Giotto and Cimabue would not even be taken on as apprentices."[91] Rabelais was to write: "I see brigands, hangmen, adventurers, and grooms today who are more learned than were the doctors

and preachers of my day."[92] Erasmus and Ulrich von Hutten believed that they were living in a golden age. Man, the creation of God, had arrived at the peak of his dignity, and was surpassing the human condition. Leonardo da Vinci, in his self-portrait, represented himself with the features of God the Father; Albrecht Durer painted himself as the young Christ.

And it was not only an age of proud intellects. The ordered societies of the past, with their grades and ranks, could be kept under control by the princes and privileged classes (whose numbers were small) only by means of ever-renewed luxury, put continuously on display for all to see, by unremitting ostentation designed to fascinate, dazzle, and subjugate. It was an old story of course, and it was by no means confined to Italy. In this respect, Philip the Good in Bruges, who had Jan van Eyck in his service by 1425, was years ahead of Lorenzo the Magnificent. The much-vaunted splendors of the Burgundian court were the first hints, the first wisps of smoke of something that would take on far greater dimensions. But what the Italian Renaissance had to offer this princely ostentation was above all a new style, a classical bearing readily adapted to the grandiose.

This was the age when princes made triumphal entries into cities which welcomed them with lavish festivities. (What headlines these would have made for the press if it had existed!) Imagine the series of triumphs that marked each stage of the Emperor Charles V's journey through Italy, after the capture of Tunis in 1535. He was solemnly received in Messina, Naples, Rome, Siena, and Florence. Everywhere the same displays were mounted, as if the

decorations, usually hastily improvised, were put up and taken down like stage sets, creating an unending sequence of the same splendid processions and decorative floats, borrowed, we may note, from the boisterous festivities of the carnival. The Italian Renaissance was indeed a continuous, moveable feast, raising by several octaves so to speak the official level of luxury regarded as the norm for princes forever obliged to dazzle the onlooking world. Even their funerals became occasions of high spectacle. Still quite modest in France in the time of Charles V's journey of 1540, triumphal entries became extravagant under the sad reign of Henri II. That these European princes should choose the Italian mode for the politically important public luxury of the street, as well as for the domestic luxury of their dwellings, both inside and outside, is an unmistakable touchstone of Italy's prestige. Italy dazzled these rulers of men.

Some art historians have deplored, in the French case at least, the partial break with a robust national tradition indicated by the adoption of foreign styles. But novelty was itself a crucial and constant element of luxury. To disdain the familiar, and to surprise people with the new, was a better method of impressing the public. In this instance, the Italian fashions had the additional advantage that they could be presented as the noble way of life *par excellence.*

If Louis XII and the Emperor Maximilian, who died in 1515 and 1518 respectively, do not figure greatly in this brilliant display, it was not for want of motivation, but because the latter was always short of money, while the former barely had time to rule in peace. Both of them preceded and

heralded the great age of Italian expansion. As for François I or the Emperor Charles V, wherever their vagabond life led them (for both were constantly on the move, one throughout France, the other by land and sea across Europe) they invariably tried to surround themselves with an Italian décor. In 1526, after his marriage to Isabella of Portugal, the Emperor spent some of the happiest and most unforgettable days of his life in the Alhambra of Granada, and it was there that he ordered work to begin the following year on the first Renaissance palace in Spain. François I had his architects work first of all in the Loire valley, that somewhat isolated heart of the kingdom. After Louis XII, he added another wing to the Chateau of Blois, and began, probably on the designs of Domenico da Cortone, the Chateau of Chambord, which was still unfinished at his death in 1547. After 1528, it was on the palaces around Paris that he concentrated his lavish expenditure: the Chateau of Madrid, the Chateaux of Saint-Germain and Fontainebleau where the new style appears predominantly in the interior decoration.

But the Ecole de Fontainebleau, with Rosso, Andrea del Sarto, Primaticcio, and Serlio, represented the true arrival of the Renaissance in France, now no longer the Renaissance of the "industrial" ornamentalists of the early days, but that of the "inspirers of schools." This was a turning point in French artistic life. Literary life lagged a little behind, as is proved by the publication date of Joachim du Betlay's *Défense et illustration de la langue française*: 1549, two years after the death of François I. But how well is it known that Du Bellay's work was in many respects plagiarized from the

Dialogo delle lingue by Sperone Speroni, which had appeared seven years earlier, in 1542? The nationalism of Italy, or rather Tuscany, provoked an echo in the nationalism of the Pléiade.

National Reactions

The Italian intrusion inevitably provoked reaction. Artists arriving from the peninsula were not numerous after all, and wherever they set up their studios they rubbed shoulders with local artists. Between the two groups there might be exchanges and often compromises. Even if there was as yet no ideology to assist the emergence of the various European nations, which had vitality without yet having fully taken shape, they were nevertheless already inclined to express their own tastes, talents, antipathies, and above all to allow national habits to reassert themselves.

There is only a short period during which these reactions can be observed, before the arrival of the Baroque, which was apparently to wash everything away. In Spain (if one considers the Plateresque as no more than the superficial application of Renaissance elements) the reaction was quick to reveal itself: Philip II and his engineer Herrera favored, for the new cathedral at Valladolid, and for the Escorial, an architecture stripped of its parasitic decoration. The Italian and classical Renaissance, in architecture at any rate, was better received in France than in any other European country. But by the same token, it was taken over by national artists and redeveloped into a national French

style. There are several signs of classicism *avant la lettre*, and plenty of exceptional cases: Jean Goujon's Fountain of the Innocents in Paris was directly inspired by the pure art of ancient Greece, which it reproduced. In Germany there was no such thing. Outside the princely courts, the Renaissance made little impact on indigenous German art, but the latter, which was still flourishing in the fifteenth century, began simply to wither away. It has been said that the Renaissance was a poisoned gift for Germany. In fact what Germany lacked in order to resist was not so much vigorous towns, of which there were many, but vigorous states: for the state and the court were increasingly becoming the essential arena for political life and cultural brilliance.

The process is easier to discern in Bohemia,[93] where there was one major city, Prague, several industrial towns, such as Pilsen, an active bourgeoisie, a nobility that owned large estates, and, above all, a royal court. Advanced signs of the Renaissance arrived here early, imported in the late fifteenth century by masons from the Como region—the *Comacini*, a generic name applied not only to artisans from that region, but also to those from Lugano, the southern Alpine valleys, Lombardy, and even from places near Genoa and central Italy. But these immigrants who entered the service of the ruler, great nobles, or major cities, did not arrive in substantial numbers until about the 1540s. It was only after this that they began to take up residence in the Karlgasse in the old town of Prague, or the Welchgasse of the Mala Strana. Here they formed colonies, with their own hospitals, and their chapels, where the Jesuits took to

preaching in Italian. Before the 1550s, Italian masons tended to stay in Bohemia only during the working season, going back across the Alps for the rest of the year; but after this date, they came to stay, married local brides, and soon obtained burgher status.

Were they becoming integrated into Bohemian life? Their contribution to their land of adoption was a varied one, since their ideas about art originated in different parts of Italy, principally the north, and related on the whole to old models, consecrated by habit. They brought with them their own working practices (often rough and ready ones, directed at finding the most rapid solution, for which the customer might foot a sizeable bill), and they brought new materials—dressed stone, bricks, and tiles—to replace the wood that had hitherto dominated in Bohemian building. Masons, painters, sculptors, and stucco-workers had their own personal recipes. Some of their solutions—stepped gables, lunettes, cornices, columns, arches and arcades, decorated façades, concern for symmetry—were quite well received. But Bohemia remained faithful nevertheless to the late Gothic, to traditional town houses, and was moreover by the end of the century welcoming masons and craftsmen from Germany and the Netherlands. Subsequently there emerged a sort of haphazard combination of styles, with mixtures, adaptations of hybrid character, giving the Renaissance there a special, local flavor. Princely palaces and town houses that had adopted the new fashion, cathedral churches, and the residences of the king and leading noble families were built in this style—usually known indeed as "Bohemian Renaissance"—and manufactured on

the spot over the years. But it was in the end a short-lived creation, and did not long survive the strange and marvelous "enlightenment" of the court of Rudolf (1575–1611), which so curiously combined science and the new art.

Since nothing is ever simple, it is in eastern Europe that one finds the earliest and most pure echo of the Italian Renaissance. But it lasted only a short while, during which artists and architects from Italy, mostly authentic Florentines this time, responded to the call from an élite of humanist princes, such as Matthias Corvinus (1458–1490) in Hungary, or Sigismund the Great, the husband of Bona Sforza (1506–1548) in Poland. This was the age of the building, or rebuilding, of the castles of Buda and Cracow. But once the new architecture moved outside the narrow radius of royal courts, once it had really conquered public opinion, its spread was rapid. In Poland in particular, it led to an extraordinary amalgam, a blend of the still resilient Gothic tradition, of the Italian model brought in by the élite, and of a northern style that was itself hybrid. (Widespread in the Baltic states, it was inspired by Italian form, but had completely transformed it by loading it with a welter of decoration.) So, in the early seventeenth century, before the Baroque had really begun to exert much influence, Poland witnessed an original, local, and popular style of Renaissance architecture.

There are no such rich and revealing examples to be found in England, where a few noble mansions followed the new designs, but where Christ Church and Corpus Christi Colleges in Oxford, for instance, were being built in resolutely Gothic style. In distant Portugal, Italian designs infiltrated here and there into the original national style,

alongside Gothic elements and the remains of a long-lived Flemish influence. As for northern Europe, Italian models would really be adopted only in the Spanish Netherlands, which remained faithful to the Church of Rome. Italian influence was slight by contrast in the United Provinces, which preserved a distinct architectural style, later to flourish in the Baltic states; and Dutch painting, soon to become a school in its own right, would develop in a determinedly individual direction.

So while the influence of the Italian Renaissance—a sure test of its strength—was intensely felt throughout Europe, each of the various European cultures accepted, modified, or rejected it in a different way. It is nevertheless plain to see that it exerted a strong pull on whole sectors of European life.

After 1550

After 1550, or rather 1559, Italy's destiny took an unexpected turn, one that at first glance is hard to explain, and which is surely more complicated than was once thought. Its major feature was the state of peace that so to speak insinuated itself between the states and economies of the peninsula, and which remained unbroken. With the exception of a few minor skirmishes, the only disturbances were domestic social troubles—and then not on any scale until the great peasant revolt of the Kingdom of Naples, a more spectacular matter than the popular uprising in the city itself, in the days of Masaniello and the extravagant Duc de

Guise (1647). Until these events in fact, political unrest seems to have been frozen in Italy, as religious unrest was in Germany by the Peace of Augsburg (1555), four years before the Treaty of Cateau-Cambrésis, or as it was in France after the Edict of Nantes (1598). It is true that religious conflict would break out again in France under Louis XIII, and that religious passions would once more be unleashed in Germany in 1618 with the Thirty Years War. But nothing could prise Italy out of the pacific prison in which circumstances enclosed it after 1559. To see in this merely the benefits of a *pax hispanica*, important as that might be, is to see only part of the picture.

There is no doubt that from the point of view of peace and quiet, Italy derived substantial advantages from its religious unity and fidelity to Rome. It is a fact that Italy said no to the Reformation emerging north of the Alps, for many reasons that have still to be analyzed. To imagine that the Alps, those mountains of magic and heresy, constituted an effective barrier to the new religion is certainly too simpleminded. With the peasant revolt in the Tyrol in 1525, Italy had witnessed both a social and a religious revolt. Yet this double explosion on the frontiers of the Veneto found no opportunity to spread and develop. Was Italy somehow immune from social and religious conflict?

The game of "uchronia," the imaginative reconstruction of the past for which we have to thank certain economists turned historian, makes it quite possible to envisage the France of François I and Marguerite of Navarre going over to the Reformation, with the French capital being (why not?) transferred to La Rochelle on the shores of the

Atlantic, the future source of world riches. But even the most imaginative "uchronist" would find it hard to visualize Italy doing the same. No doubt history and the accumulated centuries of a long past centered on Rome were deeply responsible. In any case, if for once we set aside the great reformers such as Luther, Zwingli, and Calvin, we find that it was on the whole outside the ancient Roman *limes*—in Bohemia, Germany, and the Swiss cantons—that religious unrest had first appeared, centuries earlier.

At any rate, the Reformation elements to be detected here and there in Italy—in Venice, Ferrara, the Piedmont, Lucca, or Naples—related only to individual cases. The rule of the majority became law, ruling out any fancies, freedoms, deviations, or betrayals. Ochino of Siena, Campanella the Calabrian utopian, or Giordano Bruno, who prefigured so many things without clearly realizing it himself, were but shooting stars, all the more visible since they shone clearly against the dark skies of night. But whatever the cost, intellectually and spiritually, of the Italian moral order, it did have some advantages. By avoiding a religious war against itself, Italy was spared the confessional strife that ravaged Europe until 1648. It was not torn apart internally. The fires that are hardest to extinguish are surely those that kindle themselves spontaneously and find their fuel locally.

All these reasons contributed to peace in Italy, that slightly poisoned gift which history had to offer. In an attempt to resolve this question and reach a fair conclusion, we shall have to circle Italy at some distance.

The Turks Lose the Mediterranean Again

The first leg of the journey takes us to the Mediterranean. And that means an immediate encounter with the gigantic Turkish empire. In theory, Turkish might promised years of endless warfare. In fact, the conflict came to an end, with neither the Spanish empire nor Italy being truly responsible for this turn of events.

The facts are simple in outline. In 1538, Prince Andrea Doria, in command of the galleys of the Holy League—Spain, the Papacy, Venice, and the Italian allies of Charles V—abandoned the field of battle of Prevesa near the Gulf of Arta, to Barbarossa, without giving fight. The non-battle was not a non-defeat; rather it delivered the Mediterranean into the hands of the combined fleets of the Sultan and the Barbary corsairs. Thirty-three years later, on October 7, 1571, the bloody victory of Lepanto shattered the Turkish fleet. But it rose from its ashes and was back in action the following year, modernized and holding in check the victorious navies of the Second Holy League. In 1574, it seized La Goletta, the "presidio" held by the Spanish since 1535, and the city of Tunis, which Don John of Austria had captured only the year before in 1573. The battle seemed to be drawn, with no winners. The Second Holy League fell apart as the first had done, because of basic disagreement between Venice and Spain. Venice, the last bastion of Italian freedom, looked eastward and even imagined that it would be possible to blockade the Dardanelles. Spain meanwhile could see no other possible or desirable crusade than one against the Maghreb, which was considered as

being the continuation, the natural counterpart, of the Iberian peninsula, beyond Gibraltar: here was a holy land, ripe for liberation, and on Spain's doorstep. There was a complete and congenital failure to see eye to eye. Yet, without Venice, the Christian forces in the Mediterranean would not even have been able to assemble at Lepanto, let alone win the victory. Divided, Christendom was powerless against the Infidel. Venice came to terms once more with the Turk in 1573, and Spain in fact did the same in 1577, by a series of three-year truces, renewed clandestinely, but about which the whole world knew.

In the circumstances, the Turks ought to have triumphed. But they did not. Oddly enough, the final arbiter in this long quarrel was the economic situation, the *conjocture*, which dictated the same rhythm for both sides, since the Turkish economy was dependent on the European. When the economic trend was downwards, as it was between 1559 and 1575, the two adversaries flung themselves on the enemy: crusades and *jihads* were the order of the day. When however there was an upturn in the economic climate, as there was between 1575 and 1595, they turned their backs on one another, and each expended its energies on fighting at home: it was a time of civil wars, Turks against Persians, Christians against Christians. A few years after Lepanto, and only shortly after the triumph of Sinan Pasha of Tunis, war between the great powers vanished from the waters of the Mediterranean, for no apparent reason, while fratricidal combat was soon in full swing in the west, the north, and the east. The only warships left in the Mediterranean were

the corsairs' vessels of both sides: on one hand the Barbary corsairs (who were bound to come out of it well, since privateering was always at the expense of the rich) and on the other, Malta, the Sicilian galleys, the clandestine privateers of Naples, and the Knights of St. Stephen based in Pisa. But the comings and goings of the reinforced galleys (reinforced that is with extra oarsmen, as horsepower is added to a racing car) and especially the sailing ships of the privateers, speeding about the sea from one side to another according to the seasons, the prevailing winds and the opportunities, are of no concern to us, for serious war was at an end. This game of cops and robbers—in which it was possible to change sides without turning a hair, or to do favors for the opposition—thrived on a quasi-regular clandestine traffic, as is now well known, although it does not fit the traditional images in the history books. Carmelo Trasselli tells us that Tunis was the Shanghai of the time, the headquarters of disreputable trafficking. But Livorno, Malta, Pisa, and Algiers would also deserve to be on the blacklist.

It was in fact during this peaceful intermission, when the great armadas were out of action, that the Sultan's fleet fell apart. Inaction killed it, whereas the battles in the Atlantic kept western or at any rate oceangoing fleets in fighting shape. When economic circumstances changed, in about 1595, the Turkish fleet could barely stir, and the Christians contented themselves with talking or dreaming of crusades, without taking any steps towards one. In Turkey itself, the saying became familiar that "God gave the land to the Muslims and the sea to the infidels." There

were in fact distinctions to be made between infidels. The seas had long belonged to the Christians of the Mediterranean, that is above all to the sailors of Italy. But in the seventeenth century (apart from a few Mediterranean episodes), it was in the Atlantic that the maritime battles took place that would decide the future. And ocean-going vessels now entered the Mediterranean, which was, like Italy, doomed to the debilitation caused by a general and long-lasting peace. Had it not been for the privateers, there would often have been no action at all in the Mediterranean, from Gibraltar to the Dardanelles. The center of gravity of the world had shifted.

But that did not mean general economic depression in the Mediterranean—on the contrary. In the 1570s, or rather round about 1573, there was a fresh invasion by northern merchantmen that penetrated and transformed every port. As a result the Mediterranean gradually saw the disappearance of its own merchant fleets (with the exception of the prosperous shippers of Marseille). The northerners—English, Dutch, Hanseatic, and even Breton vessels—took over. Better seamanship, less demanding crews, more effective defenses, more reasonable freight charges—everything favored the newcomers. Even the Ragusans with their great cargo vessels could not withstand this ferocious and often bitter competition, which ranged from tolerance of contraband to occasional instances of outright privateering and piracy. If one excepts the ships of Marseille and Brittany, it was the vessels of Protestant powers that were now sailing the Mediterranean and putting in on Christian and Muslim

coasts, without making any great distinction between them. Algiers became a way station for the English and Dutch, both of whom went on to Istanbul, where the French ambassador and the Venetian *bailo* watched with some displeasure as they installed their embassies and consulates. What was more, previous northern incursions had obeyed economic circumstances, which had alternately opened and closed the gates of the Mediterranean. But in 1595, even the rather abrupt downturn had no effect on them. Armadas of Italian and Spanish galleys were no longer to be seen offshore in the summer season, but northern ships were everywhere in Mediterranean waters.

Their overwhelming presence, which became entrenched and prolonged with the end of the century, was in fact a sign of prosperous commercial activity in the Mediterranean. Every port benefited: Naples welcomed the salt fish of northern seas as precious rations to feed the poor (and not only the poor); and Venice greeted the Dutch ships bringing the Spanish wool on which the *Arte della Lana* depended. Venice in about 1600 was still, despite the decline of its own merchant navy, probably the busiest port in the Mediterranean.[94] And Venice is but one example among many.

Italy Prospers

A prosperous Mediterranean meant a prosperous Italy. And in the demented world of the turn of the century, Italy reaped all the benefit of being neutral. Others fought;

Italy worked. The industry of the Low Countries was in difficulty; Italy stood to gain. Woollen cloth production in Venice went up as never before.

And then there were Spain's problems. The direct route from the Spanish coast to the North Sea, thanks to which Antwerp had thrived and survived, had been disrupted by English privateers since about 1568. The breakdown would be long lasting. This route, from Laredo, Santander, and Bilbao to Antwerp, was not only the itinerary followed by the precious fleeces of Castile to North Sea ports, but also that taken by the South American silver Spain was obliged to send to Antwerp as the price for maintaining hegemony there. For Spain was embroiled in the Netherlands in one of those remote wars, as costly as they were uncertain, by which any ailing imperialism is regularly tied down in its weaker zones; in this case, distance favored the other side.

In 1571, the revolt of the Sea Beggars who positioned themselves in Brill (April 20) interrupted for good the sea passage between Spain and the Netherlands. Coming to terms with the English would now solve nothing. The overland routes through France were possible but imperfect. Better in practice were the routes from Italy over the Alps towards High Germany. The Duke of Alba went this way, apparently to inaugurate the route, in 1567. After that, the continuous stream of Spanish troops marching to Flanders had regular stations along this route, from Genoa to Brussels, from the San Matonne hospital in Genoa, where invalid soldiers were treated, to the battlefields in the north, ever hungry for men and money.

This change of itinerary gave a boost to the already considerable fortune of the Genoese merchants.[95] They had long been settled in Castile. Philip II's first bankruptcy had hit his south German suppliers hard, especially the Fuggers. This cleared the way for the Genoese, who now became more and more deeply involved in the contracts, known as *asientos*, which businessmen, *hombres de negocios*, signed with the Spanish government, to ensure the security and regularity of payments made abroad. In exchange for promises of repayment (usually in New World silver) the *asentistas*, or lenders, committed themselves to making payments at regular intervals, in certain financial centers specified in advance, of which Antwerp was by far the most important. When the advances and repayments fell due, a balance sheet, or *finiquito*, was supposed to settle the account. In fact repayment was often postponed from year to year, with one *asiento* being attached to another to form monstrous chains of financial commitments.

Until 1568, the Genoese had also played a large part in the commercial life of Spain, notably in Seville, as we have seen, and in the raw materials markets in the peninsula, trading the fleeces of Segovia, the alum of Mazarón in the Kingdom of Valencia, or the silk of Granada. In fact this was a condition of their financial activity, profits from which were not directly exportable. It was difficult (and in theory illegal) to take silver out of Spain. The Genoese got round this by buying and exporting goods on which there was a profitable return, payable in Italy, the Netherlands, or elsewhere. In this way they had access to

capital and liquid cash at various useful points in their business network.

But after 1568 the Genoese abandoned their commercial activities in the Iberian peninsula, including even the key center of Seville, and the provision of long-term advances for the Atlantic trade. There was simply no need for them anymore. Faced with huge demands for money, Philip II's government now made numerous advances and concessions to the Genoese *hombres de negocios*, freely granting them *sacas* (silver export permits). Without meaning to, Spain had thus made life much easier for the Genoese. From now on, they turned full-time financiers, handling nothing but royal loans and South American silver. Commerce, they left to others.

The system was soon in place, thanks to a network of contacts used with intelligence, over the whole of Europe, including the indispensable Italian money markets, and was firmly anchored in Antwerp. Spain's need after 1567 to maintain an "overequipped" army in Flanders hastened the establishment and functioning of a complex but effective system of payments. In theory, the lender charged only a small rate of interest but small rates could mount up and in any case they related to literally millions of crowns, enormous sums for the period. Genoese bankers were thus appropriating the *political* money of the King of Spain and, by dint of handling these funds, attracted all the disposable wealth of the West, including Italy. Gradually, the money of Italian investors, as well as that of Spain, began to arrive in their countinghouses. The ideal situation for a businessman after all is to risk other people's money.

The fantastic success of the Genoese provoked rivalry and envy, particularly in Spain where backhanders, *aldahalas*, did not allay either the indignation of local merchants—a Malvenda or a Simón Ruiz—or the appetites of the King's financial advisers, all of them corrupt or ripe for corruption, men who were or could be bought, but who were better informed than anyone else about the practices employed, the true interest rates, and the tricks of the trade. In fact, the bankruptcy of 1575 (the third during the reign of the "prudent" King) was a Spanish maneuver, a conspiracy against the Genoese. At the same moment, the city of Genoa itself launched an uprising against the very wealthy *Nobili Vecchi*: the *asentistas* and their families. It was a long-drawn-out conflict, rich in incident, but in the end the Genoese bankers subdued the violent townspeople and their rebel leaders, the *Nobili Navi*. Finally, in 1579, they consolidated their banking activity by transferring to Piacenza the so-called Besançon fairs (so-called because they had been held in the old imperial town, but only for about thirty years).

The Piacenza fairs, which were strictly exchange fairs and did not deal in commodities, would become, under the management of the Genoese and to their advantage, a sort of clearing-house for European debts. *Scontro*, discounting, meant that debts could cancel each other out, melting like snow in the sun, and rendering unnecessary the movement of cash. It seemed miraculous to see millions of crowns' worth of bills of exchange balancing each other out with only a small quantity of cash needed for settlement. And there was always the possibility of having an

unsettled debt carried over three months to the next fair (usually at a 2.5 percent interest rate) or to send in lieu of settlement a bill of exchange to the appropriate financial center, at a rate (the *conto*) fixed by the stewards at the fair. Naturally the Genoese, who handled all the compensatory mechanisms, were more skilled than anyone else at playing the system profitably.

The skill exercised by the Genoese was in fact even more complicated and sophisticated than it looked: it required a repertoire of ruses, maneuvers and information. To have realized by as early as 1553 that gold was a better bet than silver showed considerable foresight—and it paid off handsomely. Even before 1575, the silver that men like Grimaldi, Lomellini, Spinola, and Pinelli controlled almost from its arrival in Spain, was making its way by mule-back from Seville to Barcelona on their instructions. From Barcelona, galleys sailed to Genoa carrying chestfuls of *reales de a ocho*, pieces of eight, and sometimes metal ingots; then from Genoa, the silver was resold and distributed wherever was profitable.

However, the payments that the Genoese made on behalf of the King of Spain were almost all made in Antwerp and usually in gold. The Genoese merchants therefore had to control the gold market, in order to keep exchanging one metal for another. Gold, which was worth twelve times as much as an equivalent weight of silver, was easier to transport; but only in cases of emergency and then only in small sums (5,000 crowns per man) was it entrusted to carriers for the trip to the Netherlands. The transaction was usually made in bills of exchange, the ideal

solution, since in theory bills of exchange were payable in gold.

Why was this exchange necessary? And how was it effected? The first reason usually suggested is that the troops in Flanders insisted on being paid in gold, a strong currency, since silver was tending to depreciate in this period. It is true that the soldiers asked for gold, but after 1600, they were quite willing to be paid in silver coin. So it is not out of the question that the double transaction, gold in the Netherlands, silver in Italy, may have brought even greater profits to the Genoese. The gold paid to the soldiers, who quickly spent it, soon found its way back into circulation, so it was easy to retrieve it. Evidently the Genoese had no trouble in having their bills of exchange paid in gold in Antwerp. On the other hand, silver was sought after on the money markets of Venice, Livorno, and Naples, for dispatch to the east, where it was worth more. Were the Genoese able to take advantage of this situation for a while? To find out, one would have to look very closely at their accounts and correspondence, but through a combination of circumstances these have either disappeared altogether or are virtually inaccessible. So we do not know the whole story.

In any case, the payment of gold via bills of exchange itself depended on being able to procure "papers," which had to be payable in the north, preferably in Antwerp, or in some French or German center from which the cash could easily reach its destination. We know that the Genoese bought these bills in Venice and Florence, and no doubt in other Italian cities, but in these two above all. In

Venice, the *Cinque Savii alla Mercanzia* were still reporting in 1605 that Genoese merchants controlled and manipulated exchange on the Rialto.[96] Another condition was that if the operation was to work on a regular basis, Venice (or Florence) had to have a favorable balance of payments in its exchanges with northern Europe in the broad sense, that is with a series of centers such as Antwerp, Lyon, Frankfurt, Nuremberg, Augsburg, Vienna, Danzig—further evidence, if it is required, of the sustained economic vigor of Italy during the second half of the sixteenth century.

To be capable as the Genoese were of "plugging into" trade circuits, to be able to "cut into them" as Schumpeter would have said, and to control the markets in gold, silver, and paper money, was no small achievement. In 1577, the Fuggers' factor in Spain was already accusing the Genoese of having more paper than hard cash, *"mehr Papier als Baargeld."*[97] His accusation may make us smile: after all, what was the age of the Genoese banker if not the age of paper money, of those miraculous pieces of paper that underwent a spectacular transformation? And this paper, which made so many forbidden things possible (lending at interest for a start, which it conveniently dissimulated) depended on immense wealth, solid alliances, and an excellent information network connecting a group of shrewd and implacable businessmen. The Fuggers were not, of course, the only people who did not understand the sophisticated rules of paper transactions. Even in Venice, and even in the first years of the seventeenth century, there were many businessmen who criticized this double money dealing: they saw it as a *"pernicioso e perpetuo ziro*

tra mercante e mercante, godendo quali banchieri partico-
lari le facultà de infiniti negozianti" ("a pernicious and per-
petual exchange between merchant and merchant, with
these particular bankers having at their disposal the
resources of countless men of commerce").[98]

Having triumphed in 1575 both over their enemies and
over the King of Spain himself (since he was unable to
manage without them) the Genoese also survived the sub-
sequent Spanish bankruptcies of 1595, 1607, 1627, and
1647. In practice, the Spanish state never went bankrupt
without the full knowledge and indeed complicity of the
financiers, who did not lose as badly as it might seem. And
there were ways of surmounting these troubles. When the
King ran out of money, and needed advances from bankers,
he now paid in promises, mostly in *juros*, bonds on the fis-
cal receipts of the Crown. To call this fool's gold would be
going too far, but such bonds had a way of depreciating
very fast. The financier, however, had the right to pay his
own creditors in the same detested currency with which he
had himself been paid, and did so regularly. For him it was
one way of covering or compensating for his losses, of
extricating himself from a tricky situation without undue
pain. As a result, we can conclude that it was the merchants
back home in Genoa, or the merchants and investors of
other Italian cities, who bore the real burden of the Spanish
bankruptcies, that of 1595 for instance, which led to colos-
sal losses in Venice. Other victims were unsuspecting
investors, sometimes very small savers, in Genoa, but also
in Milan, Venice, or Florence, who speculated, or who
were drawn into speculating "on the Besançon exchange

market." They seem to have been content with a very small return on their money, if we are to judge by the interest rates on the *luoghi* of San Giorgio, the public bonds on the republic of Genoa, as studied by Carlo M. Cipolla.[99] About 5 percent in 1520, this rate fell steadily over the sixteenth century, with some ups and downs, but in the end, "for one reason or another, in Genoa in the early seventeenth century, capital was regularly being lent at 1.2 percent"—a remarkable state of affairs.

Meanwhile, immense fortunes were being accumulated in the city itself—the more colossal in that the benefits of managing other people's wealth ended up in very few hands, with an unbelievable degree of concentration. If there was a single capitalist center, before the appearance of European and worldwide capitalism, it was Genoa, a city both opulent and sordid. If one were to document all the feudal estates and rents bought up by the Genoese in the Kingdom of Naples (and it could be done, using sources not all in the *Sommaria)* one would have a partial but striking image of a fortune based on unbridled acquisitiveness. But there is an even better image, a true memorial of the time. In 1608, Peter Paul Rubens arrived in Genoa, where he worked on commissions for convents and churches and painted several portraits. In between, he found time to sketch the ancient and modern palaces of Genoa, that forest of tall aristocratic mansions which, for lack of space in the town center, grew upwards. Later, in Antwerp in 1622, he published this collection of youthful drawings. They bear eloquent witness to the haughty elegance of this aristocratic city.

In the long run, however, this exceptional situation was subject to strain and deterioration. It was not simply a matter of the moneylenders' calculations, vigilance, and skill. Their conjuring tricks depended on one external condition, the continuous stream of treasure from America. When that apparently began to slow down in the first decade of the seventeenth century, a series of expedients became necessary: paying the troops in Antwerp partly in cash, partly in kind (in lengths of cloth for instance); or else reducing outlay, cooperating more among themselves, letting each other off payments. This kind of arrangement was happening discreetly between 1600 and 1610. But after 1627, the situation seriously worsened—long after the sudden and violent crisis of 1619–1622 which Ruggiero Romano[100] has interpreted as a full-blown structural crisis. It is certainly true that this crisis corresponded to the dislocation in 1621 of the Piacenza fairs. But it was after 1627 that things really began to go wrong for the Genoese; from the day that the Count Duke Olivares, on behalf of the King of Spain, appealed for money from the Portuguese *marranos*, those "new Christians" whom the Spanish Inquisition in fact mercilessly persecuted in later years and who were often straw men—agents for the burgeoning capitalism of the Netherlands. It was an odd situation certainly, with enemies lending money to their enemy: the borrower being the King of Spain and the lenders ultimately the Protestants of the United Provinces!

But it was precisely this collusion that put an end to the "age of the Genoese bankers" in 1627, according to Felipe Ruiz Martín, who has made a magnificent study of the

whole episode. And he is no doubt right to consider that the end was related to this curious about-turn by Philip IV, or rather by his all-powerful *valido*, the Count Duke Olivares. But I would slightly prefer to take a later date, 1648, and the separate peace that Spain signed with the United Provinces at Munster on January 30, to the great surprise and legitimate fury of Mazarin. By this crucial moment, the changeover was complete, or almost so. It had become irreversible. It was moreover in 1647, a year before Munster, that American treasure began to travel on the Atlantic, Channel, and North Sea routes, in ships from Holland and Zeeland. It may seem a disconcerting development, but for Spain the political problem was exactly the same as in the past: money had somehow to reach the Netherlands to prop up its presence there as a great power, maintaining troops and fighting to the death against the King of France, now that the United Provinces were no longer hostile.

But we should not therefore assume that the story of Spanish shipments of treasure from the New World no longer concerned the Mediterranean, or that Italy was now deprived of those chests of pieces of eight that had once arrived so thick and fast on the quaysides of Genoa that the coins were weighed rather than counted. In fact there is no story more tortuous and full of surprises than that of precious metals. Even at the end of the seventeenth century, huge shipments of silver were still arriving in Genoa in the holds of English, Dutch—and even Saint-Malo vessels.[101] Was there some Genoese revival, some upturn of the city's fortunes in the 1670s? If so, it must have been a spectacular

one. We can only note that even in the eighteenth century, there were still many prosperous colonies of Italian merchants, notably Genoese, in Spain—in Cadiz, for instance. So Genoa did not loosen her grip. In particular, the Italian city remained an important silver market. In the eighteenth century, according to French documents, it was Genoa that financed much of the prosperous Marseille trade with the Levant. And Genoa, like Geneva and Amsterdam, was a banker that continued to lend money to the forever short-funded European states. A financial center can generally be counted on to survive.

The Return of Pepper and Spices to the Mediterranean

Another sign of the good fortune of Italy in the period that concerns us is that pepper and spices returned to the Mediterranean, and therefore to Italy, after about 1550. This was a curious, unexpected, and, one might say, insolent return, confounding all the forecasts. But it undeniably happened, and thanks to pioneering studies by Frederic C. Lane, V. Magalães-Godinho, and Hermann Kellenbenz, we can see quite clearly how it came about.

The trade in pepper, spices, and drugs had been of exceptional importance for centuries. The long sea and overland caravan routes from the East ended in Egypt and Syria, at the great depots of Damascus, Aleppo, and Cairo, the last two being the key centers for trade with the Mediterranean. This trade could of course operate only if there was a two-way process, with silver and woollen cloth

arriving from Europe in Damascus, Aleppo, and Cairo. To keep cash payments to a minimum, Christian merchants preferred to pay in cloth or other goods rather than in silver; hence the efforts the Venetians had always made to buy the pepper, spices, and other goods they wanted *a baratto* (by barter). This was the very ancient arrangement that was compromised by Vasco da Gama's voyage. The Mediterranean's back-door supply of spices and drugs did not immediately dry up, but cargoes were reduced in quantity. What was more they became irregular, having to be taken aboard in the Indian Ocean (which the Portuguese could not easily patrol) from Arab dhows laden in Sumatra, the Moluccas, or on the Malabar coast. This pseudo-smuggling (only regarded as such by the Portuguese) delivered cargoes to the Persian Gulf or more often to the Red Sea. The revival in about 1550 of the traditional Levant trade at its former levels is explained firstly by the blind eye turned by Portuguese officials, who could easily be bribed, secondly by increased consumption of pepper and spices in Europe, and lastly by the accumulation of silver in Italy.

This revival took place roughly during the 1550s. If I had to give a date, I would choose, a little arbitrarily, 1552, when Venetian merchants, until then confined to Alexandria, obtained the right to set up shop in Cairo, and thus to penetrate to the very heart of trade with the Far East. Previously, Jewish merchants of Portuguese origin in the town had exclusive control of the commodity market. Being allowed in meant that the Venetians could now keep an eye on these formidable rivals, share their prerogatives, and possibly appeal to the Turkish authorities against

them. By 1554 at any rate, the Mediterranean was receiving as much if not more pepper than Lisbon—up to 40,000 quintals a year (at approximately 50 kilos a quintal). And when pepper returned to the old trade circuit, it naturally brought in its wake other Far Eastern commodities.

The result was a pepper crisis in Lisbon, as the tables were now turned. Jean Nicot, the French Ambassador to Portugal, unrestrainedly rejoiced at it: "If this diversion of the trade through the Red Sea becomes established once more," he wrote on April 12, 1561, "the storehouse of the King of Portugal will greatly suffer, which is the thing he fears most, and to prevent which his arms have so long been employed."[102] About the division in two of the pepper and spice trade, a state of affairs that was to last, we have unfortunately inadequate and not always compatible statistics. No doubt the proportion on each route varied from year to year, with the advantage first on one side then on the other, but the main thing from our point of view is that the Red Sea route did not dry up altogether in the sixteenth century.

There were probably various reasons why not. In the first place, as we have noted, Italy had plenty of silver, which had always been the most powerful attraction of the Far East trade. Secondly, when confronted with the networks of Asiatic markets, the imperfect Portuguese system sometimes failed to handle matters efficiently. Then in the 1530s, in Spain and by extension in Portugal, there had been a sharp and unexpected fall in prices with an attendant collapse of pepper sales. Another reason was that pepper and spices coming by the old Levant route, which

was shorter than going round Africa, had the reputation of better maintaining their quality and aroma—and this opinion was not simply a result of effective commercial propaganda by Venice: the damp holds of tempest-tossed Portuguese merchantmen were not necessarily the recommended mode of travel for such merchandise. Finally, the Atlantic route, on its European stretches, was becoming less safe. The battlefields of the so-called "Wars of Religion" were as often on sea as on French or Netherlands soil. Since nine out of ten customers for the pepper and spice trade were northerners, the supply route through Italy and over the Alps became important again.

So when Philip II proposed to cede to the Signoria of Venice the retail contract for Portuguese pepper, at the end of 1585, it was neither a bolt from the blue nor a bluff.[103] And if the prudent republic refused, after a debate of which all the details have survived, it was neither out of short-sightedness nor out of passionate hostility (to Venetians, business was business) but because by accepting the offer Venice would have cut herself off from the Turkish empire to which, as we have seen, she was bound by necessity. In any case, things being as they were, with pepper back in the Mediterranean, what need had she of this extra merchandise? So, until the end of the century, there were two pepper centers, Venice and Lisbon, but in fact only a single European market, since the two centers affected each other. In 1591, for instance, the *naos de Yndias* did not arrive in Lisbon and their delay sent up the price of certain spices in Italy. "Only pepper did not go up," wrote a Spanish merchant in Florence, "since plenty of it has arrived in

Venice from the Levant."[104] One final ironic detail: in these last years of the century, Portuguese merchants dealing in pepper came to settle in Italy—in Pisa, Florence, and Venice. They were coming there in all likelihood to gain access to the commercial network set up by Jewish merchants throughout the Mediterranean: though the Italian pepper trade was no doubt an extra factor.

But all good things come to an end. A century after Vasco da Gama, the Dutch captain Cornelius Houtman rounded the Cape of Good Hope in 1596 and sailed to the East Indies. His return to Amsterdam opened up a new chapter in the history of pepper, drugs, spices, and other Far Eastern goods, and in European trade in the Mediterranean. Even so, the effect was not immediately felt. The Red Sea does not *seem* to have been blocked, or rather deprived of its precious cargoes, by Dutch obstruction, until about 1620.

The Mediterranean had enjoyed a long reprieve, however, and Italy had taken advantage of that reprieve to become richer and to influence the entire sea, even the shores of the other civilization, Islam. In 1585, when it was being debated whether Venice should take over the pepper of Lisbon, a document informs us that between Venice and Hormuz, there were four thousand Venetian families scattered throughout the cities and lands of Islam.[105] The figure may seem excessive at first sight, but Venice undeniably had a presence as far afield as the Indian Ocean: and here and there, in Istanbul especially, the influence could be detected of Italian art and taste, which had taken root there. Nearer home, from Tripoli in Barbary to the

Moroccan Sous, there was also an Italian presence. Its beneficiaries were nearby Sicily, which was always on the lookout for advantage, and in particular Livorno, a new and rather curious town, which had grown up in a climate of economic freedom and which, through the intermediary of its Jewish merchants, held all the threads leading to the souks, the slaveholds, and the sales and profits of the privateering trade. (But will the real history of Livorno ever be written?) In Algiers, Italian labor (probably provided by prisoners) and Italian marble combined to leave traces still visible in the monuments of the city and in the villas of the *rais* in the hills of the Sahel, among the orange groves, in one of the most beautiful landscapes in the world, to quote a Portuguese captive.[106]

The Peak of Italian Influence

Prosperity then, or at any rate sound economic health combined with unquestionable wealth was the noticeable feature in Italy, as the sixteenth century turned into the seventeenth.

It is not surprising therefore that the age of the Genoese, which was also that of the early Baroque, corresponded to the peak of Italian influence. This special century, the sum in fact of two halves (1550–1600 and 1600–1650) was Italy's greatest age, if one takes as a yardstick the almost physically measurable strength of that influence. What metaphors might one apply to the influence of Italian art in the days of Lorenzo the Magnificent and Michelangelo? A few drops of

pure water, sprinkled over Europe, perhaps a small stream? To call it a river would be putting it too strongly. But during the great century from 1550 to 1650, one would have to talk in terms of wave after wave of the sea.

Perhaps I should make my point of view rather clearer. To speak of this as the great age of Italy is not to make a value judgment, placing it somehow above the age of the Renaissance. It does not mean saying, though no doubt the comparison would be permissible, that Galileo is greater than Leonardo da Vinci, or that Titian stands above all the painters of the previous generation; nor is it even a question of comparing Giovanni Botero, that sound political thinker, to his illustrious predecessor, Machiavelli. We are not in the business of giving grades to students, of deciding whether equal marks can be awarded to Renaissance Italy, for which everyone has a strong affection, and to the fervent Italy of the early Baroque. The point is to find out which of the two made more impact outside Italy, not whether the impact was of superior quality in one case than the other.

Once the question of comparison is out of the way, who could deny the ebullience and the originality of the later Italian age? Traditionally, historians have described it as exhausted, insignificant, decadent, or lifeless, and certainly out of the running as far as memorable events go, particularly feats of war: there would not be another battle of Pavia on Italian soil, no more boastful songs would be heard like the one mocking the defeated French:

Son confusi li Francios:
O Nostre Dame, O bon Jesus,

A st'ur nous sommes tous perdus.[107]

The French are in confusion:
O Our Lady, O Good Jesus,
Now we are all lost.

There would be no second Lepanto, and no more grand captains. Montecuccoli (1609–1681), one of the greatest soldiers of his time and of all time, ended up pursuing his profession in the armies of the Emperor.

Granted; yet this Italy created the Baroque, a new form of taste and culture, a "civilization" that was to sweep over Europe. It would be taxed, it is true, with having at the same time created a new and aggressive Catholicism, but that aggression was a reply to the Reformation, a defense mechanism, a reaction. That it cost Italy her intellectual leadership has been argued by the overwhelming majority of writers, in particular by Georges Gusdorf in a fine and passionate book of which more below: *La Révolution galiléenne* (1968). But I cannot agree one hundred percent with his conclusions. A culture is a combination of many things; one cannot simply arbitrarily detach one or other element and judge it on that. And I shall say more than once, at the risk of seeming an arrant materialist, that history cannot be judged exclusively by the life of the mind.

In short, like it or not, the long-lasting style known as the Baroque was responsible far a series of modern creations going well beyond the religious or artistic forms it invented. It created the modern theater, it was soon to create the opera; it witnessed the beginning of experimental

scientific research; it laid the foundations of modern science—it was one of the great ages of European history. During the whole period, Italy was under extraordinary pressure. By the middle of the sixteenth century, culture had become a leading preoccupation there, a leading industry. Regional specialities began to appear, creating so to speak a division of cultural labor: the southern slopes of the Alps exported foremen, masons, stucco-plasterers, and sculptors. Milan recruited musicians and particularly violinists; Mantua specialized in creating theatrical companies; Cremona was a center for making lutes and violins; and the outstanding feature was the participation of growing numbers of Italians in these active enterprises. There were more building sites, painters, and writers than Italy had ever seen, more intellectual ferment, and wider-flung intellectual circles than ever before.

To the historian who listens for it, the sound of endless lively debate will reach his ears and on the grandest subjects. Who could fail to listen to Paolo Sarpi defending Venice against the interdict of Paul V, thus starting the enormous controversy, which had still not abated by 1605, between the state, represented by Venice, and the papal theocracy, which seemed immutable?

One historian has argued[108] that the Italy of this period, just as much as in the time of Machiavelli, was a kind of political laboratory, and it is true: the entire population discussed politics, everyone having a passionate axe to grind—the porter on the marketplace or the quayside, the barber in his shop, artisans in the taverns, as well as men of culture. Paruta (1540–1598), Ammirato (1532–1601), and

above all the admirable Giovanni Botero (1540–1617) are by no means negligible thinkers in these difficult areas.

But politics and history were not everything. People also discussed art, architecture, literature, experimental, and theoretical science. And the primacy of culture had never been as officially accepted as it was now. Titian may not have been the first painter to live royally by his art, but his exceptional situation went far beyond the context of Venice. The "Cavaliere" Marino, who does not quite deserve either the adulation of his contemporaries or the scorn heaped on him by recent historians, was on an equal footing with the crowned heads of his time. When he returned from Paris in 1623, his journey became a pilgrimage, a triumphal progress, through Turin, Rome, and above all Naples, where he had been born fifty-four years earlier. And if one tried to describe the extraordinary career of Tristano Martinelli, "Mantuan by birth, of daring mind, earthy humor and ready wit," who played the role of Harlequin at Lyon in 1600 in front of the King of France, on the occasion of his marriage to Marie de' Medici—if one were to trace his path from triumph to triumph, inside and outside Italy, it would take a whole book. Indeed one was written, with much humor and elegance, by Armand Baschet, in 1882.[109] Tristano Martinelli was not the first to play Harlequin, but he expanded the role, and played it for over thirty years, ceasing to be Martinelli and becoming Harlequin himself, or rather, with a little pompous inflation, the self-styled "Lord of the Harlequins," *Dominus Arlechinorum*. When, in 1613, the Lord of the Harlequins passed through Turin with his company of actors, on his way to France, and set off towards the Mont-Cenis without mak-

ing his presence known, the Duke of Savoy, on being informed, sent posthaste after him, ordered the actors to turn back, and obliged them, for his greater pleasure and their greater profit, to play comedies to him for seven days running.[110]

Clearly there was an exuberance, a bubbling up of life, an intellectual effervescence, all over Italy. The public had become an ogre hungry to be fed. Germain Bazin wrote that in the early days of the Baroque, "it was perhaps more often the case that art governed life than the other way round"[111]—an appealing but incomplete comment, since in the case of Italy it was not art alone but the entire life of the mind that was guiding its destiny, shaping it, and offering it this final chance. What was on offer was the possibility of revolutionizing all of European art (whereas the Renaissance, like humanism, had been chiefly confined to the élites); of revolutionizing all of European thought, both scientific and literary (Galileo is after all the linchpin in the history of basic research); of revolutionizing an entire art of living, through the emergence of a varied and exciting form of theater, whose light would be reflected in Shakespeare and Molière. The same Baroque whose gildings and heavy ornaments so often irritate us when they seem to have been plastered all over a beautiful church in Tuscany or when they clutter the clean lines of Romanesque architecture, was in fact a ubiquitous and many-sided movement. How could history have so disdained it, as was often the case? Admittedly it has come back into fashion today [the 1970s], perhaps even a little too much.

How Should We See the Baroque?

How is one to visualize and represent, in all its flourishing diversity, this Italy that reaches beyond Italy? The word *Baroque*, of obscure origin but given currency by Président des Brosses (1739), by Rousseau (1752) and Wölfflin (1888),[112] and almost unanimously adopted today, is actually a rather convenient one. It denotes an entire age, one that goes beyond our 1650 time limit, and beyond the strict question of Italian influence, although the latter is by far the most important element of the whole. Spain, being so far removed from the center of the European stage, found it harder to export its art, which was in any case itself inspired by the Baroque. What the world took from Spain was its literature—its novels and plays—and its costume. Who would have thought that Philip II would launch a fashion in men's clothing—the severe black tightly fitting doublet with a high collar, only minimally relieved by lace trimming? Even Italy, which had ceased to be the arbiter of taste in this respect by the mid-fifteenth century, now fell under Spanish influence, as is immediately apparent from portraits painted by Titian, Bronzino, or Baroccio.

With these important exceptions, it is not too misleading to say that Italian influence, from the mid-sixteenth century on, is virtually synonymous with the Baroque. We therefore need to define the transition of Italy from Renaissance to Baroque, but that transition is elusive and obscure. It has been said of the Renaissance that in essence it enabled man proudly to take his place once more at the center of life on earth, accepting all his joys, responsibili-

ties, and sufferings. But such simplification is not so easy when it comes to the Baroque.

One would first have to reject the prudent advice of Pierre Francastel: "Neither the Classical nor the Baroque has any existence in itself," he writes.[113] That is clearly too absolute. But even if there is such a thing as the Baroque, it is impossible for it to be simple, monochrome, or homogenous. The Baroque suggests a series of storms rather than a sheet of untroubled water. It is in other words a "set" in the mathematical sense. The retrospective observer is left with the task of sorting out the different "elements" it contains. Defining it is another matter.

The debates in art history over it, though numerous, will not be of great help, since art, however one defines it, was only one element, a highly important one of course, in the great whirlpool of a civilization such as the Baroque. The Renaissance, according to art historians, represents the search for the ineffable, for the supernatural or divine harmonies evident in the beauty of the world we live in, whose principles the artist must seek to discover or identify. The Baroque, depending on which conflicting interpretation one chooses, may be seen as the rejection of the ideal of beauty and a return to the pathetic in everyday life; as "the shift from the subject to the object"; as an escape from real time into dream and fantasy, and sometimes as a determined denial of reality, with man being absorbed into the movement in which he is enfolded, "volatilized in an explosion of light." The Baroque, in fact, has a tendency to make one use baroque language to describe it; expression should be excessive if it is to be anything at all. The style that

comes most naturally to it is that of Rubens, that vision of ripe flesh, of voluptuous unreal bodies, sumptuously flowing draperies, brightly colored trees: *"Rubens, fleuve d'oubli, jardin de la paresse,"* "Rubens, river of oblivion, garden of idleness" (Baudelaire).

There is always something enlightening in statements of this kind. But such words do not define, they shoot like arrows across the whole field of study. The historian, patiently measuring both experienced time and global time (that of art, but also of all human existence), finds it quite impossible in any case to say approximately when the Baroque began—which is perhaps a sign that it emerged more than once and certainly not in any one place, or as the result of some particularly striking event. A river is made up of every little trickle of water that reaches it. But the Baroque is not a river; that would be far too clear an image. It can be glimpsed for instance, far ahead of its time, long before it is "really there," in certain tortured works by Michelangelo which betray either a shift or a break in his *terribilità*; in the tumultuous movements in Raphael's *Fire in the Borgo*; in a fresco by Correggio, or in the stormy paintings of Veronese (1528–1588) as well as in the immense *Paradiso* painted by Tintoretto in the Great Council Chamber of Venice between 1589 and 1590, a sort of celestial illusion hovering over the sulphurous life of men. But one might also regard it as having emerged some fifteen years earlier in Rome, when in 1575 the Jesuit Church of the Gesù was begun—a building destined to be reproduced many times, with numerous variations it is true. Or we might detect it in the moving painting

Madonna del Popolo (now in the Uffizi), the masterpiece of Federigo Baroccio d'Urbino. Or better still in that series of dramatic jolts given to the painting of their time by the revolutionary works of Annibale Caracci and Caravaggio.

Under Caracci's brush a new world came to life in the gallery of the Farnese Palace where he painted a sequence of pictures on the theme *The Power of Love*, among them the famous *tondo* representing *The Flaying of Marsyas.* The musician of the legend, having defended the Asiatic flute against the Greek lyre, has lost his presumptuous battle; Apollo has tied his defeated rival to a tree and is flaying him alive. Is this a symbol for the exploitation of nature by man (or by the god who serves man)? Is the subject of the painting the flaying of nature, its reduction to its true form?[114] But who would care to claim that the Baroque begins here, this minute, in the Farnese Palace, in the early and tormented years of the seventeenth century—in the same way that the Seine rises from obscure springs somewhere near Saint-Germain-la-Feuille, in Burgundy?

The historian, having no preconceptions in this domain since he is not a party to the debates between art historians, may find it useful to have one or two suggestions to light the way ahead, if not perhaps the entire landscape through which he is traveling and which is dimly perceived rather than clearly seen. Specialists often tell us that to compare the Baroque and Romanticism is misleading, to say the least. Romanticism believes in the *self,* in all its deep-rooted reality, whereas the Baroque loses the individual personality in game of mirrors, destroying and mocking the self. This may be so, but

there are several other connecting threads between the Baroque and Romanticism; to find them we need not even turn to Corneille—who was at one time claimed for the Baroque—or to quote his heroine who on being asked *"Que vous reste-t-il?"* ("What is left to you?"), replies, anticipating the Romantic age: *"Moi, dis-je, et c'est assez"* ("Myself, I say, and that is enough").

What is the same in essence in the Baroque and Romanticism is an immense and tormented anguish: man is tortured and made desperate by the human condition, he is immured in a prison against whose walls he throws himself, whose mortal chill he can feel. He is obliged to meditate on the brink of the abyss, or else pretend not to see it. No doubt from one age to another such anguish alters in tone, the despairing questions are differently formulated, and the sense of the pathetic does not attach itself to the same objects, but the state of mind is comparable. In the same way, the great European upheaval of the Revolutionary and Napoleonic wars is reminiscent of, though not of course similar in every point to, the Italian wars for which a certain France remained nostalgic after 1559. The situation had certain analogies. For me, Stendhal's *Le Rouge et le Noir* and, in particular, *La Chartreuse de Parme* have a touch of the Baroque.

Such thoughts bring us back to the argument associated with Eugenio d'Ors and his disciples[115] (too simple, too convenient, but never mind). They see literary and artistic sensibility—to avoid using a heavier term like civilization—as shifting back and forth in tidal movements that follow each other at longer or shorter intervals, con-

tradicting each other more or less vehemently: on one hand romantic imagination, siren voices, the search for the particular, the fleeting moment that can never be recaptured—giving us the Baroque, or Romanticism, and on the other Classicism, clarity, cold reason, the appeal of deep values, the nostalgia for eternal time (for time outside time) and long-lasting values, for a human nature that remains the same, throughout and as it were outside history. Of course, these alternating movements are not necessarily symmetrical: ebb and flow may be mingled, and there are some moments when the waters lie quite still or, on the contrary, are whipped up into strange maelstroms. Above all, we must remember that it is the *same* waters that are being propelled first one way then the other. Nicolas Poussin (1594–1665) was a true "classicist"; but it was in the Rome of the Baroque that he insisted on living, returning there to failure, and eventually dying there. Germain Bazin, in a fine work on the subject, has in fact distinguished no fewer than eight different divisions in Baroque art, or rather in art contemporary with the Baroque—for this was not the only style, although it eclipsed the others. Eight styles all with their particular careers, coexisting and communicating with one another:[116] such pluralism seems dictated by prudence and a concern for the truth—but can it explain everything? Of course not.

For one does sense a general trend and this is where the historian thinking about time on a world scale may either illumine or misrepresent the problems. The variously suggested starting points of the Baroque point to the

importance of those years, from Tintoretto to Caracci, at the turn of the century. These years are indeed significant. In about 1595, there occurred not merely an ordinary recession such as history has witnessed by the hundred, but a profound break: the secular trend began to falter. Imagine the caving in of a floor, or of the foundations of a house. This long, severe depression, from about 1595 until the short but sharp crisis of 1619–1621, was not followed by a sustained return to health. The recovery was imperfect. Something very similar happened in the nineteenth century, at the dawn of Romanticism, with the major realignment of the world economy in about 1817 (1812 for the Americas) after the prolonged crisis of the French Revolution and Empire. Once more, the determinism of the *conjoncture* beckons.

This time, we might do well to pay attention to the series of bad years just beginning. Their harmful effects would accumulate to undermine a society that had until then been breathing more easily. What was tending to become more widespread was a sort of all-round anxiety, an urgent desire to live, a need to break out and find refuge somewhere, to escape into dreams, or into the intoxication of words, music, the illusion of the theater and of the magic stage invented by the Italians: a house with one of its four walls removed. Yves Bonnefoy[117] has written that the Baroque was born of a "wound," of the newly discovered certainty that the outside world does *not* lead us through its secrets to God, a wound that bled, emptying the body of the will to live, evoking the image of death, which became sweeter as it became more familiar. Perhaps it is in the end

impossible to understand the Baroque unless, like Eugenio d'Ors, one feels a sort of romantic attachment to it.

Eyes or Ears?

Lucien Febvre was perhaps the first to ask whether, at different periods of history, men and their civilizations have accorded more importance respectively to the eyes or the ears, to the sense of sight or the sense of hearing, which, like gold and silver for economists, have always been related alternatives.[118] In the sixteenth century, he thought, the ear mattered more. André Chastel, repeating the same question, gave the opposite answer: in his opinion, the eye ruled supreme.[119] But with the coming of the Baroque, who could deny that the ear triumphed? "Is not all music, the music of every age, baroque?" wondered Eugenio d'Ors.[120]

These debates are by no means idle. Let us give honor where honor is due: music dominated the Baroque because it dominated Italy, before conquering the world. Leonardo Olschki, one of the finest connoisseurs of the Italian genius, is right when he says that to ignore music, "as people frequently do when writing the history of the Italian Baroque, is to deprive the Baroque of its essential element and to fail to understand its most obvious features."[121] Is he right to add that with the constraints that would soon be imposed on Italy, "music was to become the only free and autonomous sign of the artistic life of the Italian people"? We shall return later to the acute problem of Italian freedom. For the moment, what is most striking

in the fascinating and diverse history of music is the survival of popular music-making as a thriving infrastructure; this was essential if music was to accompany for instance songs and dances during Carnival, or the popular or rural verses composed for the *frottole*, sung in several parts, the *strambotti*, and the villanelles. This was music-making by local bands, who played at festivals and public ceremonies.[122] The music of the élite on the other hand was addressed to princely courts and aristocratic circles, but depending on the date this recherché music, highly sensitive to current fashions, and often borrowing wholesale from other countries, might flourish or fade in importance.

During the high age of humanism, the words of Italian poetry had thus tended to be detached from the music with which it had so long been identified. This was a time when the eye asserted its rights, promoting the figurative arts that gave it such pleasure. Poetry increasingly shook off any form of musical accompaniment, deeming it to be suited only to lesser lyric forms. It was not until about 1530—that date again—that "serious music" recovered its status in Italy. Until then, Italian music in Italy had been overshadowed by French, Flemish, and English musicians, the defenders of and experts in counterpoint and polyphony. The foreigners had made their fortunes in Italian courts and cities, in Milan, Mantua, Ferrara, Rimini, Florence, Naples, Venice, and Rome, and they were indeed often the first to re-create the link with popular Italian music. One of the most celebrated composers in Italy in the early fifteenth century, Johannes Ciconia, a canon of Padua, was a native

of Liège. As the century drew to a close, it was a Fleming, Heinrich Isaac, who was commissioned in Florence to "give artistic form to the old tunes of Carnival and the Maytime dances, at a time when Lorenzo de' Medici was himself composing lively verses for these entertainments," consisting of singing and dancing, "which drew on the authentic sources of popular art."[123]

For some time then, cultivated Italy was at a disadvantage, obliged to listen to others, and even letting foreigners reveal to Italians the richness of their own popular music, which they themselves had tended to disdain. Did this apprenticeship lead, as has been suggested, to the vigorous revival after 1530? The revival is in any case clear to see and easy to explain. The presence and activities of Italian musicians outside Italy established them and their music-making without encountering any opposition. They were everywhere: and they were teaching others.

There were, of course, some areas of resistance in this domain too. The French song was flourishing in the sixteenth century as a solidly established tradition, with schools in Paris and the provinces. The research by the group of musicians developing round Jean Antoine de Baïf and his *Académie de poésie et de musique*, founded in 1571, who gave themselves the task of "resurrecting the sung poetry of the Ancients [transposed into] the French language" on the basis of metrics using *long* and *short* syllables, may in a sense remind one of some of the experiments in Florence. But they developed independently of Italy, and themselves became a school, so Fabrizio Marino, a native of Gaeta and chorus-master at the Cathedral of

Toul, who later entered the service of the ducal house of Lorraine, applied the rules of the Baïf group when he set French poems to music.[124] In the introduction to the volume of *Airs Set to Music in Four Parts*, which he published in Paris in 1578, setting poems by Antoine de Baïf and Pierre Ronsard among others, he described himself as "a disciple of the school of MM. de Courville and Beaulieu." But this was someone thoroughly integrated into French culture.

Overall, by the end of the sixteenth century, the triumph of Italian music had become obvious and overwhelming. It had recovered its dignity, it had its own vitality, and it had been modified in energetic and revolutionary fashion. During this revival, it was able to take advantage of the unprecedented vogue for the theater. But the opposite was also true. Music and theater would finally come together triumphantly in the opera, but only, we should note, after a slow process of evolution. In the meantime Italy had a further mission to accomplish: the invention of the modern theater.

The Commedia dell'arte

Not every delight for the ears or even the eyes was immediately procured by the magic box invented in Italy: the proscenium arch, the stage as we still know it, the sophisticated house with one wall missing so that the spectator can look in. Later on, for instance in productions of Lesage's *Le Diable boîteux* (1707) or Luis Velez de

Guevara's *El Diablo cojuelo* (1641), the roof of the house was also removed, the better to see in.

The complicated refinements of the Italian stage set—backcloths showing houses, windows, and streets; machinery; the possibility of making the stage dark or light; rotating or sliding sets; the curtain (which did not appear in France until about 1640); the successfully created illusion of fire, or of collapsing buildings—all these spread slowly, but always from Italy. It took even longer for theaters to be built in semicircular form with raked seats. It was indeed an Italian, Cardinal Mazarin, who saw to the building, in the Palais Cardinal (Richelieu's former residence, on the site of the present-day Palais Royal) of the first semicircular theater in Paris. The other theaters in the French capital were still rectangular, with the pit in the center; spectators remained standing and the boxes, ranged down the two long sides of the rectangle, provided a very poor view of the stage.

So not everything came out of the magic box. It was a sign, a means, an opportunity but not the reason for the new upsurge of the theater. The setting was not the scene. And the first scene, the first image that appears on this retrospective screen is the lively and irrepressible one of the *commedia dell'arte*, about which there is much to be said. It enjoyed a spectacular and popular career all over Europe. It can still amuse us today, and it can be seen as an extraordinary touchstone by which to explore the sensibility and the truth of a complex period, at first sight hard to decipher. What was more, the *commedia* had roots far back in time; it had a long future ahead of it, and it traveled far

and wide outside Italy after about the 1570s. There was hardly anywhere it did not reach. So this is a theater with unlimited dimensions, in time and space.

Popular in conception, it probably goes back over the centuries to the very ancient *Fabulae atellanae* of Campania, which combined dialogue, dance, and music, and in which the actors regularly wore masks. Such origins seem plausible, but the form would have undergone many changes and transformations in the rich and varied history of popular festivities. Some elements will certainly have been adopted from Carnival situations, models, some of the costumes (possibly Harlequin's), and, of course, further examples of masked players. Such borrowings from popular tradition are surely inevitable: all forms of literature return to it from time to time, like Antaeus setting foot on the earth. Think of the farces and *fabliaux* of the Middle Ages or, in the period that concerns us here, the vogue for the picaresque novel, which was by no means confined to the Spain of *Lazarillo de Tormes* or *Guzmán de Alfarache*. Ortega y Gasset argued that Enlightenment Spain in the eighteenth century re-created its theater from popular spectacle, hence the *zarzuela*.

There must also have been other sources. The *commedia dell'arte* was closely related to the classic comedy of the humanists, itself broadly based on that of the ancients, recited by actors who had learned their parts by heart as in the modern theater. But one should not imagine this *commedia erudita* as being overserious: it was in fact full of broad humor and jests such as the "marvellous buffoonery" in Aretino's *Marescalco* (1533), or an early play by

Machiavelli, *Mandragola* (c. 1520), less known than *The Prince*, but rather charming.[125] In this case, the new comedy benefited by drawing heavily on the old. And the creation of companies of "full-time," professional actors also helped. Faced with the problems of finding employment, benefiting from the new style of production, but always needing to find an audience, they had to move from town to town in search of one, on interminable tours during which they were obliged to change the program as often as the scenery.

Possibly because of this need for variety and for a number of different programmes, the real novelty of the *commedia dell'arte* was that the actors were allowed to improvise, within the framework of a fairly simple situation and a scenario that was no more than an outline. Dozens of these scenarios have survived. The direct style of the *commedia all'improviso* impressed audiences (think of the difference between a lecture that is read out, and a spoken or improvised lecture). And its style was the most striking aspect of the new comedy, if not the most important— another being the unfailing appearance of the same typical or stock characters, about ten or at most fifteen, whose names, characters, and even costumes remained virtually unchanged. As in comic strips, or in the series of films about Don Camillo and Peppone, the same people kept reappearing, figures from an irreverent folk tradition, as if from an unchanging social repertoire: a pack of cards with a limited set of faces.

Apart from the lovers, the actors were usually masked; it is *possible* that the play with masks was developed in Venice out of the perennial double act between Zanni the servant

and the *Magnifico*, Pantalone himself, who was to become a permanent fixture in the tradition of the *commedia dell'arte* as a miserly Venetian merchant, the father of beautiful but of course disobedient daughters. It is worth underlining this master-servant relationship, which is always prominent in this kind of theater and is so characteristic of an ordered society: it transposes into an urban setting the relations between landlord and peasant, with the servant as a sort of domestic slave, tied to his master for life in reality if not in law. The apotheosis of Zanni is Arlecchino, or Harlequin, the quick-witted Bergamask manservant, capable of weaving and unraveling an intrigue, yet no less greedy, dishonest, and prevaricating than the others. He soon had many brothers, or rather regional masks: Pedrolino, Brighella, or Pulcinella, the Neapolitan with the hooked nose who specialized in disguise, impersonating by turns a pseudo-prince, a false doctor, or a lady of Spain. The French version, Polichinelle, emerged quite late in the reign of Henri IV, and was really popular only during the Fronde: he changed in appearance, keeping the hooked nose but acquiring two humps and abandoning the original all-white costume based on that of Pedrolino (Pierrot). In this theater, and especially in the use of disguises, there was a certain "social realist" imperative: the theater had to offer recognizable types out of everyday reality, and make references to it. Besides the many servants and Pantalone, the rich merchant, there was for instance the *Dottore*, preferably from Bologna, either a hopeless pedant or a shameless charlatan, who readily resorted to quotations in ridiculous Latin (one can see where Molière's doctors come from). Then

there was the *Capitano*, Spavento, devoted to his sweetheart, and indeed to all sweethearts, swaggering and boastful but deliciously cowardly, often played as a Neapolitan, or a Spaniard (sweet revenge!), sometimes as a German, in which case he was an innkeeper and a drunkard to maintain the stereotype. There were the would-be suitors, Oratio and Flavio, and the ladies they were to woo, Isabella, Flaminia, or Colombina, plus the indispensable bawd, the prostitute, and the usurer—and the company was complete.

With a few variations between companies, the characters were all well known and always the same, with unvarying age and social status, allowed to express only those passions which their part required and permitted. Everything was governed by a theatrical language that was without surprises, easy to understand on first hearing, and certainly not, it would seem, related to the instant, the particular, the originality of the moment, which is supposed to be the spirit of the Baroque. But the *commedia dell'arte* in the mid-sixteenth century, when it began to take to the boards, was a much older creation than the Baroque, which was merely a contemporary fashion, gradually imposing its laws and preferences. The *commedia* was a gift from earlier years or rather centuries. And since it had to attract an audience, it had to draw the public into the performance, into the language, and into the illusion. These prefabricated characters, who could neither deceive nor surprise, were brought to life only on condition that they were flung into frantic action, with lively dialogue and a plot full of incident. The show was punctuated by deliberate

contrasts, marked by the lanterns that either illumined the stage or went out to leave it pitch dark: violent quarrels or slapstick clowning *(lazzi)*, with acrobatics thrown in, would be succeeded by the slower-motion love scene with the lover in the street, the lady at the window of the house. If the course of true love was running smooth, they enacted a "great duet" of *amore corrisposto*, requited love; if they had quarreled or were being forced to part, they played a scene of *amore disperato* or *contra Fortuna*, love in despair or star-crossed.

But the aspect that would most intrigue a sociologist (or a psychoanalyst) is the compulsory and persistent wearing of masks. It obliged the actor, whose face was now hidden, to translate everything into the language of gesture (*le gestuel* is the term coined by Marcel Brion, who sees the entire Baroque as being governed by gesture). The actor had to express with his body what he was unable to show on his face. The *commedia dell'arte* lay above all in movement, footwork, fast action, gesticulation, all obeying a certain code. The lovers, for instance, were not allowed to raise their hands higher than their eyes, according to the stage directions on the scenarios; all the other characters were allowed, indeed encouraged, to turn somersaults, or do anything they liked. Bodily movement was all, and the plot had little need of logic, but simply ran along with the aim of getting laughs in the same way as, say, a Feydeau farce, although that would seem very stiff and classical by comparison.

The masks have much more to tell us. They were not like the masks of antiquity that fixed the expression of the

face, as a sign of the *persona*: instead they concealed it. The actor hid behind a screen. Was this in order to criticize a social or moral order that was being more firmly imposed on Italy as the century progressed? From whom were the actors hiding? Vito Pandolfi, who is probably the leading expert on this spontaneous kind of theater, remarks, without developing the idea, that "since freedom of expression was stifled . . . it was to the invention of masks that there fell the historic role of expressing the life and nature of our people."[126] It does not however seem that there was any conscious revolutionary social protest in the *commedia dell'arte*; but one cannot help feeling that the freedom to improvise (done on the spur of the moment, so leaving no record) combined with the satirical verve and realism of a popular and everyday language (the *commedia dell'arte* readily used local dialects—Venetian, Neapolitan, Bergamask—and all the pithy resources of slang) must have given it that allusive farce that any song can acquire if it refers to some topical reality. This seems all the more likely since, in the sixteenth and seventeenth centuries, the actors of the *commedia* were recruited from the middle class or from among modest intellectuals, and were all educated people. When everything is held up to ridicule and treated as a joke, with much clowning, facetiousness, and wit, social satire (perhaps unconscious) is never far away. And such satire might be sharp at times, since everything was possible in this free form of comedy—not unlike the modern music hall or nightclub entertainment. In any case, presenting unvarnished reality could seem satirical in itself. Pulcinella, for instance, was the eternal backstreet beggar

of Naples, wretched and scorned, so hungry that he could be bought by anyone for a plate of macaroni. "Beneath the violence of the invented words and gestures [we must imagine] a concentration of pain, the expression of plebeian Naples in the seventeenth century"—in other words a form of social protest. The quotation is from a commentary by Giuseppe Galazzo.[127] When Giordano Bruno was burned at the stake on the Campo dei Fiori in 1600, the masked actors had already been improvising on the stage for fifty years or so. Is this merely coincidence?

The *commedia dell'arte* was certainly established in Italy with its own style and companies of actors by about 1545, and would spread throughout Europe about twenty-five years later, having had plenty of time to develop and refine all its significant details. In fact it was played by the same companies who put on the *commedia erudita* and traveled from Italy as a sort of double bill with it. Or rather it followed on its heels, since the *commedia erudita*, with parts learned in advance and recited, and a repertoire that freely interpreted authors of antiquity, was the first to be exported. It was put on in Lyon for instance, a city particularly open to Italian influence, when in 1548 the "Florentine nation" and the Lucchese and Milanese merchants there entertained Henri II and Catherine de' Medici on the occasion of their triumphal entry. The comedy, played in a garden belonging to the Cardinal of Ferrara, Ippolito d'Este, Bishop and Duke of Lyon, was the farcical *Calandra*, performed by the Compagnia della Cazzuola. Spectacular *intermezzi* were put on between the acts.[128] Even in later years, when the *commedia dell'arte* swept all

before it, the classical comedy was not entirely eliminated. Companies still included it in their programs, and we should not imagine a complete contrast between clowning on the one hand and serious action on the other, as the adjective *erudita* might imply. Plautus was the great model for the classical comedy, which employed earthy language and satirical dialogue. In September 1613, Malherbe was present "at the Queen's express command" at a performance given either at the Louvre or at the Hotel de Bourgogne, palaces in which the monarchy lent the players halls usually reserved for official ceremonies. The *lazzi* or *scherzi* of the Italian players provoked him to bad temper. "They played a comedy that they called *Dui Simili*, which is the *Menaechmi* by Plautus . . . I left with no other pleasure.[129] Was he right "not to be amused"? Was he indulging in the prickly national sentiment we associate with him? Or did the actors translate Plautus's already earthy language into Italian-style farce? The *commedia dell'arte* often borrowed the theme of identical doubles and it may have been easy to slip from the learned part to the improvised, from the classical to the nonclassical.

In France and the rest of Europe, the nonclassical took longer to be accepted than the classical. The first performance in France of the *commedia dell'arte* probably took place in the *hôtel* of the Duc de Nevers, who was half Italian, in February 1571. On May 1 the same year at Nogent-le-Roi near Chartres, an improvised comedy was staged before the King himself. The company playing that day were the Gelosi players, who were to return to France and become famous. In Spain the first performances of Italian farce seem to have

taken place in 1574, and in England in 1578. The most interesting "première" so far recorded in Europe must have been the comedy improvised in Munich in 1568, on the occasion of the marriage of Duke William V of Bavaria. Did the frescos of the castle of Trausnitz, at Landshut in Bavaria, painted *ten years later* (and partly destroyed by fire in 1961) commemorate this joyous occasion? Possibly or even probably, since in them it was possible to recognize Pantalone, Zanni (Harlequin), several bawds and courtesans, and various typical scenes of serenades and chases.

We shall not follow all the comings and goings of Italian theater companies in Europe; even if it were possible it is not really called for. The interesting thing, let me repeat, is the surprising way in which this cultural influence spread both inside and outside Italy. The *commedia* came as a package, a rich combination of cultural offerings. How did the rest of Europe come to accept these masks, stock characters, acrobatics, and the combination of genres? If it had been only plebeian or semibourgeois Europe, that would be easier to understand. But these were princes, aristocrats, great lords, and, far from disdaining the whole thing like Malherbe, they entered into the spirit of something that had been created not at their social level, but considerably below it.

Plenty of answers and suggestions have been proposed of course. There was for instance the novelty of the stage, the sets, the new perspective for comedy. There was the shock of seeing a different kind of theater evolving before one's very eyes, there was the appeal of the earthy language, the cheeky challenge to established society, at once insolent

and harmless—since it was confined to the stage. (Although in France, the satire became sharper.) There were also the burlesque interludes between the scenes, spectacular acts that were closer than the comedy itself to what we would now recognize as music hall, circus, or variety turns. All these things entertained, amused, and gripped the audience, transporting it to a different world. And, in any case, was European court society really so sophisticated? French high society had not yet been "civilized" by the Marquise de Rambouillet. And in the Europe of the Baroque and the picaresque, there was often a tendency in high society to go in for what the twentieth century would call slumming. In Spain, this was common knowledge. Philip II himself, in his royal youth, was reputed to put on a mask and go out at nightfall to mingle with the crowds in the streets.

Finally, in the longer term, the *commedia dell'arte* served to reveal Western theater to itself—theater as escapism, as the mirror in which the spectator sees himself as more brilliant and better appreciated than in real life—and even able to taste revenge—to see Pantalone done down! I agree with Gustave Attinger's view[130] that the function of the *commedia dell'arte* was to provide a clearer identity for the artificial, entirely man-made world of the modern theater, in particular in the way it demonstrated, by giving the performers free rein, what a theatrical language and a theatrical world could be, a world that, precisely because it was false, rendered a more faithful image, as it were, of real life. Italian comedy echoes down the ages, leading to Shakespeare, Molière, even Marivaux, flourishing

until the end of an *ancien régime* in which it was readily comprehensible. Its vogue lasted for years. In October 1675, a troupe of *commichi italiani* came from France to London to play some farce of *Scaramouche* in front of Charles II and his court. When the Swedish ambassador learned from the King that the company was leaving town, he moved heaven and earth to make it stay on a few weeks longer.[131] In the early eighteenth century, Watteau painted *Gilles* and the *Comédie italienne*. The decline came later. The *commedia* was eventually relegated to traveling fairs, and to puppet shows for children, the last remaining live record of it: here it still glows quietly, like embers under the ashes.

But during the century when it carried all before it (1550–1650), the interesting thing surely is the way it appealed to every kind of audience. From the beginning to the end of this century, and even later, there was a passion for the theater that one has to make an effort to imagine: it was in the nature of a revolution. What else was the Baroque but life viewed through this magic lantern: pointless brawls, stage-managed illusions, unreal bodies, theatrical gestures, mock sword fights, exaggerated emotion, strings of misunderstandings. The theater could explain and excuse many things.

Ballet and Opera

One of the many things the theater helps to explain is the breakthrough made by music, with the opera as its culminating form.[132] As breakthroughs go, this one was

rather complicated. It depended, of course, on the progress of the theatrical spectacle and therefore of the society that made that development possible and encouraged it. It also depended on the particular progress made by the musical entertainment. And finally it depended on the internal development of music itself, which had to be grafted on to the rest. Since its uses varied so much, music had to adapt. But by modifying itself, it was also modifying its position. There was in effect a musical "renaissance" in about 1600, one no less complex than its contemporary, the scientific renaissance. Did music and science go hand in hand? In both cases, their renaissance was delayed.

In the sixteenth century, until the very last years, music evolved without causing too much disturbance to tradition. But gradually the innovators and revolutionaries became more numerous. Zealous research into the music of antiquity—which had the reputation of being different in the very texture of its techniques as well as being clearer and more moving than the music of the late sixteenth century—combined with the need for something new, which was felt everywhere. It was a time when former innovations were being revived, almost rediscovered: the tonal scale of Giuseppe Zarlino (1517–1580) for instance, or the experiments in chromaticism of Niccolò Vicentino (1511–1572) and Cipriano de Rore (1516–1565), which would become widely known only after 1580, after the deaths of their creators. And the same was true of the *basso continuo*, the figured bass, which was to transform and destroy traditional polyphony.

And all this in order to resolve essentially simple

problems that remained much the same: fitting dances to music, setting the words of poems to music, combining different instruments, composing the music for some fashionable stage performance. Theoretical debates about how these questions should be resolved slowed down and complicated musical development. One should certainly not assume a linear logical development with each step dictating the next. It seemed more as if music, like Saturn, was prepared to devour its own children, or at least to reject and ignore them, with the option of recalling them to favor later. In addition, the circumstances of history, the constraints of princely and aristocratic or even bourgeois societies, could not fail to weigh heavily on a world of fragile and competing forms: the ballet, the pastoral, the madrigal, the cantata, the oratorio, the opera. These forms developed in closely linked ways: the ballet and the pastoral led to the opera, while the madrigal, which was absorbed into the opera during Monteverdi's lifetime, was to be one of the most fertile testing grounds for the renewal of musical style, perhaps the most profitable of all.

The ballet—the *balletto*—was introduced to France in the time of the Valois by Italian dancing-masters. What the French meant by this name (the diminutive of *bal*) was a dance in which the dancers were free to improvise their steps, as opposed to dances with fixed forms. The word was usually associated with *bal, danse, entrées, entremets (intermezzi), carrousel*. But before long the word would denote a combination of extravagant princely entertainments which in fact predated its other

sense, since such events had already been put on at the court of Burgundy.

Let us consider the ballet then as an Italian initiative that underwent unexpected and expansive developments in France, becoming in the end a sort of yardstick of the fortunes of the French court—going from strength to strength; or meeting difficulty and decline. It was French ballet, also known as the court ballet, *ballet de cour*, which was exported from France; it would be imitated by the masks of the English court under James I and Charles I: their ephemeral beauty lasting one magical night inspired both the architect Inigo Jones and the poet Ben Jonson. Transformed by its stay in France, the ballet would even enjoy a new vogue on its return to Italy, where it was described (even by Monteverdi) as ballet *alla francesa*, as if the French royal court had invented it—which was not so far from the truth. It was equally true that the French ballet did not yet have a fixed form. It continued to be modified, appearing in almost unrecognizable shape from one spectacle to the next, until the mid-seventeenth century. Since the ballet was fabulously expensive to put on, and was always devised for the occasion, there were long gaps between these costly performances. Ballets were neither repeated nor did they resemble each other. The first known example, *Le Paradis d'amour*, was performed on August 20, 1572 (four days before the St. Bartholomew's Day massacre) for the wedding between Henri of Navarre and Marguerite de Valois. But the most famous and innovative was the *Ballet comique de la reine* (*comique* in this case meant in the form of a comedy) also known as *Circe*, which

the Piedmontese Baldassarino di Belgioioso (known in France as Balthasar de Beaujoyeulx) arranged at the request of the charming Louise de Lorraine, wife of Henri III, in honor of the wedding of the Duc de Joyeuse and Mademoiselle de Vaudémont, the Queen's sister, in 1581. Balthasar, an attractive figure who had been musical director and valet to the Queen Mother since 1567, and who according to Brantôme was "the best violinist in Christendom," was one of the many musicians who emigrated at this time from the Milan region and Piedmont.

The novelty of *Circe* was that the action followed a plot, a real play (written by the poet Pierre de la Chesnaye) put into dialogue and song, with episodes all relating to a central theme: Circe, the sorceress who changed men into swine and immobilized and petrified some of the lesser gods. This theme linked all the scenes. If the whole thing had been sung, we would be looking at one of the early forerunners of the opera. That point had almost been reached. Balthasar said, or had the view attributed to him, that his innovation had been *far parlare il balletto et usar canto e suono alla commedia.* "I have enlivened the Ballet and made it speak, and have made the Comedy sing and resound; by adding to it several rich and rare ornaments, I may say I have pleased, in a well-proportioned body, the eye, the ear, and the understanding."[133]

This was certainly an important step towards musical theater. But the score itself, divided among several composers, was not particularly remarkable. It was really derived from the polyphonic choir accompanying a soloist. One would not find here any hint of the stylistic experiments that

would lead to the *seconda pratica*. But the fact that the music was entirely subordinated to the text led to "a concern for dramatic truth and for an expressive melody that would throw the words into relief."[134] The French court ballet would for this reason be closely studied in the Florentine *camerate*, which were enthusiastic about research into music and monody, especially the circle around the poet Jacopo Corsi, the composer and expert impresario Emilio Cavalieri, and the singer and composer Jacopo Peri. But it was on the pastoral that this group was to base the crucial experiments that would lead to the opera.

The *literary* origins of the pastoral went back to the fifteenth century and beyond that to antiquity. It had quite soon become associated, in the sixteenth century, with musical interludes, and the genre had been given a considerable boost by the success of Tasso's *Aminta*, which was performed in Pesaro in 1573 with choral interludes. The first performance had been a year earlier at Ferrara, but without music. Between 1590 and 1600, Cavalieri and Peri in Florence, but also Guarini in Mantua, put on a series of pastorals in which the music was no longer confined to the intervals but invaded the action of the play, which was now being sung from start to finish. "The art of accompanying and commenting on a dramatic plot by music" had come to stay. The recitative for the stage had been born, with a "measured melody, already partly separated from its harmonic bass, with the singing containing inflections appropriate to the text."[135]

All these deliberately experimental attempts culminated

in Jacopo Peri's *Euridice*, with a libretto by Rinuccini, which was given a lavish production on October 6, 1600 in the Pitti Palace on the occasion of the wedding of Marie de' Medici and Henri IV of France. This is usually regarded as being the first opera. It was written throughout in the new recitative style, also known as *rappresentativo* (meaning representative of the words, which the music should underline, being content simply to transcribe the inflections and emotions of speech). This was the *seconda pratica,* the modern style as opposed to the *stile antico*, the old counterpoint, or polyphonic, style in which all the parts merged into a homogenous whole and in which the meaning of the words was unimportant. In French it was known as the *"style concertant."*

Claudio Monteverdi, a musician in the service of the Duke of Mantua since 1590, had been present at the performance of *Euridice*. Its novelty did not entirely satisfy him. He found the *recitativo secco* and that *"altromodo di cantare che l'ordinario"* rather monotonous.[136] He was thirty-three years old and already had a long musical career behind him, but one tending in a quite different direction from that of the Florentine circle. He had published three books of madrigals (in 1586, 1590, and 1592) and was about to publish two more. The madrigal was one of the freest musical forms of the time and was to be the chief vehicle of technical musical developments in the Renaissance. The Italian version of the Franco-Flemish polyphonic song, amorous or elegiac in tone, the madrigal was a short piece for five voices that could either "be treated as a very simple homophonic and syllabic counterpoint or

in more elaborate polyphonic style [with] great freedom permitted in the writing . . . : fifths and octaves, or discordances, etc., which would be considered serious mistakes in any other genre, were regarded in the madrigal as elements tending to improve the expression."[137] The madrigal gave free rein to all kinds of fantasies and even to *stravaganza* in itself. It had even been used in experiments of "monodic form" by the Camerata of the Bardi in Florence.[138]

Monteverdi's secret was that he took up all these different variants and practiced them with increasingly bold departures from the norm. Indifferent to theory, he was simply searching for an accurate expression of his own lyricism. In short, he was prepared to try out any form and was a composer of genius. Some months before the performance of *Euridice*, he had been violently attacked by Giovanni Maria Artusi, a canon of Bologna and a stickler for musical rules, in a pamphlet on "those new-style composers who day and night belabor their instruments to find new effects . . . [making] modern music disagreeable to the ear. One hears a cacophony of sounds, a jumble of voices and a grumbling of harmonies intolerable to the senses . . . Everything is singing, how can the mind recognize where it is in this whirlwind of expressions?" Characteristically, Monteverdi would reply (several years later) that "concerning consonance and dissonance" all he was interested in was "the satisfaction provided for the sense of hearing as well as for the reason";[139] his only aim, he added, was to "produce emotion."

It is easy to see why Monteverdi's *Orfeo*, performed

during Carnival in 1607 in Mantua, should be considered the first "real" opera. Although in theory faithful to the *seconda pratica* that gave precedence to the words, Monteverdi was in fact too much of a musician to sacrifice music to poetry. "In his *Orfeo,* as if to challenge the Florentine *Euridice* operas, alongside the admirable recitative, by turns *speaking* and melodically developed, he sets airs, chorales and dances in a prodigious variety of forms."[140] The rich orchestra was not simply used to accompany the singers, but had its own dramatic function, with a particular instrumental sound for each of the characters, in which one can see the beginning of the orchestral theme, or *leitmotif.* In fact all the forms and possibilities of the opera of the future are already there.

All it lacked was its true name, *opera,* which was already being used, but which only became widely adopted much later, in the second half of the seventeenth century. Monteverdi's opera was still only a *"favola."* By the time opera got its name, it already had a long history behind it. In Italy, it had three essential homes: Florence until about 1627, Rome till about 1660, and finally Venice, which would eventually become the capital of opera, without by any means monopolizing it. This flowering came late and corresponded to the last glorious years of Monteverdi's life: shortly before his death in 1643, he wrote two operas very different from *Orfeo*, since years had passed and public tastes had changed: *Il Ritorno d'Ulisse* (1641) and *L'Incoronazione di Poppea* (1642).

The first opera house, the San Cassiano theater, had been built in Venice in 1637. Over the next two years, there

appeared the second—Santi Giovanni e Paolo—and the third, San Moisé. In 1641, the fourth, the Nuovissimo, opened its doors. In the previous year, the Venetian republic had embarked on what was to be a thirty years' war to recover Candia (1640–1669), a running sore of a colonial war, which Venice nevertheless waged practically alone, with courage, determination, and resources indicative of the city's wealth: ships purchased from northern Europe and even troops recruited in distant Scotland. The glory of the Venetian opera did not blossom in a poor, weakened, or gloomy city; rather it was a triumph of extravagance in a city of luxury, of high prices and comparatively high wages, a city that was a rendezvous for dazzled foreigners, but that was well able to support its theaters, with rich patrons sitting in the boxes and a less well-off clientele that thronged to the pit. The music, which had previously been heard free of charge, since it was paid for by the Signoria or some rich patrician, now had to be paid for by the public. The illustrious Tron family, which owned the San Cassiano theater, invented paying turnstiles—a move that was not without consequences: popular audiences would put an end to the refined opera of Monteverdi, which did not satisfy the newcomers. During the intervals, clowns, acrobats, and comedians from the *commedia dell'arte* offered their services to make spectators laugh, whether they were in the boxes or the pit. This was the boisterous and lively period presided over by one of Monteverdi's pupils, Pier Francesco Cavalli, who willingly provided exaggerated effects.

Already opera had begun to spread all over Europe, being accepted with respect, enthusiasm, and gratitude.

Italy, which was awash with music from Naples to Venice, in turn flooded Europe with it, even faraway England. Nothing could better indicate the success opera was enjoying abroad than the popular dimensions of what was being exported from Italy. By about 1660, "dozens of wandering or colonizing musicians" were setting off from Rome and Venice, their "satchels full of *Orfeos* or *Artaxerces* they had written themselves on two staves, mere outlines that the . . . singers would later develop or even transform completely. . . This was no longer an art, it was an industry."[141]

In France, the grand première of the opera was another *Orfeo* (libretto by Buti, music by Luigi Rossi) in 1647, thanks to Mazarin, who had brought an Italian company to Paris. French music, which had grown up on the "tradition of the song and the court ballet" suddenly became "Italianized" on the death of Louis XIII—and its "de-Italianization" was equally swift and politically calculated, after the death of Mazarin in 1661.

Was this a natural reflex, like all the about-turns to which France has accustomed us? It was too deep and long-lasting for us to be content with a circumstantial explanation—though one comes readily to hand in the person of Giambattista Lulli, or Jean-Baptiste Lully (1632–1687), the Italian who wanted to be French.

It was apparently the frivolous Duc de Guise, the man behind the Naples uprising, who had, a few years earlier, in 1643, discovered and brought from Italy this child prodigy, a humble miller's son born in Florence. He had brought him to France "to converse with Mademoiselle de Montpensier in the [Italian] language." So the little boy

was never, as some malicious tongues later suggested, a scullion in the household of La Grande Mademoiselle, where he completed his musical education. In 1652, he opportunely transferred to the King's service. How he won the affection of the young Louis XIV (born in 1638), and how the King heaped honors on this Florentine "of somewhat unprepossessing appearance," this youth of verve and talent, but with a strange look in his eye, was a long story, worthy of a novel. The musician of genius revealed himself to be tough, manipulative, presumptuous, and remarkably pugnacious. He was a courtier of unimaginable suppleness yet at the same time he was obstinate, touchy, and determined. When, during the year 1661, he completely transformed himself from an Italian musician specializing in the recitative into an all-French musician, it was merely a sign of the breakneck "de-Italianization" of the moment. The ebb tide carried him along, with his consent. But there was personal conviction in this about-turn, as well as unremitting ambition. And he would pay the price for it.

The Italian recitative had been based on a "word-stressed" language; unlike Italian and German, French is "sentence-stressed" and was therefore structurally resistant to the treatment it received in Italian music. Lully looked to the *air de cour*, the court song, to see whether some compromise was not possible between the French and Italian languages, to allow the transfer "from recitative to song." How successful he was is a matter of debate among specialists qualified to judge. But his attempts were certainly good training for the arduous but glorious career ahead of him, for Louis XIV granted his official musician and musical

director the monopoly of the "musical theater," enabling Lully to eliminate his rival, Marc-Antoine Charpentier, and to remain until his death in 1687 the unchallenged composer of all operas put on in Paris. The first of these, *Cadmus et Hermione* (1673), was a great success that led to the composer being offered, the following year, the theater in the Palais-Royal, until then occupied by Molière's theater company. (Molière had just died.) In 1674, Lully put on a second opera, *Alceste*. Madame de Sévigné was enthusiastic: "It surpasses everything one has ever heard . . . The opera is a prodigy of beauty." "French" though it was and deliberately sought to be, the opera had now conquered Paris. After that, working with his designer Vigarani, and his librettist Quinault, Lully would produce a new piece every year. The "French" opera was in business.

So too, to take one last example, was German opera, or rather Italian opera in Germany. For Germany would be more timid or more modest about opera. Its musical tradition was unrelated to the theater. Moreover, the country was just recovering from the Thirty Years War, which had brought to a halt, if not all musical life, at least all major court entertainments. So Italy reigned unchallenged in Germany when, towards the middle of the seventeenth century, the first opera houses were created in Vienna and Munich. The composers were all Italian: Bertali, Cesti, and Draghi in Vienna; Porro and Stefani in Munich. The works were Italian, both in musical style and in language; and the singers were mostly Italians. Dresden soon followed suit, and there the key figures were Carlo Pallavicino and Giovanni Andrea Bontempi. In 1671, for the first time in

Germany, Bontempi's *Dafne* was performed there "with a German libretto, with characters familiar to the German audience, and with interludes in the form of *Lieder*." This was the first attempt, an isolated one, as yet, to give a national form to this completely foreign genre.

It was above all in Hamburg, where a German opera house had been founded in 1678, that there developed that hybrid genre known as the "German baroque opera," written by German composers trained in the Italian manner, but drawing very largely on the German *Lieder*, often transforming the Italian recitative, and seeking to vary the subjects. This genre, of which the youthful Handel's *Almira* was one example performed in Hamburg, did not survive very long. Handel, like most musicians of his generation, firmly turned his back on German opera to join the Italian camp. By the early eighteenth century, the German opera houses were one by one obliged to go over to Italian opera.

The future of German music in the eighteenth century is well known. But in that marvelous development, it was Italian chamber music and the concerto, rather than the opera, that would play an important role.

Poetry and the Baroque

With music and the wide range of comedy, we have traveled deep into the enchanted country of the Baroque. Another way to get there is along the complicated path of sophistication and preciousness that is baroque poetry. This was an age ready to plunge with delight into those

verbal experiments which so often recur at intervals in the history of poetry, from the Alexandrian poets, or the Neoteroi of ancient Rome, to the Dadaists and futurism. At times like this, it is not so much the subject that matters as the language, the originality of expression, the wayward charm of the bizarre or the hermetic: the poem is a play on words, a combination of sounds, alliterations, onomatopoeia, and sometimes even a picture in words: the calligram was practiced in the seventeenth century. This kind of experiment can either lead to a lyrical renewal or become tedious and pretentious. In the event, the *précieux* was a temptation to which the Baroque frequently succumbed.

That the literary world of the Baroque originated in Italy, with Spain as a secondary influence, is too well known to call for comment. The Spanish Baroque, though very visible, was itself somewhat Italianized and the Spain whose influence we notice alongside Italy's was, like Italy, in a period of decline from greatness, as if any culture that gave so much of itself abroad must consume the source of its own light.

With so many reflections flickering on the surface of Europe, it is easy to lose one's bearings, especially if one is trying to distinguish authentic Italian influence from a complex of interrelated influences. Perhaps a single witness, examined as a case study, will suffice and speak for the others. Let us confer this distinction on the so-called *"cavaliere"* Marino, who was overpraised in his lifetime and probably over-disparaged after his death—perhaps because his reputation was indeed inflated beyond his talent. For our purposes, he makes an excellent witness, and

a spectacular one. (Imagine perhaps, though this is a weak comparison, Anatole France in Buenos Aires in the early twentieth century.) By the time he arrived in France, he was certainly no anonymous traveler, eager to reach his destination. Between 1604 and 1614 he had written several collections of poetry, notably *La Lira*, and since then had been regarded as a prince among poets of his generation, something like the standard-bearer of the avant-garde, leading a rebellion against the literature of the previous age, in this case the Renaissance.

Born in Naples in 1569, Giovan Battista (Giambattista) Marino had apparently had an eventful life, both in Naples and in Turin, where he had taken refuge but had immediately got into trouble, even spending some time in prison. At last, in 1615, he reached France, where he made his fortune, returning to Naples only in 1623. France had been ripe for some years to receive with enthusiasm this complicated and brilliant Neapolitan poet, who knew how to advertise himself, and who was both ambitious and temperamental. Philarète Chasles, who disapproved of this adventurer, said that, like Naples in the early seventeenth century, he combined all the vices of both Italy and Spain.[142] All the same, "le Cavalier Marin," as he was known in Paris, was intelligent, sensitive, and witty. That he was thirsty for gain, or that he sent huge sums of money home to Naples, where he was having a palace built as well as a gallery overlooking the Posilipo, was neither here nor there. His protector in France, Concini, the Maréchal d'Ancre, apparently said to him at his first audience: "You may have five hundred crowns"—a generous sum. But

Marino told the cashier who was counting out the money to pay him a thousand. Concini on hearing this exclaimed: "You certainly are a Neapolitan!" To which Marino replied: "I don't understand a word of French. Now be a good chap and thank me—I might have understood you to say three thousand instead of one thousand."[143] The court loved the story.

Marino was certainly not short of talent. Who could fail to appreciate at least the prose of his letters, even the most fantastical, the so-called "burlesque" letters? In May 1615, he was on his way to France across the Mont-Cenis, leaving behind the troubles that had landed him in prison. A wretched hired horse was carrying him, or rather failing to carry him, as they reached the cold and snow of the high passes: "The slopes of the mountain were so white that they seemed to be covered in clotted milk, and winter, having turned academic painter, had daubed them with a coat of plaster and white lead. The few trees that had not completely disappeared under the snow were also so white that one would have said they were dressed only in their shifts and were shivering more from the cold than from the wind."[144]

This style, which is at once contorted and concrete, perhaps illustrates the kind of intellectual game lying at the heart of a certain poetry—that practiced by Marino and his followers—whose message often can no longer reach us, or at any rate fails to inspire in us the enthusiasm it aroused in the seventeenth century. This was a poetry designed to surprise and strike the reader, not to move him. As Marino put it:

È del poeta il fin la maraviglia
Parlo dell'eccellente e non del goffo.
Chi non fa stupir vada a la striglia.

The aim of the poet is to create wonder
I speak of the excellent, not of the incompetent.
If he cannot astonish, let him be thrashed.

He certainly knew how to astonish. Take this extract from a long poem describing the person of the Queen Mother:

Sentieri lattei onde van l'alme al cielo;
Valli di gigli, ove passeggia aprile;
Canal d'argento, che distilla odori,
Solco di neve, che sfavilla ardori.

Milky way, by which souls go to heaven,
Valleys of lilies, where April passes,
Silver channel that distills perfumes.
Furrow of snow that sparkles with ardor.

This purported to be a description of the breasts of Marie de' Medici, and was no doubt a case of courtiership *oblige*, but these images probably strike the reader as being well beyond the call of duty. He should not on this account simply be dismissed as a charlatan. The three lines quoted earlier, which are his *Ars poetica*, would do very well to describe a trend in French poetry of the period. Marino took his calling very seriously, and allowed it to consume much of his time: the 40,000-line poem *Adone*, completed during his

stay in Paris, was a mighty labor. His correspondence shows him at odds with the printers, tearing his hair at the misprints marring the work—a sure mark of the man of letters.

If Giambattista Marino met such success in Paris, where he had been preceded by his reputation as "the prince of modern poetry," it was not of course purely on account of his talent, real or supposed. One also has to take account of the snobbery of the court, the only thing that enabled him to survive the mortal disgrace of his protector, the Maréchal d'Ancre, who was assassinated on April 24, 1617 on the orders of the young Louis XIII. One should also bear in mind the helpful friendships that the Neapolitan cultivated. Grandees often liked to play patron of the arts. That was why the Marquess di Manso, whom he had known in Naples, when passing through Paris gave Marino luxurious lodgings in his town house in the rue de la Huchette—that narrow winding street that still happily exists, a few yards from the Seine. Marino naturally frequented the Hôtel de Rambouillet (one would be surprised if he had not)—the residence in the rue Saint-Thomas-du-Louvre of the Marquise de Rambouillet, herself of Italian origin—a little literary court, like the princely courts of Italy. It was here that French aristocrats and literati learned good taste, distinction, politeness in female company, and the affectations of refined language—all in the name of Italian elegance and under the aegis of Ariosto and Tasso.

What needs more exploration is the degree to which everyday life in France was contaminated by foreign influence. Louis Courajod, being hostile to this "invasion," observed and described it better than anyone else, and it is

amusing to read him again. The worldly education of young noblemen, he says, "the academy, or the science of 'high society' was Italian. Italian too were the grooms in the stables, the fencing teachers, musicians, and dancing masters. "Even the "baigneurs" were Italian, that is the "purveyors of scented waters and trifles, as were the *zingari*, who were not so much Bohemian and Spanish as Italian." One might add that Italian architects and engineers felt that in Europe they were "citizens of the world," but this remark does not come from Louis Courajod.

France, or rather Paris, which was increasingly becoming the center of intellectual life in the kingdom, experienced its baroque period between the early seventeenth century and about 1660, though these are approximate and perhaps too generous dates: a more limited definition might confine it to the years 1620–1635. It was in 1635 that France entered the Thirty Years War. It was certainly not until 1660, however, on the eve both of Mazarin's death and of the personal reign of Louis XIV, that classicism could really be said to have arrived.

The France of the pre-classical Baroque, which enjoyed its liveliest period during the reign of Louis XIII, a France open to influence from beyond the Alps and the Pyrenees, is in fact a fairly recent discovery for literary criticism,[145] which has restored to favor a number of little-known or misunderstood writers, such as Jean de Lingendes (1580–1616) and Honorat de Racan (1589–1670); or those who had not previously received their proper due, such as Agrippa d'Aubigné (1552–1630), the author of *Les Tragiques* (1616); Claude Garnier; and Saint-Amant (1594–1661). All of these writers

generally conform to the precept formulated at an early date by Mathurin Régnier (1573–1613): "Let the pen go where its inspiration takes it" or better still, as Théophile de Viau wrote, "Rules displease me, I write disorderedly/True wit does nothing if not effortlessly."[146]

As the years went by, the French Baroque seems to have deteriorated from within by dint of talking of everything in terms of inspiration, by mixing all the genres, engaging in preciosity (a short-lived mode in fact), producing a spate of heroic comic poems, tragicomedies, or wild utopias, like those of Cyrano de Bergerac (1620–1655), and before long indulging in the dangerous fashion of the burlesque (such as Scarron's *L'Enéide travestie* of 1648). While this French Baroque may have recently been granted naturalization papers, French literary criticism is still finding it hard to characterize it properly, to distinguish what is original about it, to make clear its true European dimensions and in particular to relate it to the specific influence of Italy. Although the same causes could well have produced the same results north and south of the Alps, there were indeed borrowings, and important ones.

But the baroque episode came to an early end in France; it was already beginning to fade out by mid-century. How did it come about that the Baroque, in which one would like to detect some kind of pre-classicism or even a French counterculture, gave way to classicism? This is a problem that has not yet been solved. One would have to read and reread contemporary works and resolve several tricky points. Can one in any sense classify Malherbe as belonging to the Baroque? What about the early Corneille?

Or the writers between Chapelain and Boileau? In the novel, where matters are more clear, the Baroque certainly runs from *L'Astrée* (1620–1627) by Honoré d'Urfé to *Le Grand Cyrus* by Mademoiselle de Scudéry (1650).

So the *Cavaliere* Marino arrived at just the right moment, in a Paris witnessing rapid transformation, becoming more complex and open-minded. The reading and writing French public had for many years been welcoming great works by Italian writers, either in the original or in early translations: Boccaccio's *Decameron* in 1545, the first fifteen cantos of *Orlando Furioso* in 1555, Bandello's *Tragic Tales* in 1564, and so on. And it would be quite impossible to list the countless borrowings French authors took from Petrarch, whose *Sonnets* and *Triumphs* were so often published in French.

It was to these earlier conquests (although he took care to disavow them) that Marino owed his triumph during the ten years or so he spent in Paris. Triumph is the only word for it: the Queen would stop her coach to chat with him; he was the king of the magnificent and frivolous world of the Hôtel de Rambouillet: the salon of "Arthénice" was at his feet. Dante and Tasso were eclipsed, Petrarch sent packing. The man who from the beginning of his stay in Turin in 1610 had mocked *"poeti tisicuzzi, i quali non sanno fabricare se non sopra il vecchio"* ("incompetent poets who can make something only out of old stuff"),[147] openly announced his intention of breaking with the past. And on this point, his influence must have been decisive, more so certainly than that of the great Luigi Alamanni whose destiny had been to become steward to Catherine de'

Medici, and whose *Ars poetica* was pillaged by the entire Pléiade, starting with Joachim du Bellay.

Marino's triumph was a sign of the times, a measure of the impact of the Baroque. Whereas during the reigns of François I and Henri II, Italy had merely influenced French culture, during that of Louis XIII Italy simply *submerged* it. This was why France, the major target of this cultural bombardment, in the end reacted more quickly and vigorously than other countries and turned well-assimilated borrowings into something that was truly French: out of the Italian opera was born the French opera; out of the Renaissance and Baroque emerged what we call Classicism. The quarrel between the Ancients and Moderns finally bore fruit.

Surrounded by more or less servile flatterers, the *Cavaliere* did not however understand the growing power of the society before his eyes: he never mentions it in correspondence with his friends.

But one can still read and thoroughly enjoy the delightful picture of Paris—highly colored, burlesque, and full of telling details—that he sent to his friend Lorenzo Scoto in 1615. These are not considered reflections, simply the impressions of someone newly arrived and still suffering from culture shock.

> *Vi do aviso che son in Parigi . . . Circa il paese, che debbo io dirvi? Vi dirò ch'egli è un mondo. Un mondo, dico, non tanto per la grandezza, per la gente e per la varietà, quanto perch'egli è mirabile per le sue stravaganze. Le stravaganze fanno bello il mondo; perciochè, essendo*

composto di contrari, questa contrarietà constituisce una lega che lo mantiene. Né più né meno la Francia è tutta piena di ripugnanze et di sproporzioni, le quali però formano una discordia concorde che la conserva. Costumi bizarri, furie terribili, mutazioni continue, guerre civili perpetue, disordini senza regola, estremi senza mezo, scompigli, garbugli, disconcerti e confusioni: cose, insomma, che la doverebbono distruggere, per miracolo la tengono in piedi. Un mondo veramente, anzi un mondaccio più stravagante del mondo istesso . . . Qui gli uomini son donne e le donne son uomini . . . Voglio dire che quelle hanno cura del governo della casa, e questi si usurpano tutti i lor ricami e tutte le lor pompe. Le dame . . . per esser tenute più belle, . . . si spruzzano le chiome di certa polvere di Zanni, che le fa diventar canute, talché da principio io stimava che tutte fossero vecchie . . . Gli uomini in su le freddure maggiori del verno vanno in camicia. Ma . . . alcuni sotto la camicia portano il farsetto: guardate che nuova foggia d'ipocrisia cortigiana . . .

Hanno per costume d'andar sempre stivalati e speronati; e questa è pure una delle stravaganze notabili, perché tal vi è che non . . . cavalcò in sua vita, e tuttavia va in arnese de cavallerizzo. Né per altra cagione penso io che costoro sian chiamati "galli," se non perché appunto come tanti galletti hanno a tutte l'ore gli sproni a' piedi . . . Ma in quanto a me più tosto che "galli" doverebbono esser detti "papagalli," poiché se ben la maggior parte, quanto alla cappa ed alle calze vestono di scarlatto, sí che paiono tanti cardinali, il resto poi è di più colori che non son le tavolozze de' depintori. Penacchiere lunghe come code di

volpi; e sopra la testa tengono un'altra testa posticcia con capelli contrafatti, et si chiama "parucca" . . . Anch'io per non uscir dall'usanza sono stato constretto a pigliare i medesimi abiti. O Dio, se voi mi vedeste impacciato tra queste spoglie de mamalucco, so che vi darei da ridere per un pezzo . . . Infine tutte le cose qui hanno dell'appontuto, i cappelli, i giubboni, le scarpe, le barbe, i cervelli, infino i tetti delle case. Si possono immaginare stravaganze maggiori? Vanno i cavalieri tutto il giorno et la notte "permenandosi" (così si dice qui l'andare a spasso); e per ogni mosca che passa, le disfide ed i duelli volano. Quel ch'è peggio, usan di chiamar per secondi eziandio coloro che non conoscono (eccovi un'altra stravaganza), et chi non vi va è svergognato per poltrone; onde io tutto mi caco di non avere un giorno ad entrare in steccato per onore e morirmi per minchioneria. Le cerimonie ordinarie tra gli amici son tante ed i complimenti son tali, che per arrivare a saper fare una riverenza, bisogna andare alla scuola della danza ad imparar le capriole, perché ci va un balletto prima che s'incominci a parlare . . .

Circa il resto, per tutto non si vede che giuocchi, conviti, festini, et con balletti e con banchetti continovi si fa gozzoviglia e, come dicono essi, "buona cera." Si fa gran guasto di vino, e per tutti i cantoni ad ogni momento si vede trafficar la bottiglia.

La nobiltà è splendida, ma la plebe è tinta in berettino; bisogna sopra tutto guardasi dalla juria de' signori lacchè, creature anch'esse stravagantissime ed insolenti di sette cotte. Io ho opinione che costoro siano una specie di gente differente dagli altri uomini, verbigrazia come i satiri ed i

*fauni . . . Tutto questo è nulla rispetto alle stravaganze del
clima, che, conformandosi all'umore degli abitanti, non ha
giamai fermezza né stabilità. Le quattro stagioni quattro
volte al giorno scambiano vicende, e perciò fa mestieri che
ciascuno sia fornito di quattro mantelli per potergli muta-
re a ciascun'ora . . . Volete voi altro? Infino il parlar è
pieno di stravaganze. L'oro s'appella "argento." Il far
colazione si dice "digiunare." Le città son dette "ville."
I medici "medicini." I vescovi "vecchi." Le puttane
"garze." I ruffiani "maccheroni" . . . Eccovi fatto un som-
mario delle qualità della terra e delle uzanze di questa
nazione . . . Apparecchiatemi dunque costì in Turino nel
mio ritorno un bel gabbione da pormici dentro; perché, se
non vorrete ch'io vi scusi beffana alla festa di san
Giovanni nella Balloria, vi potrò almeno servire alla fine-
stra per parrochetto, overo sarò buono per essere messo in
piazza il giovedì grasso per passatempo de' putti.*[148]

"I must tell you I am in Paris . . . What shall I say about
this country? I will tell you that it is a world. A world I say,
not so much on account of its size, its people, and its vari-
ety, as because it is remarkable for its extravagance.
Extravagances provide the beauty of the world, for, being
composed of contrasts, it is the combination of these con-
trasts that maintains it. So France too is full of contradic-
tions and disproportions, and these nevertheless combine
to form a concordant discord, which perpetuates it.
Bizarre costumes, terrible rages, constant changes, perpet-
ual civil wars, disorders without rules, extremes without
half-measures, tumults, quarrels, disagreements, and con-

fusions, all these things in short ought to destroy it, yet by some miracle, they keep it upright. Truly this is a world, and indeed an impossible world, even more extravagant than the world itself. Here the men are women and the women men . . . I mean that the women are in charge of running the house and that the men have borrowed all their lace and finery from them. The ladies . . . in order to be thought more beautiful . . . shake on their hair a certain Zanni powder [from Zanni, the comedy character] that makes it turn white, so that at first I thought all the women were old. The men, even in the coldest weather, go about in their shirts. . . . But some of them wear a doublet under their shirt—see what a new kind of courtly hypocrisy there is! They are all in the habit of wearing boots and spurs all the time. And this is one of their signal extravagances, for some of them have never sat on a horse in their lives and yet there they go, wearing the clothes of a horseman. And I think the only reason they are called *galli* [in Italian this meant both Frenchmen and cocks] is because these *galletti* [little roosters] wear spurs on their feet all day. To my mind they should not be called *galli* but *papagalli* [parrots] for although most of them have capes and breeches of scarlet, so that they look like cardinals, for the rest of their costume they use more colors than a painter's palette. Their plumes are as long as foxes' tails and on their heads they wear another false head, with false hair: it is called a *perruque* [wig]. And I myself, so as to observe custom, have been obliged to adopt the same dress. *Dio!* if you could see me prancing about dressed like a pasha, I know I would make you laugh till you cried . . . Then everything here is pointed:

hats, doublets, beards, shoes, brains, and lastly the roofs of the houses. Can one imagine greater extravagance? The gentlemen pass their days and nights "walking out" (what we would call *andare a spasso*) and every time a fly goes past, there are challenges and duels in the air. What is worse, they are in the habit of calling as witnesses people they do not even know (another example of their extravagance) and the man who refuses to turn up is branded a coward. So I am soiling my breeches at the idea that one fine day I might have to enter the lists in the name of honor and will meet my death through foolishness. Ordinary ceremonies between friends are such, and so great the compliments, that in order to learn how to bow, one has to go to dancing school and learn to do *entrechats*, because one has to go through a whole ballet before one can begin to speak . . .

For the rest, there is nothing to be seen but games, invitations, feasts, and on the occasions when there are ballets and constant banquets, there is much eating and what they call here *bonne chère* [a play on words, *buona cera* meant good health]. Wine flows plentifully and in every corner at any moment you will find someone sampling a bottle.

The nobility is splendid but the plebeians are grey in color. One has above all to beware of the fury of messieurs the lackeys, who are also the most extravagant of creatures and diabolically insolent. They seem to me to be of a different race from other men, something like fauns and satyrs . . . And all that is nothing compared to the extravagance of the climate, which, matching the humor of the inhabitants, has no firmness or stability. The four seasons

take it in turns to appear four times a day. So one has to provide oneself with four coats so as to be able to change every hour . . . Shall I go on? Even the language is full of extravagance. Here gold [money] is called silver [*argent*]. To take a meal is to *digiunare* [it meant "to fast" in Italian]; the clothes are called villas [*ville*]; . . . the whores are *garze* [gauze]; ruffians are *maccheroni [maquereaux* perhaps?]. Here is a summary of the qualities of the country and the habits of this nation. So on my return to Turin prepare a handsome great cage to put me in, for if you do not want me to be your *beffana* at the Balloria on St. John's Eve,[149] I can at least be a parrot to be shown in the window, or displayed on the piazza on Mardi Gras to amuse the children."

We now find it easy to believe all the images, the white powdered wigs, the lace and the bright colors of men's costumes. No doubt Marino would have been surprised to be told that this fashion had a long future ahead of it, that it would catch on in Italy, and that it marked the beginning of the influence, not to say grandeur of France.

Rome and the Baroque

The most familiar aspect of this widespread distribution of cultural goods by an Italy generous to excess nevertheless concerns the "mainstream" fine arts: painting, sculpture, and architecture. All these were lavishly distributed from the great center of imperial influence, Rome, which in

its pioneering and championing of the new art played, *mutatis mutandis*, the same role that Paris was to play during and after the Impressionist era, on a world scale. Rome's influence was largely confined to Europe, but some examples were exported to America, where a "colonial Baroque" put down strong roots and came up with some exotic vegetation.

The central role played by Rome is of obvious importance. Rome was the capital of Catholicism, the point of departure for a violent crusade against the Reformation—which had after all fired the first salvo. Behind the Baroque then, there was more than a fashion, a certain sensibility or a particular vision of life and of the world. This was a civilization rising up in anger, and using every weapon that came to hand, since religious life, in its struggle against the enemy, had enlisted the whole of cultural life on its side.

All artists went to Rome. Italians came from every region of Italy, to join Frenchmen, Dutchmen, Flemings, Spaniards (though these often preferred Naples), and Germans. Among the foreign arrivals were, for instance, Rubens, Valentin, Poussin, and Claude Lorrain (1600–1682), who first made the trip to Rome with one of his relations, a lace merchant. And there were many more. Once they got to Italy, they were often given pseudonyms. Nicolas Cordier from Lorraine, a sculptor, became Il Franciosino; the Dutchman Gerrit van Honthorst, Gherardo delle Notti, because of his paintings of nocturnal scenes with stark contrasts between light and dark. Joachim von Sandrart describes at length in his *Teutsche Akademie* the doings of the large colony of German painters. Many of

these foreigners "allowed themselves to be captured by the fascination of the ancient city, at the risk of growing old alone there, [since they were] neither Italians nor any longer of another nationality,"[150] for these journeyings came at a time when, for an artist, his home was where his work was or wherever he preferred to live.

The fascination arose from friendships struck up between colleagues, from the ease with which one could find employment, but also from the pleasures and habits of a milieu whose feverish atmosphere reminds us of Montmartre or Montparnasse in the days of Utrillo and Modigliani. It was a strange and not always happy world. Borromini, Bernini's rival, killed himself in 1667; Valentin (1591–1634), a native of Coulommiers, drank himself to death; the Lucchese Pietro Testa (1607 or 1611–1650) threw himself into the Tiber. A curious bohemianism, both local and foreign, seems to have been the rule. It even created an original kind of painting, which had repercussions elsewhere. In 1625, Peter van Laer, a painter from the studios of Haarlem, arrived in Rome and joined a group of northerners who were living a merry life on the fringes of serious and academic painting. Presumably he carried a certain weight among his new friends, since his nickname, Il Bamboccio, became the name by which the whole group was known. Not long after his arrival, at any rate, the *Bamboccianti* began to sell little pictures of their own in shops and even in fairs. These *quadri a passo ridotto* depicted in the Dutch manner familiar scenes from life, beggars at the church porch, street and market scenes, peasants carrying out their rural tasks. It was in this vein

that Herman van Swanewelt painted his *Campo vaccino*, the great cattle fair which in those days was held in the old forum.

This preference for popular realism contrasted sharply with the grand Italian painting of the time, and local artists were scathing in their sarcasm and dismissal of this vulgar form of art. As was remarked by Giovanni Battista Passeri (1610–1679), a painter and biographer of painters, it was simply a *finestra aperta*, an open window on to everyday life, and had nothing to do with Beauty. Nevertheless, this mode of painting, which was much appreciated in Spanish circles in Rome, even at the embassy, seems to have had some influence on Velázquez, who admired it when he passed through Rome in 1630, and possibly also on Le Nain at about the same time. It must surely have played some part in the development of Italian landscape painting; and we know that it found loyal customers since twenty years later, in the mid-seventeenth century, Andrea Sacchi and Albani were still complaining about the decadence of painting brought about by realism.[151] So even in the days when the Roman academies enjoyed unrivaled prestige, the "bipolarization" of European art, the double presence of north and south, was able to gain a footing and maintain itself in the exclusive capital of the Italian Baroque.

For all that, it was in the end the Italians who dictated what happened—and what *changed*, in this passionate and strained world. The Italian painters, who formed the great majority of the artistic workers showered with requests and commissions, only rarely these days came from Florence. The Caracci and their followers, "a mafia of fellow coun-

trymen as much as a school of painters,"[152] Domenichino, Albani, and Guido Reni all came from Bologna. Francesco Borromini and later Carlo Fontana were from Lombardy; Caravaggio bore the name of his native village near Bergamo; Bernini, the architect of the Barberini and St. Peter's, was a Neapolitan; Carlo Maderno was born in Switzerland. So it is hardly surprising that Piero da Cortone, one of the very few Tuscans then working in Rome, should seem very unlike a Florentine to a historian such as Yves Bonnefoy. Did the arrival of all these varied and even cosmopolitan recruits (since they included foreigners of renown) explain the end of Florence's predominance in the art world, as there grew up a generation less learned, less intellectual, less rational perhaps, but a little closer to the reality of everyday life? It is not impossible. But art has to be paid for, and artists go where the work is. The dialogue between the artist and the patron who gave him a commission remained the alpha and omega of the trade.

And from now on, the art patron *par excellence*, far outdoing wealthy aristocrats and more often than not princes too, was the Church. Since the Council of Trent, the Church had resolutely gone on the offensive: in victory, the Church sought to hold on to her gains. The rectangular churches which were now being built, on the model of the ancient basilicas, were weapons in a bitter struggle. They enabled all the worshippers to see the high altar, to hear the voice of the preacher (from the pulpit which was located in the middle of one of the long sides), and to follow the Mass reading their missals, for these churches without stained

glass were lit by a flood of white light, especially from the high windows of the cupola. They were also flooded with music, but the musicians and choir were hidden from view in galleries, so as not to distract the faithful. Only the organ, whose design became fixed between 1580 and 1640, was visible, with its enormous case and long pipes. On walls and ceilings, frescos, painted in a style designed to tug at the emotions, stressed the cult of the saints, the triumph of the Virgin Mary, and the beauties of Paradise. Everything was calculated. These churches were like theaters with a didactic aim. They were magnificent dwellings—after all they were the dwelling place of God for whom nothing was too good—but at the same time they were a statement of the splendor of the south, compared with the mean-spirited poverty of the north. Wherever we see the domes and symmetrical façades of these innumerable baroque churches, we know without being told that the prince or the Church, or both together, ruled here.

The great dates of the Baroque, forming so to speak its epicenter in Rome, correspond to the pontificates in particular of Urban VIII (1623–1644)—"the last of the great Popes"—Innocent X (1644–1655), and Alexander VII (1655–1667). The earthquake that sent tremors all over Europe essentially corresponded to the building of St. Peter's and the countless other churches in the city, mostly the work of the two bitter rivals, Bernini (1598–1680) and Borromini (1599–1667). We need not enter into the detail of their fruitful rivalry, which is often cited in historical explanations. The interesting thing is how Rome became transformed into the capital of an immense spiritual empire,

just as Madrid in the days of Lope de Vega attracted all the glories of the Golden Age, and became the capital of an empire on which the sun never set. The Baroque felt at home in empires: it had been imperial from birth.

Bernini Arrives in Paris Too Late

But what is of special interest to us at this point in our history is the way in which the Baroque reached the various regions of Europe, encountering a different history every time with its particular dates and local coloring. There are visible time-lags between the Italian Baroque *intra muros* and the various Baroques outside Italy. It is of course true, let me repeat, that the same causes could perfectly well produce the same effect and the foreign examples of the Baroque could have arisen of their own accord on distant soil. But they reflected back an image in which Italy is entitled to recognize itself, or rather to recognize by turns its architecture, literary thought, and most of all its painting, bearing the unmistakable stamp of Caravaggio. "Caravaggism" took Europe by storm, with its now familiar attributes: violent scenes, pathetic naturalism, and *chiaroscuro* effects, opposing night and day, God and the devil. It became such a structural feature of European art (even in the Protestant United Provinces) that it was possible to "conceive of a Caravaggism without Caravaggio, springing up at the opportune moment, so well prepared had the ground long been to receive it.[153]

All the same, imitations can be tracked to source, and

the distant mirrors—France, Spain, central Europe—all reflected images and models familiar in Italy; there was a network of similarities, even when the reflected image displayed different contours or colors.

Spain, to be sure, was too powerfully and exclusively independent to be docile, even if it had tried to be. The Escorial, built by Philip II and his architect Juan de Herrera (1530–1597), was classical in its deliberate austerity. And since Herrera had followers, he imposed a sort of "penance," as Pierre Lavedan has written,[154] of which the major landmarks are the Church of the Incarnation in Madrid (1611–1616) and the Jesuit College at Salamanca (from 1617), both by Juan Gomez de Mora. It was not until 1617, with the arrival of the Italian Crescenzi, that the Roman Baroque reached Madrid. Between 1622 and 1626, the Jesuit father Marciano F. Bautista began to build the Jesuit church in Madrid on the model of the Gesù in Rome (it is today the Cathedral of San Isidro el Real).

If we jump to the end of the century, to consider the most famous of the three Churriguera brothers, José (1665–1725), "at once an El Greco and a Góngora," according to his admirer Eugenio d'Ors, we find a form of national development going beyond the Baroque. "Churriguerism" attracted tremendous popular enthusiasm, intoxicating itself with its own appeal. Similarly the Spanish theatre of the Golden Age no longer had anything, to do with the *commedia dell'arte.* Where could we put Cervantes if we were charting influences? He is unclassifiable. And how would one classify Velázquez (1599–1660), who was more Italianized *before* his first visit

to Italy in 1629–1631 than he was afterwards? In José Ribera (1588–1656) we would have an example of Italianism almost too good to be true, but Il Espagnoleto, as he was known, adopted Italy as his second homeland. He had closely studied the work of Correggio, in Parma, had fallen head over heels in love with the luminism of Caravaggio, and spent most of his life in Naples, where he died. So the best example might still be Francesco de Zurbarán (1598–1664): he never left Spain but, during his apprenticeship in Seville between 1613 and 1616, he encountered the Sevillian *"tenebrismo."* In the eighteenth century, he had the reputation of having been "the Spanish Caravaggio" although this firm typecasting does not entirely account for an *œuvre* that changed a good deal in the course of a life itself subject to change.

Turning from Spain, an ambiguous case, to France, where the problems are clearer, though not necessarily resolved, we find that France, which was open to every European influence, and which welcomed the literary Baroque of both Italian and Spanish inspiration, was no less receptive to painting. A foreigner visiting Paris during the reign of Louis XIII would have had the overwhelming impression of an all-invading Baroque, "for everything that had been devised for the occasional or the temporary, decorations for festivals, processions, and funerals . . . was unquestionably baroque, as we can see from contemporary engravings: showing pyramids of symbols piled on triumphal arches, or theatrical catafalques intended to impress mourners. The Church readily drew on these effects in its liturgy, processions, and worship, and they

eventually became immortalized in altarpieces."[155] But all the ephemeral displays were, of course, swept away by the wind of history and the essential monuments surviving today to bear witness to the age—the Luxembourg Palace, the Sorbonne, the Val-de-Grace—are examples of a much toned-down Baroque, verging on the classical, with echoes of the Renaissance. The placid and regular Place Royale (today Place de la Concorde) of the reign of Henri IV, with its stone, brick, and slate, is already speaking another language, that of a kind of classicism, influenced by Flanders—though the arcades surrounding it are suggestive of Italy.

Does that give us a *terminus a quo?*—the death of Henri IV? The architectural Baroque would in that case begin only in about 1610, and we would be on the way to narrowing down the duration of the true French Baroque in architecture as in the case of literature. In 1613, the Carmelite Eglise des Carmes was built on a rectangular plan. Later landmarks, in Paris, were the Oratoire (1621), the Jesuit Saint-Paul-Saint-Louis (1627), and Notre-Dame-des-Victoires (1629). And the *terminus ad quem* might just be the building of the "second" Versailles by Le Vau in 1668–1678, clearly under Italian influence. Not everyone agrees about that: some experts[156] think that there was a change, a shift in style about 1635, a date also remarked by literary specialists. From then on in France they suggest there began to take over that "desire for sobriety, the rule of 'nothing to excess,' that restraint in expression," known as Classicism, whose praises French historians are all too inclined to sing. But what no one can tell us is the underly-

ing reason for the classical takeover, a process that was slow and not at all clear. After all the Baroque did not melt away overnight.

If we turn to painting for clarification, the result may be equally disappointing and would lead us (if the experts, who are inclined to be nationalist, are correct) to a similar chronological shrinking of the baroque years. The first witness, hardly an arbitrary choice, must be Georges de la Tour (1593–1652). He was probably about twenty when, like so many others, he traveled to Italy; there he saw the paintings of Caravaggio, who had died tragically a few years earlier in 1610. He probably benefited from Caravaggio's teachings via Guido, but that did not prevent him from joining the *tenebrosi* of the north, the Honthorst school, which also issued directly from Rome. Thus this painter from Lorraine was influenced both directly and indirectly by Italy. And he reinterpreted the *chiaroscuro* for others. So he is perhaps the earliest example; alongside him one might perhaps set the Le Nain brothers. The latest French example, though this selection is certainly debatable and open to challenge, could be Philippe de Champaigne (1602–1674). A native of Brussels, and "originally under the spell of Rubens," he was summoned to Paris at the age of nineteen to take part in the decoration of the Luxembourg Palace. "The French capital," we are told, "weaned him away from the Baroque."[157] But it was not quite as simple as that. The question of Philippe de Champaigne's "classicism" has been open to debate. Between 1643 and 1648, when he was about forty, Champaigne made contact with Port-

Royal. Behind the motionless light and silent faces of his canvases there is an internal drama.[158] Andreina Griseri, writing before Louis Marin (1970) and feeling, like him, that this painter was "a challenge to Classicism," argues the point strongly: "Baroque, too, is that tension to be sensed in the paintings of Philippe de Champaigne, that exaltation of a rigor intended to be completely internal."[159] In this sense we may agree—but then should one also claim Racine for the Baroque? What seems clear is that there is a fundamental difference between this form of the Baroque—if that is what it is—and that of the Italian school of Rome of the same period. A certain kind of Classicism—whatever name one gives it—seems to have appealed early on to the French painters, even to those who lived in Rome. Poussin was only thirty-six when, after a few works that put him firmly among the Roman practitioners of the new style, to the enthusiastic applause of Bernini (in particular for the *Martyrdom of St. Suzanne*), he went off to engage in a personal direction, quite free from other influence. This freedom, which he owed to the material independence provided for him by his patron Cassiano del Pozzo, led Poussin to opt for a certain order and rationality, to abandon the frantic convulsions of the Baroque, and to refuse an excess of expressivity. Or rather the expression changed its object. It was Poussin who wrote, very much in the spirit of Descartes's *Treatise on the Passions* (1644), "The subject is yourself." Another French painter isolated in the art world of Rome was Claude Lorrain, who went off for days on end from dawn to dusk into the Roman *campagna*,

becoming an obsessive pursuer after light. How are we to classify him?

To close this unsuccessful attempt to define chronological frontiers with a well-known event, let us take Bernini's visit to France. Summoned by Louis XIV in May 1665 to draw up plans for the eastern façade of the Louvre, the "sovereign of the art" arrived with the firm intention of proposing a design "that will aim straight at the exceptional." "I won't hear of anything on a small scale!" he explained to the King at their first meeting. But the old man (now sixty-seven years old) had arrived too late by French time. He would never build the most baroque palace he had ever imagined. A classical solution was chosen rather than his.[160]

The Venetian Baroque

It was in the north-northeast sector of Europe that Italian influence was more pervasive and longer-lasting than anywhere else. As much as, or more than Rome, Venice was the source of this wave of influence—Venice, the home of that exemplary and original artisan of the Baroque, a contemporary of Bernini and Borromini, but one who remained faithful all his life to the city of St. Mark: Baldassare Longhena (1598–1662). A pupil of Scamozzi, he had worked alongside him on the building of the Procuratie Nuove and finished them after his master's death. His masterpiece was the church of Sta Maria della Salute, which he began building in 1632, shortly after the

outbreak of plague of 1629. This admirable monument was as much an influence in its way as St. Peter's in Rome. But note the dates: it was roughly a hundred years later, between 1716 and 1723, that Johann Bernhard Fischer von Erlach built in Vienna the votive church of St. Charles Borromeo, the Karlskirche, which looks far more like the Salute than the Roman style of church. In that city of cities of the Baroque—Prague—where the Baroque is in the house fronts or the tiled roofs one looks down on from the old town, the early days were marked by the arrival of numerous architects, sculptors, painters, and masons from Italy. The superb Wallenstein Palace, at the end of the Mala Strana, was built between 1625 and 1629: a vast and strange palace, deserted almost as soon as it was completed, when Wallenstein died. In fact, from the outside it seems to be Renaissance in inspiration, but the internal decoration, the great banquet hall, the frescos, lunettes, stuccoes, and scallop-shell niches are all unquestionably inspired by the new Italian style. But perhaps the clearest example was the even more extravagant and even more authentically baroque palace built between 1669 and 1687 for Count Cernin at Hradčany. Thus the chronology inexorably brings us to the last third of the seventeenth century and could easily take us into the eighteenth, in this special zone of Europe, from Rome to Vilnius in Lithuania, taking in the Alps in a great curved sweep.[161] This was not only the zone of baroque influence *par excellence*, but also the one in which the sights and sounds of Italy were best reflected.

Do these dates, roughly centered on the 1660s, have any significance in themselves? The reader may have guessed

that we are returning by a roundabout route to the switch-back curves of the *conjoncture*, the economic trend, which are always available as a source of explanation. One's first impulse, no doubt rightly, is to mistrust them. But one has to admit that the facts are there: a new depression began to loom from the middle of the century, compounding the gloomy atmosphere of the preceding years. The result once more was the return of peace: in 1648 and 1659, major wars came to an end and would not erupt again until the bitter conflict of the Augsburg League (1684–1697). Once more we have the usual contrast: war comes to an end; the economic climate deteriorates; but culture and peaceful expenditure enter a phase of expansion. The thesis that has accompanied us throughout our travels seems to be serving as well as ever.

But can we really be sure? It is too easy to put words into the mouths of people who did not think of recording their thoughts for future historians. But perhaps one is allowed occasionally to imagine them. In 1660, Barelli began building the Church of the Theatines in Munich; Carlo Carloni, from the Ticino, began work in 1663 on the Church of the Nine Angelic Choirs in Vienna; and in 1701–1703 Fra Andrea Pozzo started work on the University Church, also in Vienna. Here were three Italians in charge of major building projects outside Italy. They would surely have been very surprised to be told that Italy—their different Italies—was already on the path towards inexorable decline. Just as surprised as I would have been in 1935, when I was teaching at the University of São Paulo in Brazil, alongside my colleagues

the mathematician Fantappié from Bologna University, the poet Ungaretti, and the anthropologist Claude Lévi-Strauss: if someone had asked us a question about the decline of Europe or of France, we should no doubt have smiled disbelievingly.

Science, a Misleading Yardstick?

Throughout Europe, the turn from the sixteenth to the seventeenth century represented a critical moment; some people have called it "the birth of modern science"; others describe it as the "scientific Renaissance." The latter expression may seem debatable and possibly confusing, but there was in fact a "renaissance," since the invention of printing had made available, belatedly but effectively, the pioneering thought of Archimedes and of Appolonios of Rhodes (on conics), and this contribution was decisive. One thinks of the times Leonardo da Vinci tried in vain to get hold of one of Archimedes's manuscripts. Such publications made it easier for science to get off on a new footing.

It is probably improper to make a distinction, during these critical years at the very beginning of the long career of modern science, between *pure* and *applied* science, in other words between science and technology. The miraculous rendezvous between science and technology would take place only in the future; for the "practical knowledge of the artisan" would only very slowly combine with the abstract thought of scholars—or "logicians" as they were sometimes

called by the men whom we should probably describe as the technicians of the period (such as the English Robert Norman, a former navigator and compass-maker, who published his book, *The New Attraction*, in 1581). Modern science would pursue a path between these two basic poles.

This was already the position of the pioneering thinker Francis Bacon (1561–1626), the "Christopher Columbus of philosophy"; here philosophy really meant science, or natural philosophy. In his *De dignitate et augmentis scientiarum* (1605), *Instauratio magna*, and the *Novum organum* (1620), Bacon recommended experiment and observation before any attempt at logical interpretation. He therefore "very clearly perceived the status of modern science. It was a question of apprehending the concrete in order to apply correct theories to it."[162]

In all these disciplines—pure science, technology, experimental or empirical science—Italy in no way lagged behind the rest of Europe. During this key period when science needed "a bold pioneer, one who dared to advance on shaky ground, with unlimited confidence in his own intuition." [163] Italy promptly produced the fantastic work of Galileo. If there was a balance in these matters, at this point it came down heavily on the Italian side.

According to Alexandre Koyré, modern physics "was born with and in the works of Galileo Galilei, and brought to completion in those of Albert Einstein."[164] Galileo was a thinker whose work powerfully anticipated the future. "Without Galileo, there would have been no Newton, and it is hardly paradoxical to say that without

Newton there would have been no Galileo."[165] Galileo's principle of relativity must surely be regarded as a first step on the path later taken by Einstein. Einstein himself was well aware of this: his enthusiasm is evident in the preface he wrote to his *Dialogue Concerning the Two Chief World Systems*; indeed he says that he is in danger of exaggerating and giving a superhuman image of his hero, so great is his fascination with him.[166] Looking resolutely into the future, Galileo came very close to making discoveries that came to light later. I am inclined to agree with Umberto Forti[167] (as opposed to Alexandre Koyré) that Galileo understood, and analyzed, if he did not perfectly formulate it, the principle of inertia, and that he came very close to discovering universal gravitation and the infinitesimal calculus that would have completed his explanation of the world.

Historians have also looked in the other direction, working backwards to discover his debts to writers of the immediate and distant past, in order to situate his work. And indeed Galileo's thought pursued its careful course by examining the explanations, errors, and hypotheses of previous thinkers, for until the end of his life, Galileo seemed to be patiently and slowly following in the footsteps of his own genius. It is true that he failed to make good use of the work of Kepler; on the other hand, very early on, when he was still teaching the works of Aristotle and Ptolemy, and even before his famous letter to Kepler in 1597, he had accepted Copernicus's theory of heliocentrism, taking it as a hypothesis of which he patiently set out to discover the many consequences. He also made use of "all the methods imagined since the fourteenth century [by the philosophers

of Oxford and Paris, including the great Nicolas Oresme]
to discover the spatial and temporal properties of
motion."[168] He also went as far back as the mathematics
and hydrostatics of Archimedes. And it would be unfair to
leave Aristotle out of the list: it was after all the Aristotelian
explanation of the world that Galileo set out to demolish
and the close attention he therefore accorded to that expla-
nation makes it in a sense a component and determinant of
his own work.

For Galileo, the great problem was the identification,
once and for all, of the earth not as a fixed point in the
center of the universe, but as a moving body, floating
within the celestial world that surrounded it. Of the two
worlds distinguished by Aristotle—one our own, imper-
fect and subject to corruption, the other perfect, divine,
and heavenly—he sought to make a single one. The work
of Kepler (1571–1630) would have helped him if Galileo
had not been so allergic to the Pythagorean and mystical
thought of his contemporary, who was possibly the great-
est thinker of his age. But the mass of Kepler's writings
could itself conceal their astonishing potential. Galileo
was much hampered by his failure to consider the theory
of elliptical orbits devised by the German scientist, as well
as Kepler's theory of the tides, which was far superior to
Galileo's own. No doubt "the individual creator is often
lacking in receptivity" as Einstein suggested, pleading
extenuating circumstances on Galileo's behalf. Moreover,
Kepler did not have a very satisfactory answer to the ques-
tion that haunted Galileo: that of the unity of the universe.
His *Physica coelestis* of 1609 in theory brought the heavens

within the laws of terrestrial physics—but only in theory. He continued to believe that motion and repose were opposites, "like light and darkness," and even that "repose was ontologically at a higher level than movement." These were odd hesitations for the exceptional man who had written *"ubi materia, ibi geometria,"* who discovered the scientific meaning of the term *inertia*, but who could nonetheless never completely rid his mind of the old formulae for the explanation of the cosmos. "The medieval world still refused to die";[169] to deny that world was no doubt a difficult step to take. But that left the way clear for a more free-thinking mind. After the publication of Galileo's *Nunzio Sidereo* (1610), Kepler, who verified for himself the existence of the moons of Jupiter that it announced, exclaimed: *"Vicisti, Galilee!"* "You have won, Galileo."

It was Galileo's revolutionary explanation of the world that was to cause his problems. An infinitely geometrical world, in which all motion is eternally prolonged unless it encounters an obstacle, amounted to blasphemy. One of Galileo's most loyal disciples, Benedetto Castelli (1577–1644) became anxious: *"Conciosiachè se fusse vero che il moto fusse eterno, io potrei diventar ateista; e dire che di Dio non avevo bisogno,"* "Given that if it were true that motion is eternal, I might become an atheist and say that I had no more need of God."[170]

Was Galileo's explanation an opinion or a demonstration? It seems more likely to have been an opinion, and Father Lenoble has pointed out how much it owed to intuition and imagination in the early stages. Galileo chose to make an extremely audacious wager. When in 1623 he

wrote that "Nature is written in mathematical language," he had not yet put together his observations of falling bodies. "Satisfactory formulae" date only from the *Dialogue on the Two Great World Systems* of 1632. But that did not stop him pursuing his idea. "For thought, pure and unalloyed, rather than experiment and the perception of the senses underlies the 'new science' of Galileo Galilei."[171] When, in the *Dialogue*, his Aristotelian adversary puts to him the question, "Have you carried out an experiment?", he himself replies, "No and I do not need to. And I can declare without any experiment that it is so, because it cannot be otherwise."

One evening toward the end of his life, Galileo was at Arcetri, depressed and virtually under house arrest. With him was Vincenzo Viviani (1622–1703), at the time a lad of not yet sixteen. Galileo was explaining to him the laws of accelerated motion when the boy suddenly said, "Yes, but you have not demonstrated that mathematically." The objection must have struck home. The old man did not sleep that night, and in the morning he had found the demonstration, which would appear in the later editions of his *Discourses Concerning Two New Sciences* (1638), his last and finest work. Viviani was no doubt thinking of this incident when years later, on August 20, 1659, long after the death of Galileo, he wrote to Prince Leopoldo de' Medici and told him the famous anecdote of the young Galileo, in 1583 when he was not yet twenty, seeing the lamp swinging in Pisa Cathedral as a sort of experimental pendulum. Speaking once more of motion, Viviani added that "our great Galileo was the first to subject it to the strictest laws of

divine geometry" (*"seppe il primo sottoporlo alle stretissime leggi della divina geometria"*).[172] I would underline the last two words, and if I insist on geometrization, that is because it lies at the heart of the debate. "The transformation of physical problems into mathematical problems . . . is the true task of natural philosophy; this entails a certain number of requirements," at the very least "a kind of conceptualization that is able, without deforming them, to render natural phenomena homogenous in the face of mathematical reasoning." But that mathematical reasoning is itself a toolkit: either one possesses it or one does not. Galileo himself was hampered on one occasion because he did not have a correct theory of centrifugal force, another time because he did not have the theorem eventually formulated by Bernoulli in 1696, and so on.[173]

But our purpose is not to dwell on this remarkable man's thought, overturning as it did the ancient conception of the world. Our problem is to situate it. It precedes Descartes and it precedes Newton. The discovery of a single infinite geometrical universe, including both heaven and earth, was Galileo's achievement. The others, great though they were, were following the trail he had blazed. But it is only comparatively recently that he has received his due. "To English-speaking historians," writes Louis Rougier, "the father of modern thought is Bacon; to the French it is Descartes. But Galileo preceded, completed, and surpassed them. Bacon saw only the role of experiment in scientific procedure; Descartes saw only mathematical deduction; Galileo combined mathematics and experiment to found the quantitative science of the Moderns. Yet the

Baconian prejudice and the Cartesian prejudice remain so powerful that, with the exception of the *Mécaniques de Galilée* translated by Father Mersenne, there is no French edition of his major works, which is quite scandalous . . . It is as if the condemnation of 1633 has lasted down the years, banning the man without whom our civilization would not be what it is."[174]

Galileo was not only a leading thinker in theoretical research, he was also fully up-to-date with experimental science. He describes in *Nunzio Sidereo* and also in *Il Saggiatore* how on hearing in Venice that a Dutchman had invented a spyglass "with which things appeared closer," "the next day I made the instrument and I told them about it in Venice . . . Then I took pains to make one more perfect," which he exhibited to friends and visitors for a month.

But the important thing, as everyone knows, is what he did with the instrument we still call "Galileo's" telescope. To discover that there were mountains on the moon and spots on the sun was to destroy myths, proving that the heavenly bodies were no more perfect than the earth! The idea of the sunspots in particular seemed like sacrilege. Could there be for an Aristotelian "a more erroneous notion than that there should be a blemish on the eye of the world, which God had created to light up the universe"?[175] Accordingly, Galileo's colleague at the university of Padua, Cesare Cremonini (1550–1631), although a man of independent mind, refused, as a good Aristotelian, even to look through the diabolical spyglass. There is little purpose in retrospective superiority on our part, rather we should give

a smile of recognition: we are well acquainted in our own time with fierce conflict between the "new" and the "old" mathematics—or the new and old schools of history for that matter.

We need not dwell on the debates of the time. Here I wish simply to point out the importance of experiment and technology in Galileo's life, and thus indicate how his work extended into this important domain. He was, for instance, responsible for a patent for bringing water uphill (1593)— a machine that was tested in 1604; for the construction of a thermoscope, the forerunner of the thermometer (1606); for a study of the motion of projectiles in 1609 (remember that he visited the Arsenal in Venice); for observations made with the aid of a simple microscope (1614); and for a study of the tides (1614). He had been an adviser to the Grand Duke in Florence, whenever his engineers encountered difficulties. And it would surely be wrong to fail to mention alongside his own work that of his disciples, who continued to make paths of light through the dark night that is supposed to have engulfed Italy during the seventeenth century, sometime after Galileo's own trial and sentencing in 1633, and especially after his death in 1642.

The greatest of his pupils and friends was perhaps the Jesuit, Francesco Buonaventura Cavalieri (1598–1647), who was responsible for the diffusion in Italy of the principles of trigonometry and calculation by logarithm, and who with his theory of indivisibles was verging on the miraculous terrain of infinitesimal calculus. The best-known of his pupils was perhaps Evangelista Torricelli (1608–1647) who in his brief lifetime dabbled in everything,

from the flooding of the Arno to the problems of the fountain makers in Florence (hence his measurements of atmospheric pressure), from the parabolic trajectories of ballistic weapons to the properties of that curve that was for a while the infuriating center of research and disagreement in the scientific world: the cycloid. And the most curious of them was Vincenzo Viviani, who in his long life achieved many successes, both in research and in popularization (for instance in conics). In 1667, he was invited to Paris by Colbert, who was trying to attract the best astronomers and scientists at the time when the future Observatory was being built, and a year after the creation of the *Académie des Sciences*. Viviani, who could bask in the glory of having been the pupil of both Torricelli and Galileo, and who was the most celebrated member of the *Accademia del Cimento*, was approached at the same time as Huygens, Leibnitz, and Newton—an honor that indicates the continued influence of Italy in European scientific circles.

In the event, Viviani refused the French invitation, and it was transferred to another Italian, Gian Domenico Cassini, who had been born in Nice in 1625. A professor at Bologna, Cassini agreed to go after first visiting Viviani in Florence and attending a meeting of the *Accademia del Cimento*. He arrived in Paris on April 4, 1669, and was introduced to Louis XIV on April 6. (He immediately threw the plans for the Observatory into disarray.)

Where are the signs of Italian decadence in all this? Hardly visible, any more than they had been twenty years earlier, in 1644, when Father Mersenne wrote his important

Magni Galilei et nostrorum geometrarum Elogium utile, which goes beyond Galileo's own extraordinary case: *"Taceo* (a conventional formula] *etiam subtilem Bonaventurae Cavallieri Geometriam per indivisibilia; praeclarosque tractatus ab acutissimo Tauricello Galilaei successore brevi speramus,"* "I will say nothing about the subtle geometry of indivisibles of Buonaventura Cavalieri; and we shortly expect the eminent treatises of Torricelli, the penetrating successor of Galileo." The two pupils were thus associated with their master. One would like to quote everything from this *Praise of Galileo* and of his astronomical discoveries by the remarkable Father Mersenne, who was an ideal intermediary between scientists all over Europe. I particularly like his highly colored images, reminiscent of Rimbaud: Jupiter, "orange-red or tawny, Mars as black as earth, the Moon reddish-tinted, Venus very white, and Mercury tinged with blue." Alongside the planets, "the solar disc . . . very bright in the center, its light verging on silver, and its rim surrounded by a less bright corona about a quarter of its radius wide, reddish or rather fiery in color."[176] One hopes Galileo saw the heavens in these colors through his telescope.

In short, without wishing to underestimate the acute tragedy for science represented by the trial of 1633, about which I shall have more to say, I cannot believe that Italian science and technology were immediately plunged into darkness. In the short term, it is simply not true. Neither science nor technology faded away overnight. In the crucial area of technology, Italy continued to export its engineers, who were probably the best of their time. They were to be found at

work during the great siege of Antwerp in 1585, under the command of Alessandro Farnese, and at the equally large-scale siege of La Rochelle by Richelieu in 1628; they were still being employed in Vauban's time.[177] What was more, Italian treatises on machines were the finest in the world and often remained in use until the eighteenth century; examples are the works of Agostino Ramelli (published in Paris in 1588), Fausto Veranzio (1617), Vittorio Zonca *(Novo Teatro di machine et edificii,* Padua, 1624) and Benedetto Castelli *(Delle Misure dell'Acque correnti,* 1628).

Umberto Forti, the well-known expert on the history of science and technology, has recently re-edited the *Nuove Macchine* [178] by Fausto Veranzio—a remarkable character, a humanist who wrote on every subject, amazingly intelligent and fascinated by all mechanical problems such as automatic milling, the various types of wind and water mills, even mills using tidal power. It is a pleasure to discover the ingenious processes the author proposes in this mechanical wonderland.

Finally, one should mention the pioneering activity of the *Accademia del Cimento*. It had been formed in 1651, though the official date of its foundation was 1657. The Grand Duke Ferdinand de' Medici and his brother Leopoldo had had a laboratory built for their research scientists: the anatomist Borelli, the embryologist Redi, the anatomist and mineralogist Steno, and the astronomer Domenico Cassini all worked there. The experiments carried out by the *Accademia* were largely concerned with measuring temperature and atmospheric pressure, ballistics, the speed of sound and light, fluids, and the freezing

point of water. But the *Accademia* was short-lived: in 1667, it was dissolved. Since this coincided with the moment when the Grand Duke's brother Leopoldo was elevated to cardinal, it was rumored that the disbanding of the *Accademia* was the price for his cardinal's hat; it is not impossible. Certainly, one of the members of the suppressed *Accademia*, Antonio Oliva, was arrested by the Inquisition in Rome: in order to avoid torture, he killed himself by jumping out of his prison window, one more sinister event in line with Galileo's trial in 1633. But to look on the positive side, proof of the scientific value of this Florentine "Academy of Science" was provided by the success of the *Saggi di naturali esperienze fatte nell'Accademia del Cimento* published by Magalotti in 1667. These summaries were translated into English (1684), and into Latin (1731) for Dutch readers. A French edition appeared in 1755. Was this, as Georges Gusdorf called it, "the swan song of Italian science"? [179]

Possibly; in the life of a society, everything may stand or fall together. However—and this is the meaning behind the title of this section—we cannot view the scientific explorations of the past in terms of those of today. Today, science and scientific research have become major indicators of levels of economic development. Every nation has to show signs of excellence in these areas. In Galileo's day, the important of science had not been carried to such a pitch. It could not be a yardstick of truth, but was simply one index among others; and, in the Italian case, by no means a negative one.

Until now, we have been looking systematically, and to some extent sympathetically, for evidence of the vitality of Italy and Italian influence between 1450 and 1650. We have now to consider the darker side of the picture. It is undeniably there, although I do not regard it as having advanced so far as to plunge the whole of the canvas into shadow by about 1633 or 1650. In this respect, I am at odds with virtually every other historian. But history is all too often rewritten after the event. The obsessive image of *decadence* creates a smokescreen of false problems between today's observer and the reality of the mid-seventeenth century. Now that we have embarked on this murky debate, we shall have to find a way through it.

Was Italian decadence really a case of "moral decadence, weakness, egotism, and error," words quoted by Benedetto Croce, who was unwilling to accept them?[180] This pessimistic view seemed to him partly attributable to the Italian historians of the Risorgimento, who had a tendency deliberately to underestimate and blacken the centuries of political division and impotence before Italy was unified. But, to borrow another phrase from our illustrious guide, the old Italy of the past, *"sarrebbe morta, ed ella non*

mori," "it was supposed to be dead, but it did not die."[181] And indeed in about 1670, it started to come back to life and recover ground. Already it was showing signs, two hundred years in advance, of the true Risorgimento. But that is to look too far ahead. It would indeed be paradoxical to claim that the clearly visible decadence of Italy could be reduced to a few difficult decades. The phenomenon was on a larger scale. The general movement of progress in the eighteenth century, affecting all Europe, had a much less obvious impact on Italy, which lagged behind. And that is probably the real problem.

Is Georges Gusdorf Right?

I do not think one can accept all the conclusions of Georges Gusdorf's fine and categorical book *La Révolution galiléenne,* convincing though it is on first or even second reading. After all who would quarrel with the proposition that the destiny of a people does not depend on economic factors alone? There are also cultural factors. Gusdorf writes: "We are today so convinced that the determining factors in historical evolution are of an economic and social order that we hesitate to admit that cultural processes may have cultural causes."[182] I recognize the thrust of his protest and would agree with it, if only the last words could read "may have cultural *as well as other* causes."

For this apparently unexceptionable and sensible remark has a radical import that the context of the book immediately indicates: for Gusdorf, Italian "decadence" is

in fact an almost entirely cultural process, with both the symptoms and the causes of decadence being strictly cultural: the Council of Trent (1545–1563); the creation of the Index by Paul IV in 1557; the posthumous trial in 1616 of Copernicus (who had died in 1543); and the trial and sentencing in 1633 of Galileo (who would no doubt have received a heavier sentence had he not been protected by the Medici). Religious intolerance, he argues, was gradually stifling all scientific thought—and indeed any other form of thought. Italy, lying at the heart of the Counter-Reformation, was paying heavily, in terms of backlash, for the great success achieved, with the aid of Spain, in the effort to re-Catholicize Europe, in that reconquest advancing toward the Rhine and Danube frontiers, the old *limes* within which Rome was once more reasserting its rights. In this violent ideological struggle, Rome, and with Rome all of Italy, became more unyielding. In short, "the Reformation paved the way for Italian decadence, by placing Rome on the defensive; it obliged Rome to consolidate its threatened positions which had to be held at all costs."[183]

I would not of course for a moment deny the wave of obscurantism unleashed across Italy by the vigilant intransigence of the Inquisition, allied what was more to anxiety—which is always a poor counselor—on the part of the faithful. Giordano Bruno was after all handed over to the Inquisition by one of his own friends, in Venice, the most liberal city in Italy. And how could one forget the emigrations, the flight to foreign and Protestant countries, by so many desperate men, whom Benedetto Croce is right to see as witnesses of an intolerable age? One thinks too of the

book burnings. The first bonfire was lit in Venice in 1524 on the feast of St. Peter and St. Paul—and that day would long afterwards be the one chosen for the ritual bonfires on the Rialto.[184] Other cities followed suit, and the practice was carried on until the end of the century or later. In 1600 in Ferrara, the heretical books from the library of the French duchess Renée of Ferrara were burned. Let one detail stand for the rest: when the devout Benedictine friar Benedetto Castelli asked permission to visit his old master Galileo, who was ill and close to death, on the excellent pretext of "preparing him to die as a good Christian," he was granted permission, but the interview had to take place in the presence of a monk of the Inquisition.[185]

After reminding us pertinently of these facts, Georges Gusdorf goes on, "It was no doubt by some sort of compensatory mechanism that the Catholic south (Italy and Spain) gave rise to the overwhelming aesthetic flowering of the Baroque. The demand for freedom, smothered by the repressive discipline of the Counter-Reformation, found expression in the sublimated form of plastic creation. Being unable to control the world with science, or to transform it by technology, the Baroque imagination sought pleasure in playing with the forms and dimensions of reality. Life is but a dream and the landscape an opera set, erected for festivities in honor of God or the prince."[186]

The image is a telling one. But are we to be convinced by "an explanation that explains nothing," to turn one of his favorite expressions against our author? The Counter-Reformation was a cause but it was also an effect. Where did it come from? If theologians had begun to trespass on

the territory of others, as they were correctly accused of doing by an eminent Italian who emigrated to England,[187] it was not simply by their own initiative and free choice. They were as much acted upon as actors in this drama.

It is even clearer that there can be no sector of human life hermetically sealed off from the rest. Despite the very great esteem I have for Alexandre Koyré, I do not believe that there is such a thing as a history of science in itself; nor do I agree with the majority of art historians that art somehow falls outside social contingencies, in which it is in fact deeply rooted; nor that the economy is just one more compartment of human life, with its own history, and so on. History is made up of hundreds of correlations, and at best we manage to see a few of them. So let us not jump to conclusions on the basis of oversimple premises.

Faced with the vast problem of Italian decadence between 1633 and 1670, to take both the date of Galileo's trial and the year when, according to Croce, the recovery began, how can we fail to see that this turning point has an immediate relevance to the whole history of Italy or at least the entire period between the Renaissance and the Risorgimento? And that not only culture, but also society, the economy, and the general march of history must have played some part in it?

The Rise of the Northern Countries

Italian decadence—a relative concept in many respects and in more than one sense—is perceptible only

by comparison with the new all-round predominance of northern Europe, in particular of the United Provinces, as the Golden Age began, but also to a lesser extent that of France under Mazarin and Louis XIV, or of England after the Civil War.

With the striking but limited exception of the United Provinces, as already noted, northern Europe had in fact welcomed the southern Baroque with open arms—if only to move more or less quickly away from it, as France had done, or to borrow only selectively from it, as had been the case in England. Everything that underlay the Baroque— that anguish in the depths of the soul, that conquest of the imaginary world as a substitute for control of the real world—was thus already present in the area where the new destiny of Europe was being shaped. This area was in part also that covered by the Reformation, a point that sends us toward the theories of Max Weber, of which more later. But Georges Gusdorf does not take exactly the same path. What he is defending and advocating retrospectively, in his moving indictment, is freedom and tolerance. Without them, he argues, there could be no science, no fruitful philosophical thought. But if one takes that line, the trial of Galileo is not the only sinister event of the seventeenth century: the expulsion of the Arminians from the United Provinces in 1621, the English Civil War (1642–1649), and the Revocation of the Edict of Nantes in France (1685) were by no means innocuous events. And there were others. One has to recognize that the spirit of tolerance was under attack everywhere. In the preceding century, Calvin is certainly not a good representative of it: the trial of

Michael Servetus could match that of Giordano Bruno in horror. And as far as Luther was concerned, Copernicus was a madman. The spectacular rise of science and the improving economy of northern Europe had had to come to terms with these obstacles.

But what was now missing from the new intolerant Italy was not only science, but economic preponderance. The body was suffering as much as the mind. Should we therefore unhesitatingly follow Max Weber, whose thesis about Protestantism and the rise of capitalism must by now be familiar to everyone? In his view, the Reformation had one exclusive advantage in the competition for world supremacy: it had, he says, invented capitalism—as if the capitalism now witnessing a new flowering in the north had not originally taken root and grown up in the Mediterranean south!

Economic supremacy in this period depended on supremacy in *commerce*, that is upon a volume of trade impressive on the world scale of those days, though it would look insignificant on a world scale today. It is hardly surprising then to find the long fragile threads of trade one day being torn away from their former moorings and attached instead to Amsterdam, where they remained firmly anchored for a good hundred years. World supremacy was undoubtedly the prize that rewarded agility in trade and in credit (in other words, the efficient handling of funds in time and space). But such agility was not necessarily the result of crucial innovations, of superior inventive qualities, of greater freedom of thought, or of the supposed creativity of Puritanism.

The capitalism of Amsterdam was in fact no more

sophisticated than that of the Catholic countries it supplanted. Bills of exchange, banks, trading companies, sales of shares, loans at interest—these were all practices already familiar in Genoa and Venice. The model for the Bank of Amsterdam was after all the Banco di Rialto created in 1587, and Venice had discovered for herself the convenience of "bank currency" which was more desirable than all the real currencies in circulation on the market. And even the Banco di Rialto was not itself the prototype of the banking institution. Between southern capitalism and northern capitalism, the relation was one of transfer, imitation, and continuity, not of rupture and rediscovery.

Corresponding to the bourgeoisie of the north, whose portraits look down at us in the museums of Amsterdam, Leyden, or Rotterdam, were equally self-confident bourgeoisies in Catholic Augsburg or, south of the Alps, those bourgeoisies camouflaged as patricians to be found in Venice, Florence, and Genoa. They too look down at us from museum walls. These southern patricians may have assumed the privileges of nobility, but they were practising the profitable callings of commerce and banking, without any risk of losing status. This was explained to Simón Ruiz by one of his Spanish friends in Florence, on the occasion of the wedding of Balthasar Suárez, another Castilian merchant living there; he was marrying (to his own amazement) the sister-in-law of the Grand Duke of Tuscany. "In this city by very ancient tradition, merchants are highly respected; princes and noblemen are themselves businessmen and in the house of the princes of Tuscany, and in his wife's family, they all are"[188]—not only were they bourgeois

we may venture to add but capitalist bourgeois into the bargain!

But the history that was sweeping them from the world stage was in fact a very old history. Protestant northern Europe, which was about to become the dominant area of the world, had long been a sort of colonial Europe, which the Rome of medieval times had disciplined, educated, and exploited. Ecclesiastical principalities had been established there, rather as the Jesuit colonies would be in South America, as states within the state. The exploitation had been religious, cultural, and material. In England, the Peruzzi and the Bardi had tried to lay hands on the entire fiscal wealth of the country and on all the merchandise suitable for export. And the merchant or shipper from the south had easily been able to call the tune in the northern centers for the North Sea and Hanseatic trades, whether London or Bruges. Was it a coincidence that the Protestant revenge was even more violent in the waters of the Atlantic, once they had been opened up, than on land? And that it was directed against the commercial wealth of the enemy as much as against its armies? Or that military effort went hand in hand with a silent everyday conquest by a low-cost, hard-working merchant fleet that had gained control of shipping links with Spain by 1530 and that invaded Mediterranean waters in the 1570s? In the end, it was the poor deprived northerner who conquered. The over-wealthy Mediterranean of the late sixteenth century and its central component, Italy, proved unable to withstand this determined competition, which succeeded in seizing the profitable trade routes leading all over the world, for those

routes were long, overstretched, and vulnerable to takeovers.

Competitive in the boats it used, competitive in its industry, and competitive by virtue of an undemanding labor force, the northern victory was a proletarian triumph, identical to that earlier victory won over Islam and Byzantium by an Italy that itself had once been aggressive, active, and little inclined to luxury. It was a perfectly normal phenomenon, but contemporaries—both the victors, unaware of their victory, and the vanquished, blind to their imminent defeat—had no clear perception of it.

It will be observed that the real rise of Amsterdam took place between 1595 and 1600, as the economic climate shifted, veering towards recession. Was this, as economic historians have perhaps a little hastily concluded, because change occurred later in the north? I am inclined rather to think that the *conjoncture*, the economic trend, as it affected south and north, had a differential impact on the rich and super-rich on one hand, and the poor and proletarian on the other. The south suffered, as the flow of precious metal from America slowed down, because its economy, above all that of Italy, was characterized by a sophisticated and demanding superstructure. What was about to collapse was the ingenious scaffolding built up by the Genoese, but it would not happen overnight. The north, the countries bordering the underprivileged Atlantic from Lisbon to Amsterdam and Hamburg, had a simpler and healthier economy. It was along this ocean seaboard that the merchant won his battle over the financier. I outlined this argument many years ago,[189] before

discovering that Kurt Samuelsson had put forward simi-
lar views, and I am happy to find that we are in agree-
ment. Having rapidly, but I hope clearly, outlined these
considerations, we should now be able to bring a differ-
ent perspective to the realities of Italian life in the mid-
seventeenth century, at the lowest point in its history.

An "Authentic" History of Italy in the Mid-Seventeenth Century

Italy as it appeared about 1650 had certainly been
stripped of many of its privileges and prerogatives. It was
adapting to the depressing, or should one say tragic, seven-
teenth century. It no longer had the freedom of expression
necessary for the unfettered blossoming of the gardens of
the mind. Its trading networks had not disappeared, but
they no longer dominated either the Mediterranean, which
had lost much of its importance, or the wider world
reached by European trade, which was now expanding eco-
nomically and gaining in significance. Italian ports were still
busy with ships coming and going, but now most of them
flew foreign flags. If any port experienced unusual pros-
perity it was Livorno, a strange town created by the acquis-
itiveness of the grand dukes of Tuscany, and where the
Jewish merchants were intermediaries for the distant but
vigilant capitalism of Holland. This was a sign not of vital-
ity but of enslavement, precisely the reverse of the situation
in the past. In Naples, the great vats of oil near what is
today the Piazza Dante also told a visible story, that of the

victory of the Dutch merchant and shipper. Only a few years before, oil would have been transported by merchants from Bergamo, who were living in Apulia and acting on behalf of Venice. Similarly, Italian banking had lost its prestige: Genoese money was staying in Genoa, it seemed, and Venice acted as a training ground for apprentice bankers, rather than as an important financial center. The University of Padua was no longer a rendezvous for the European intelligentsia. And last but not least, brightly colored clothes for men, white powdered wigs and women's fashions (advertised by dolls sent out from Paris) were catching on in Italy. This kind of leadership spelled approaching political success, as we know from the previous spread of Spanish costume. Nowadays, mass culture, the general adoption of fashions at every level of society, and their rapid spread from one country to another, has attenuated this phenomenon without completely eliminating it. Yesterday, the man who wished to indicate his refined taste might have bought his clothes in London; today he would probably dress according to the norms of New York.

Finally, among the losses Italy suffered, we should include the prodigious population losses following outbreaks of plague in Venice (1629), Milan and Verona (1630), Florence (1630–1631), Genoa, and Naples (1656). Not since the Black Death had there been such loss of life. But Europe as a whole was also hit by plague, and when it was all over, Italy still remained the most densely populated country in Europe. If mere pressure of numbers and population density had been a determinant factor, Italy would have been well placed.

The catalogue of lost privileges relates essentially to the influence of Italy outside the peninsula. Imagine for a moment, if you will, the still splendid Italy of 1575–1595, stripped of everything that made it a power and influence on the world stage—and you have the Italy of 1650. There would have been some difference between the two, but by and large the reality would be the same. We may note in passing that comparatively little (in our eyes) had really disappeared: in other words, there was not very much separating greatness from nongreatness. Italian supremacy was dead, but if one sets aside a few groups of patricians and a certain category of artisan, not very numerous all told, not much had changed in Italian life. If one takes Sicily for instance, which had always been exploited by outsiders— first as a Catalan fiefdom, then dominated by the merchants and traders of Genoa—and which had never been involved in the Italian exploitation of the rest of Europe, practically nothing had changed there for hundreds of years. A historian who has collected all the available statistics on the island is adamant in his conclusions: whether Sicily produced grain, silk, or sugar, it remained imprisoned in an economic straitjacket, neither changing nor advancing; indeed it was incapable of doing either.[190]

What is revealed by the retreat of the 1650s or so is an Italy continuing, as it always had, to take both agricultural and artisanal production as far as they would go. It is the Italy that Guicciardini in the opening pages of his *Storia d'Italia* describes as being "cultivated up to the mountaintops," and the Italy that so delighted Montaigne in 1580, when he described the ingenious appropriation for agriculture of

the high hills surrounding Lucca. Emilio Sereni in his pioneering study does not indicate that there was any crucial break in Italian farming at about this time.[191] Indeed on the lowest-lying reclaimable land, the painstaking struggle had long been under way against the stagnant waters where malaria flourished. In the Veneto, in the Milanese, in Piedmont, and elsewhere too, land improvement had slowly been making progress. The spectacular result, as much cause as effect, was the widespread return of the wealthy classes to farming. The Italian property-owning classes had gone back to the land—a process that is sometimes described as *refeudalization*, a term I do not much like, but what else is one to call this move by society back toward a predominantly if not exclusively agricultural mode of production?

This return to the land, or rather this retreat of the wealthy into country-house life, took place with the underlying support of vast fortunes and in a spirit of appreciation of good living. Before long, it was less important to own a huge palace on the Grand Canal in Venice than a luxury villa on the banks of the Brenta, as one traveler discovered to his amazement in 1591. It was a change not only of lifestyle but almost of national identity.

We can almost imagine ourselves back in the mind of a landowner of the time by reading Vincenzo Tanara's book published in 1644.[192] He gives sensible advice to those wishing to build villas: the main house should be positioned so; a pool here could provide freshwater fish for masters and servants—and so on. One would like to be able to complement his descriptive remarks with some

statistics (they are beginning to appear); they might give us some indication of the extent and the real turning points of this long process, dating back to the fifteenth century and the splendors of the Renaissance, and subsequently gathering speed. In Venice, the major turning point was in about 1550, and no doubt represented the most spectacular transformation in Italy: a city built on trade, made of stone and water, woke up one morning to find itself endowed with country estates. It is true that the countryside on the mainland was farmed in "capitalist" fashion, a word that seems appropriate in this case, since what might look like sinking capital in stones and mortar, lavishing money on what would today be called "second homes," in fact represented intelligent investment in productive agriculture. This aspect of the Venetian estates would become well established in the eighteenth century and Jean Georgelin has revealed the remarkable profits made by these "gentleman farmers."[193]

This vigorous commitment to farming was a privilege whose true significance can perhaps best be grasped by comparison with elsewhere. Like Italy, and roughly at the same time, Spain had been going through a bad patch: in 1640, there was the Catalonian uprising and the secession of Portugal; in 1643, the battle of Rocroi; in 1647, the rebellions of Naples and Sicily; in 1648, the peace of Westphalia; and in 1659 the Peace of the Pyrenees. What politics so relentlessly registered was the gradual drying-up of the flow of silver from America. Major recession hit Spain, as it had hit Italy, in its foreign extensions, depriving it of all the trappings its grand history had acquired. But as

Felipe Ruiz Martín has so clearly demonstrated (1971), while Spain's decline had origins in America, its downfall was its own doing.

Agriculture in Castile, which had been by and large abandoned since 1550 by wealthy investors, now collapsed, and this was a mortal blow. It was a blow that Italy, it should be strongly pointed out, had never experienced—in fact the opposite was the case. Throughout the seventeenth century, taking one year with another, Italy was able to live by its own labors, and eat its own bread, with the exception of a few years of extremely bad harvests, or in cities precariously situated (such as Genoa, Livorno, or even Rome) or overpopulated (such as Naples). This was a source of considerable superiority. Italy had not fallen to an insignificant level, whatever people may say. And if Italy remained obstinately alive, as Benedetto Croce puts it, it was because agriculture continued to hold up well, while the network of cities remained in position, although it was now somewhat reduced in size: so there was still capital accumulation and a possibility of recovery. Industry survived, if only in the form of silks and Neapolitan goods, while Italian commerce survived as more than a "passive" activity, as they said in the eighteenth century. In short Italy maintained an equilibrium that cannot have been as unsatisfactory as is sometimes alleged.

The Case of Naples

If we now pause for a moment to look at the huge Kingdom of Naples—huge by the standards of the other

Italian states of the time—our arguments do not seem so self-evident. We shall either have to make them more precise or, more seriously, modify them. If we do so however with the help of studies by Giuseppe Coniglio, Rosario Villari, Ruggiero Romano, Pasquale Villani, and Antonio Di Vittorio, the result may turn out to be positive.

It seems to me beyond dispute that Naples in the seventeenth century presented the clearest case of refeudalization in western Europe. Refeudalization is here taken to mean very broadly a return to the social situation of the early fifteenth century, two hundred years earlier.

Perhaps we shall have a clearer view of the problem if we remind ourselves that feudalism or refeudalization could take place only where some pre-existing state had fallen apart. It was from the elements released by this collapse that feudal societies as a rule were constituted. The Kingdom of Naples is certainly a good example of the collapse of a state. The external circumstances that shaped its destiny had been responsible for this state of affairs. Spain had had to defend itself in the Netherlands in the sixteenth and seventeenth centuries. In that distant outpost Spain was under threat, but at the same time, by virtue of its strategic position there, it was well placed to threaten others: England, Germany, the Netherlands themselves, and especially France, whose very heart, Paris, was the target of attack in 1543, 1596, and 1636, for instance. After 1569, the political objectives of the King of Spain were still pursued with efficiency in the rather inaccessible Netherlands, by using Italy and the routes overland across Europe. After 1618, with the outbreak of what was to be the Thirty Years

War, after 1621 when war restarted with the United Provinces, and finally after the French intervention of 1635, Italy became more than ever a point of departure for all Spanish actions. It was more than that: for now not only was it necessary to have a safe supply route, Spain also needed to find locally, in Sicily, Naples, and Milan, the wherewithal to wage the war: in other words, to recruit both cavalry and foot soldiers, to requisition supplies, and, in order to pay for it all, to find money.

The entire situation of Naples was dictated by this last requirement. Everywhere in Europe, the war effort was leading to fierce and effective extra turns of the fiscal screw. Under Richelieu, the royal exchequer doubled or tripled its revenues. So it is not surprising that in Naples, with or without the consent of the *Sommaria*, the viceroy and his aides were always dreaming up new taxes, more efficient methods of collection, extra resources, and extraordinary levies. In these early years of the seventeenth century, when times were already hard, the state, in Naples as in the rest of western Europe, was the only "industry" or enterprise to be doing well. Everything else was either stagnating or giving that impression; only the state prospered. In France, political authority was being sold off piecemeal to "officeholders," and the sale of office became established. We might be tempted to agree with Martin Göhring[194] that this was the means the Crown hit upon to make the rich pay up. But it was a procedure bound to have social consequences and repercussions on the economy. Money collected by the state vanished from the profitable commercial circuits of

trade. And this was what happened in Naples too, with disastrous results.

What was being sold off by the viceroy on orders from Madrid was not income, but what one might describe as the state's *capital*: the right to levy certain taxes, the property of certain jurisdictions, more or less lapsed royal dues, harbor taxes, the tax on silk, titles of nobility, and lastly peasants, that is, estates within the royal domains. Thanks to all these sales and alienations, Spain managed to hold out against its enemies, in particular its irreconcilable adversary France, an enemy all the more menacing and aggressive since it believed itself to be threatened by Spain and on the point of being overwhelmed. It is odd to note at any rate that France did not succeed in making any real inroads into Italy beyond Savoy and Piedmont. Had Mazarin succeeded in doing so in 1647, one of the essential mechanisms of Spanish resistance would have been crushed.

It would of course be foolish to imagine that this fiscal extortion in Naples was entirely effective. Most probably, part of the extra resources obtained stayed on the spot: the difficulty of checking accounts as well as certain Neapolitan practices and ruses meant that money often apparently left one place without arriving anywhere else.

But the success or otherwise of fraud need not concern us: we are interested not so much in the Spanish state as in its partners. If the state had something to sell, it needed buyers. And it found them in bankers, who in parasitical style were able to take advantage of the critical situation; it found them in merchants, of whom there were still not a

few in this kingdom rich in raw materials, natural resources, and people; and it found them in particular in nobles—let us call them "feudal landlords"—of ancient or recent extraction. At bottom, the whole operation was being financed by the peasant, from the hills or the plain, the primary producer of grain, wool, meat, wine, oil, or silk; like fishermen and other small traders, he brought his produce to the fairs of Salerno and elsewhere. These fairs swarmed with buyers and sellers and the volume of trans-actions remained continuously high, which argues that the peasant did have a certain margin of saleable surplus, and that he was not limited to self-sufficiency; it also argues that the game was worth the candle for those who acquired fief-doms: that their estates, even when purchased at high prices, brought in some kind of income. All of this leads us to assume that the economy was in reasonably good shape.

Yet in 1647, the whole system was cracking up from within. Rebellion broke out in the city of Naples, spread to the rest of the kingdom, and sparked off a peasant revolt. It is true that the contentious climate was not confined to the Kingdom of Naples; in 1649, there was a rebellion in Paris too. It was merely one more in a series of earlier rev-olutions (directly related to American silver, to the Atlantic, and to Spain's imperial pretentions), which had swept through western Europe: hitting Catalonia and Portugal in 1640, and England in 1642. All these revolu-tions failed, however, the longest-lived being the English Revolution, which lasted until 1660 and the restoration of Charles II. The Fronde was defeated in 1653 with the return of Mazarin, the *intendants*, and the new absolutism

of Louis XIV, already operational even before the King seized power and began his personal rule in 1661. Apart from some pockets of resistance, Catalonia too capitulated in the end. In Naples and Sicily, the revolution had flared up only to die down. Only Portugal won the day—but had to wait twenty-four years for a diplomatic act sanctioning that success (1664).

The return to calm of Naples and Sicily revealed to the aristocrats there that Spain still represented the peace and social order from which they stood to benefit. This was not exactly new, after all; if the peasants of Naples had lost the battle and paid dearly, that had invariably been the outcome of all the many peasant revolts in European history. Rebels had always been brought back into line.

IS ITALIAN DECADENCE
A DISCERNIBLE PROCESS?

The section that follows is probably the most contentious in the book. It seeks to propose a framework for tackling the major questions already considered in such a way as to integrate them into a valid model of Italian grandeur and decadence between the fifteenth and the seventeenth centuries. The model will of course make it necessary to go back earlier than 1450 and to look forward beyond 1650—and even to seek comparisons outside Italy. Our biggest problem will be to avoid repeating the arguments already outlined, but they must nevertheless be taken into consideration.

Imaginary Graphs

Nowadays historians are familiar with graphs. But no graph, however skilled the programmer, could be constructed from a systematic ordering of the quantitative and qualitative data at our disposal in this instance. In any case, what "indicators" could one use to measure "greatness" or "non-greatness," terms too vague for prompt mathematical equivalents? The only alternative is to imagine a graph.

This may be worth doing, on condition that it is regarded simply as one way of discovering a language and logic that can at best do no more than *simulate* the evidence. If this approach does nothing more than eliminate others equally gratuitous, it will not have been a complete waste of time.

Our impossible graph then (which I will now take as drawn) would begin in about 1100 and end in about 1650. Between these two dates, we should imagine not *one* but *two* peaks: I suggest 1350 and 1595, debatable choices certainly, but our graph cannot possibly be a simple one rising to a single peak like a symmetrical Gaussian curve. The low point between 1350 and 1595 might fall at about 1450 or possibly 1500—in other words I am suggesting that we can find a long-term crisis in Italy during the same hundred years (1350–1450) that the rest of Europe was subject to a violent, dramatic, and durable crisis, in which plague (the Black Death) and war were compounded by a series of long economic recessions. Italy was not immune from these troubles. In the *Decameron*, Boccaccio and his friends take refuge in a villa in the Florentine countryside to escape the plague in the city. But Italy, being better placed thanks to its wealth and accumulated technical skills, and having more or less successfully emerged from feudalism during the twelfth and thirteenth centuries,[195] withstood the battery of disasters better than Europe as a whole; it therefore did not lose its *comparative* superiority—and that was what mattered.

Having established our two peaks then, we are immediately faced with another thorny question: supposing our dates to be reasonable, should the 1350 peak be higher,

lower, or about the same as the 1595 one? Some historians, Pierre Chaunu among them, have come to argue that the "long" sixteenth century (1450–1650) was as much recovery as advance. Perhaps they are right. But I think they may have been distracted by the greater accuracy of the population statistics we now have, thanks to progress in historical demography. The year 1350 is probably at about the same level as 1550 or 1575, if one is thinking in terms of the population figures for Europe as a whole. And the same would be true of Italy. But demography is not everything. World supremacy after all passed in turn to Holland and then to England, neither of which had a large population: in about 1600 there were some two million inhabitants in Holland and five million in England.

What "greatness" really meant was *surplus* wealth, of which the dazzling presence could be sensed for so long in Italy: it was what existed over and above everyday life, the basic economy. It did not, let me insist, mean a fantastic accumulation of goods, but rather a stream of ships returning from the Levant or the Indies, carrying precious cargoes (pepper, spices, silk), it meant luxury industries, and it meant a supply of gold and silver. Between 1500 and 1650, according to official records, a total of 160 tons of gold and 18,000 tons of silver from America arrived in Spain and from there reached the rest of Europe. Its effects are nevertheless well known. So if one thinks of the rapid increase in production, the massive new amount of currency in circulation, and the change in the dimensions of the known world, one is surely bound to recognize that the economic level in 1595 must have been higher than in

1350. And along with this superiority went everything else: volume of trade, power of the state, and before long a new impetus in science.

It is in any case an error to suppose that decadence is a kind of return to square one. The Italy of 1650 was not the Italy of the early days of Venice and Amalfi. And I do not see it as necessarily inferior to the Italy of the fourteenth century, brilliant though the earlier age may have been. Everyone thinks for instance that "France under the Sun King," Louis XIV, was "greater" than France under de Gaulle, but the "inferior" France of the 1960s had a population two or three times greater and was many times richer. Greatness, in the sense that historians use the word, is always measured by the greatness of *others*. Greatness means being "greater" than someone else. The Britain of today is more beautiful (which is not difficult), more equitable, but less *great* than it was in the Victorian era: less great, even if in June 1940 it saved the world, less great precisely *because* the Second World War confirmed the superpower status of two massive states, the United States and the Soviet Union, with the inevitable rise of China to come.

So behind the graph for Italy, one has to imagine graphs representing Byzantium, Islam, and the Western world as a whole. If Italy was soon to emerge above the rest, it was because Byzantium was falling apart, because it was a capital with nothing left to feed on—and because Islam had almost entirely lost the Mediterranean Sea.[196] And if Italy declined, it was because the graphs of the other Western powers were now set to climb. Italy followed suit,

but neither overtook nor any longer controlled the trend. Italy declined because Holland was rising. In sum, the stakes of greatness are substantially if not entirely external ones. It is the rest of the world that tolerates, accepts, or destroys our greatness. So our fall, if fall there be, is shared.

The Means of Achieving Greatness

Greatness implies access to the outside world: if that is restricted, greatness is likely to wane or fade; if it is increased, greatness asserts itself. It is clear that this two-sided problem one way or another brings us back to the means whereby domination is created, expressed, and maintained. If we consider the possible comparisons before the Industrial Revolution (which altered the proportions of any form of domination), then the "modern greatness" of Spain, Holland, England, or France always tells us one simple thing, namely that in a given economy (the Mediterranean plus Europe, or the entire world in early modern times), there is always, justly or unjustly, a hierarchy. Greatness basically benefits one of the partners, creating an *asymmetry* in the economic area within which it is an agent and in which it has longer- or shorter-term privileged status. This rule is not only valid in Western and Mediterranean history, but could be applied anywhere: Islam, India, and China have all enjoyed greatness on the same basis.

True greatness endures—it has time, that precious

commodity, on its side. But ephemeral instances of great-ness can sometimes tell us more than durable ones. They expose how the whole thing works. France is a good example in this respect. Historians see France as forever collapsing and rising again, chasing after a greatness that has always evaded it, leaving it bruised and embittered; then along comes the new opportunity it was waiting for and the adventure begins all over again; a series of actions both comparable and mutually explanatory.

A period of domination, if it lasts, attains a certain degree of perfection, but never perfection as such. If we were to visualize in the abstract, outside history, all the means one could imagine of achieving domination, and then to confer all these means on some imaginary power, we should of course have created a monster unknown to history. No great power would ever have possessed all of them; every great power has its feet of clay, its Achilles heel. And it is the *failings of greatness* that take us to the heart of the problem. For if every domination is imperfect from the start, precisely because of the very structure of its success, it is easier to see why its history is endlessly interrupted by troubles, anxieties, failures, and disorders. Imperfection helps to explore the mystery of these inevitable repeated setbacks. It is only *natural* then that Renaissance Italy does not appear under the completely unclouded sky imagined by naïve admirers. Britain in the past or America today, although great powers, have witnessed their share of alerts, dramas, and crises, as no one would deny.

Sea Power

The five European examples of greatness chosen for comparison not surprisingly perhaps add up to a commentary on the notion of sea power as understood by Admiral Mahan. All of them were based on strength at sea. Being only half successful in this respect was a constant source of weakness in the case of France. France had money, population, competent commanders from the aristocracy, soldiers, political will, plentiful natural resources, a state established both early and comparatively solidly, and policies, energetically and skillfully pursued, that were at least as reprehensible as everyone else's. But, in the sixteenth century, France lost Italy, of which it had so long dreamed, not on the field of Pavia in 1525, but three years later in 1528, when Andrea Doria abandoned the blockade of Naples and went over to the imperial camp with his galleys. Without the Genoese navy, it was impossible for the King of France to dominate either Italy or the Mediterranean, so imperial or "universal" domination was out of the question. Then in the seventeenth century, Louis XIV was defeated at La Hougue on May 26, 1692. His immediate response was to say "Forty-four of my ships have beaten ninety of my enemy's," which was true, but in reality the French navy never recovered from a "victory" that was in fact a disaster. And, finally, the great epic of the Revolutionary and Napoleonic wars, that expenditure of huge capital to no avail, came to an unprofitable end at Trafalgar on November 21, 1805, between two in the morning and five in the afternoon. So on three separate

occasions, for reasons so obvious that no one can fail to see them, France lost greatness just as it was within reach. A book written long ago by Emile Bourgeois pointed out the mortal conflict between France's maritime and continental destinies. France lies at a crossroads of Europe, surrounded by lands and seas and unable to neglect any of them. Thus it has had to divide its efforts. England by contrast could afford to ignore land power.

Spain's problems were different but equally instructive. Let us agree for a moment that Spain "won America in the lottery," although that is not quite true. At all events, Spain proved quite equal to her destiny. Castile organized the "Spanish Indies" and the system of Atlantic crossings that Pierre Chaunu insists on calling "Seville's Atlantic." We know about the thousands of boats traveling to and from Spain in this essential trade zone. Was Spain's big mistake to have paid too much attention at the same time to Italy and the Mediterranean? Possibly, for Spain triumphed where victory was not really important—at Lepanto in 1571—and lost, or began to lose, where the real conflict was being played out, in the Atlantic, or rather in the treacherous trap of the English Channel and the North Sea, which closed on the Invincible Armada in 1588. I say "began to lose" since in 1597, and again in 1601, Spain proved capable of sending north two more armadas, only to see them dispersed by unpredictable northern storms. It was only in 1628 that the fatal blow eventually fell on the fleet of the Carrera de Indias, when it was surprised and captured by Piet Heyn's Dutch fleet at Matanzas, on the way out of Havana. Nevertheless for more than a century

(from 1492 to 1628) Spain had controlled the middle Atlantic with her ships from Biscay (possibly the best in the world) and Andalusia, as well as the heavy vessels of Flanders and the Hansa. That control would probably have been more effective if all the ports in the Peninsula had been allowed to engage in the Indies trade from the start (something that happened later, much too late, in 1784).

With Italy and the sea it is practically the same story. The Italian navies maintained their supremacy from the twelfth century until at least 1550 or so, possibly until about 1570. The date is uncertain because, unlike the French or Spanish cases, there was no major disaster to mark the end of the Italian fleet, no date to go down in history, no La Hougue or Trafalgar. But there can be no doubt that Italian greatness in this respect came to an end about then.

In 1530 or so, as we have seen, the ships from the Atlantic had stopped coming on their usual Mediterranean voyages, and they stayed away for years. But they returned with the economic upturn of the years 1570–1575. At this time, while they did not sweep all before them, they unquestionably helped bring about the decline of the old order.

This was not so much because they were backed by a powerful economy. Shipping was a business on the whole handled by the poor. The rich tended to hire other people to do it for them, and to recruit foreign crews. Venice recruited in Dalmatia and the Greek islands; Genoa was from the start a major customer for the great sailing ships of Ragusa, financing their voyages, buying *carats* or shares in the profit on their cargoes and having a large say in their itineraries. The golden age of the Ragusan merchant fleet corresponds,

as if by coincidence, to the 1530s to the 1570s, when northern ships were absent from the Mediterranean.

The consequences of the northern invasion were foreseeable: during the latter part of the century, there was a regular reduction in the tonnage of the Venetian merchant fleet, if not of the shipping in the port. Custom was being taken away from Venetian ships and crews. And this is a significant example. The northerners had better-built ships, better cruising speeds, and better defenses in the event of attack. They were also prepared to turn pirate themselves on occasion. The Catalans to some extent, and the Marseillais to a greater one, played a part in this proletarian conquest of the seas. Even the fleet of the Algiers corsairs was a northern one.

The history of Holland's greatness follows exactly the same pattern and has already been referred to. The initial achievement was the seizure of the sea route from the Baltic to the Iberian peninsula, to Lisbon and Seville. This had been accomplished by 1530, sixty years before Cornelius Houtman's voyage, and a century before the encounter at Matanzas. The Dutch breakthrough in its early stages very closely resembled the slow but steady progress made by the ships, the seamen, and the aggressive cities of Italy in the eleventh century. Behind the Italian exploits, there had been a similar infrastructure of ships that were more maneuverable and efficient, and crews less well paid than anyone else's. And the Mediterranean of the tenth and eleventh centuries was also quite a primitive and open sea. As in the days of Hesiod, anyone could set off on an adventure at any time: such as the group of Muslims

from a suburb of Cordoba—well inland—who set off by boat in the tenth century, sailed to the other end of the Mediterranean, and seized the island of Crete: Byzantium had a good deal of trouble getting it back.

The Italian seamen of those early days were also ready to turn adventurer. Their voyages remind me of the trips made by the wild "Americans" of the eighteenth century: whalers or traders in flour, timber, and rum, who sailed to the northern Pacific and the China seas, in unsound vessels manned by alarmingly filthy crews often drunk on rum, and navigating without compasses (indeed this "primitive" navigation at such a late date obliges us to reconsider our oversimple versions of shipping history). But the American shipping of the late eighteenth and early nineteenth century did not last. The steamship finished it off, and by the 1840s English steamers were working the Atlantic route— a silent victory often ignored by history.

In short, it seems to be a general rule that there is a lean and hungry phase at the beginning of every episode of sea power. Then comes the wealthy period, for which Venice coined or repeated the proverb "Sailors like fish go rotten if their heads are out of water"—leading inevitably to takeover by a poorer rival.

Space and Greatness

Every episode of greatness assumes an area of domination (abroad), larger than the area actually possessed (at home). Greatness, that is, implies *extra* space. For Spain,

simplifying somewhat, that extra space meant the mid-Atlantic and the Americas: the ocean, which was not easy to control at first, then the land masses of America, and the islands, which were held on to with the tenacity of a peasant race. Spain could not be ousted from its territorial possessions.

In much the same way, Genoa and Venice held on to the areas of the Mediterranean necessary to their greatness, either by force or by means of their merchant colonies. These areas began to slip from their grasp only in 1453 with the Turkish advance, and it did not happen all at once. Meanwhile the strengthening of their trading colonies in the west, thanks to the flow of trade to the New World and the Far East, compensated for the grievous losses in the Levant—compensated in terms of money, that is, not of territorial possession.

The old geographical explanation of the reorganization of world trade routes faces us once more, of course. I have questioned its importance—but only as regards the sixteenth century. In the seventeenth, there can be no doubt whatever that the new shape of the world brought immense disadvantages, indeed it dealt a mortal blow, to the Mediterranean world by which Italy was surrounded. But it is surely untrue that the effect of one space on the other is a merely physical phenomenon. Space is activated only by human intervention. It was not the "rise of the Atlantic" that ruined or outclassed the Mediterranean, but the initiative grasped by the United Provinces in visualizing the possibility of a world economy: and that was a *human* initiative. What people could accomplish in the

north could surely have been accomplished in the south. After all the Genoese had in their own way for a while dominated Spain's Atlantic trade.

Werner Sombart perceived this problem in his book *The Jews and Economic Life* in which he assumed this change to have been caused by the transfer of the networks of Jewish merchants. But was it not rather the success of Amsterdam that attracted the Jewish merchants in the first place? He is however right when he remarks that Genoa was just as well placed on the map as Hamburg, London, Antwerp, or Amsterdam to exploit the seventeenth-century world economy as it gradually emerged. Before air travel, passengers for South America preferred to board in Genoa or Marseille, rather than in Hamburg, Le Havre, or even Bordeaux. Geography was not the problem: what was needed was both the will and the capacity to hold on to these world routes.

The best position for action of this kind is usually a mid-way one, at the point where a short-radius area meets one of longer radius. Amsterdam's value lay in the shorter circuits linking it with the Baltic, England, Germany, Poland, Muscovy, France, Portugal, and Spain. Merchandise arrived in these centers for resale. Could the area around Genoa compete with this maritime arc from Gibraltar to Kronstadt? I doubt it, although, through Cadiz, Italy remained firmly connected to Spain and thus to the Americas.

Another form of greatness is possible, relating to the immediate area. Sixteenth-century France for instance represented a very large area at the time. It could accommodate

almost anything without being entirely occupied by it, whether the Hundred Years War or the Wars of Religion, neither of which overwhelmed the country. And external war remained on the periphery; the enemy made few inroads on French soil, even if he captured Marseille (1536), Meaux (1544), Amiens (1596), Corbie and Saint-Jean-de-Losne (1636), or Cambrai, and Douai (1712). I have always imagined France during the Wars of Religion as something like China in the days of the generals, in about 1930: a huge expanse in which couriers, travelers, and even armed troops could be swallowed up. To travel from Paris to Marseille took ten to fifteen days in the age of Louis XIV. Italy was a large country too, but it could be crossed without too much difficulty and lay open to the outside world, as it had long before the Italian wars. To enter Italy meant opening a series of doors, but only one after another, so the difficulty was divided up in advance. And the peninsula was accustomed to invasion. There had already been "Italian wars" in the time of Barbarossa, Frederick II, the Angevins, and the Aragonese. But the leading cities, which thought themselves unique in the world, had long been able to feel sheltered behind their fortifications—until the day when cannonfire proved capable of demolishing their gates.

The United Provinces, one might argue, were even smaller. But in 1672, if the dikes had not been opened in time, what would have become of Amsterdam at the hands of an efficient French army? A miracle is an exception that proves the rule. As for England, its small size was compensated for by the sea that magnified the area around it, enabling it to breathe and defend itself. But in

today's world, where size is a source of supremacy, England's size is a disadvantage.

Capitalism and Sectors of the Economy

Every example of greatness operates through a system of action and control, in other words an economic system plus a political system. If they are to be efficient, these systems have to be linked and coordinated; the means of production, the organs of decision-making, the intermediaries, the institutions, and the priorities to be pursued have to form a coherent whole; in the centuries we are studying, there had to be already in existence an effective *capitalist* order. The words *capitalist* and *capitalism*, particularly the latter, are anachronistic terms but convenient tools for the historian, making it possible to identify the question immediately. They are so indispensable that one finds them being used by historians who fiercely deny their ambiguity—only to find that they are hard to pin down. But why not simply accept them, since everyone knows, and it has been perfectly obvious since the Industrial Revolution, that there is capitalism and capitalism! To my mind, there has to be some kind of capitalism at the center of any rise to dominance in modern times and, inevitably, in every process of decline.

In this last respect, what kind of system was at work in Italy when decline began, or even earlier?

In Venice, where the chance survival of sources gives us some information, commercial life was dominated above all by the Florentines, who owned trading firms, and by

the Genoese, who controlled currency exchange, the trade in silver, and maritime insurance. The Florentines seem to have been even more firmly ensconced than the Genoese. Indeed following the interruption to the Piacenza fairs in 1621, which had brought heavy Venetian losses, there had been something of a reaction against the Genoese. At any rate, here we have a clear image of capitalist maneuvering as between different active Italian groups: some were winning, some were losing. But we do not entirely understand the game. A tentative model for what was happening might go as follows: Jewish moneylenders at the lowest rung of the ladder, handling everyday transactions, Florentines a little higher up, dealing in medium-level but still prudent affairs, and the Genoese at the top level, the narrowest and most precarious platform of capitalist business. If this was so, Venetian patricians looking around for some alternative when the profits from trade began to diminish would have found all these positions occupied and would therefore have fallen back on buying landed property instead. But perhaps they needed no incentive to move in this direction?

Naturally, if we are interested in Italian decadence, we would like more information about the establishment in Italy of foreign capitalism, about the slow ousting of the dominant Italian system by Dutch or English money. The Dutch seem to have made an early impression on Venice, on Naples, and above all on Livorno, whose merchants were, according to one expert, nothing but "commission agents" by 1720. English investors seem to have preferred Genoa, where the first English firms appeared in about

1640. Felipe Ruiz Martín has even wondered whether the money that Genoa continued to lend the King of Spain was not actually English money in disguise. But secret financial deals are only suspected, not confirmed. And what route could such foreign money have taken?

It certainly did not come in the first place by the straightforward route of banking and credit. The English and Dutch attacked the Italian system from below, with their shippers, merchants, industrial goods, their indispensable commodities such as Cornish tin and lead, hides from Russia, and barrels of herring. And such assaults—or services, whichever way one looks at them—were often in fact the work of Italian émigrés, sometimes Protestants, often merchants who had settled in England or Amsterdam. They can be traced through the commercial correspondence surviving in the archives. The economic system of the Italian cities gradually became disorganized—or perhaps a better word would be dislocated. An economy forms a whole, from the most basic transactions and humblest activities in the marketplace to the most hazardous speculation by the specialists (at the Besançon exchange fairs for instance). Everything is connected. If any single sector is experiencing either weakness or strength, the negative or positive impulse is reflected throughout the system. In Spain, the decline of agriculture, since neither the nobles nor the bourgeoisie were investing in it anymore, opened up the national market to foreign corn, from the Baltic, controlled (ironically) by Amsterdam. In Italy, the reverse happened: the money of patricians who had once been merchants went into land purchases,

whether in Venice, Florence, or more predictably in Naples. Social tensions followed and peasant society found itself back under a stricter order. But production and productivity went up. From now on, Italy needed no foreign bread. In that case, it no longer needed so urgently to export either manufactured goods or liquid cash. Was this a good thing? From the point of view of the quality of life perhaps it was: I would certainly rather have lived in Tuscany, than in Spain under Philip IV or even in France under Louis XIV.

What was definitely disorganized however was the merchant fleet. Italy lost some of the profits from freight, and one way or another ended up paying foreign shippers. In any case, the latter had quite simple tactics: they tried to include in their itinerary either Genoa, Livorno, or Naples, where they would obtain cash in return for barrels of herring, copper rosettes, and pigs of tin or lead. Once they had the coin, their most advantageous course was to go to the islands in the Levant to buy raisins or casks of Malmsey wine, or better still to press on to Syria and Egypt, returning with silk, spices, drugs, and cotton.

This trade would fall off to some extent but it remained highly profitable after 1620. One had to reckon with a steady rise in price as the cargoes approached Europe. Naturally, manufactured goods going the other way were part of the system: English kerseys (*carisee* in the Italian documents) were to be found in the Mediterranean before the sixteenth century. They were not only sold in Italy but also re-exported to the Balkans and Asia, indeed they flooded the Mediterranean, coming overland from the Netherlands and

Hamburg, across the well-organized roads of Germany or even France, but also by the easier sea passage.

In the Mediterranean, northern shipping thus gradually took over from the Italians. In fact Italian merchants had always, since the Champagne fairs, bought with one hand to sell with the other. This also explains the early association of the most active cities (Venice, Milan, Genoa, Florence) with Germany, since German products needed outlets in the Mediterranean. Venice's relations with Ravensburg, Ulm, Regensburg, and Augsburg—over a very wide radius— were the classic ones of the merchant to the craftsman. It was only in a series of erratic bursts punctuated by pauses and slowdowns that industry became established in Italian cities. So in Venice the *Arte della Seta* and the *Arte della Lana* (the wool and silk guilds) were eclipsed from time to time. The latter did have an Indian summer between 1580 and 1610, but that was followed by a severe decline. The example simply confirms the rule that industry is a shifting activity, starting up in one place then another, then some- where else again. In about 1650, the silk industry virtually deserted the south of Italy for the north. Sooner or later in the seventeenth century, all the other Italian industries went into decline. Rising prices and wages had their effect. The artisans could no longer afford to live in town. The *Arti*, which kept wages high, could no longer compete with external competition. And the retreat of artisans to the countryside did not promote a spurt of industry there, as it did in France or England. So the looms fell silent.

The outcome of this decline and fall has often been studied. We could do with more detail, but the general

result is already apparent. What happened in Italy was that a long, catastrophic industrial crisis followed on the heels of a long, catastrophic shipping crisis.

There still remained the enviable credit machinery. City banks had become more numerous in the late sixteenth century while leaving plenty of room for private credit firms. During the general recession, credit and financial and banking capitalism survived quite well. In Genoa, the system remained in working order until about 1627 and even later. But was this to Italy's advantage? This credit was disconnected from normal economic life in the peninsula, and was basically used to manipulate the money of the King of Spain. Nevertheless it attracted, by what seemed to be a natural development, the money of the Genoese themselves, speculators, rentiers, aristocrats, tempted by the interest rates on offer: 8 or 10 percent a year, reckoning postponements between fairs at 2 or 2.5 percent. What happened here was what would happen to French savers during the Third Republic: money was taken out of national circuits to be invested in whichever foreign government loans looked tempting—including in the later example those of the Russian government. The same thing took place *mutatis mutandis* in eighteenth-century Holland. So the Amsterdam bourse became the center for loans, the foreign bond market. Dutch investors held between a fifth and a third of English government loan bonds. They lent money to all governments, whether Catherine the Great, Louis XVI, or the Elector of Saxony, who wanted to become King of Poland.

That said, let us imagine that Italy, which had not yet

faded from the scene in 1600, had been able by some miracle to benefit from the advice of a modern economist (with some historical knowledge) and that he had proposed a remedy, a plan. It is of course a quite impossible scenario; the gulf between his warnings, advice, and requirements, and the situation as it was then viewed by those in responsibility, who considered themselves reasonable men, would be enormous and unbridgeable. The learned doctor would have been treated to gales of laughter from a patient who did not consider himself ill. For what authoritarian policy would have been able to make the Venetian patricians go back into shipping, when they were making profits of 100 percent on their agricultural land, as against 10 to 15 percent (risks not included) by financing ships to sail to Egypt or Syria? In Genoa, to snap off the cursed thread of the *asientos* would be to cut off the flow of silver; it would mean making a heavy loss in the immediate future, since an *asiento* was usually repaid with another *asiento* in a sequence rarely settled by the *finiquito.* One might as well have invited these wealthy persons to declare themselves bankrupt. And who would have been able to explain to the princes and republics of Italy, as well as to the Spanish who had an interest in the question, that they ought to be working towards the political unity of the Italian peninsula, and towards a "common market" in the interests of all Italy? Long-term lucidity is not the usual characteristic of political leaders—still less of businessmen.

Greatness and Culture

The most important thing has yet to be said. I remember a melancholy conversation I once had in 1945 with the French Revolution historian Georges Lefebvre. What he said was in substance: "People have always said that power and culture, or rather cultural influence [we were talking about French cultural influence] are quite independent of each other. Germany in the early nineteenth century, they said, had plenty of cultural influence, but it was divided, trampled by French soldiers, and later controlled by Metternich. *But really power and cultural influence are two faces of the same coin.*"

I am not so sure of that as was my illustrious colleague—with whom indeed I argued fiercely that day in a corridor in the Sorbonne. I am still not so sure. Cultural influence in the case of Spain during the Golden Age was a sort of afterglow. And could the same not be said of France, without going as far back as the *secolo senza Roma*? French cultural supremacy always seems to follow some political failure. In 1529, only fourteen years after Marignano, French expansion was over, given the mistakes made by François I and the incredible luck of the Habsburgs; but this was when the French Renaissance flowered—for there was a French Renaissance. After the great wars of Louis XIV, another resounding failure, came the France of the Enlightenment: "*le grand siècle,* I mean of course the eighteenth," as Michelet said. After 1815 came Romanticism; after 1919 and the failure of the French peace as France understood it, after a "victory"

that left France totally exhausted, came a literary, artistic, and scientific flowering such as we had not seen for a long time. Leon Brunschvig, referring to Greece and to the owl, symbol of Athens and its influence, used to say: "The bird of Athena, which unfortunately takes flight at nightfall." Rightly or wrongly, it seems to me that there must be a kind of nightfall preceding, and determining, almost every case of cultural greatness. It is the darkness that provokes a multitude of lights. France has been quite privileged from this point of view. And in this sense, night, or a version of night, fell at least twice on Italy, first in about 1450 then again in about 1600. The sky of the whole of Europe was lit up by it.

NOTES

INTRODUCTION. ITALY'S SEVERAL AGES OF GREATNESS

[1] *Essai sur l'inégalité des races humaines*, 5th ed., I, p. 2.

[2] Cf. Armando SAPORI, *Studi di storia economica (sec. XIII-XIV-XV)*, 3rd ed., vol. II, p. 933, note 2.

[3] Franco SIMONE, *Il Rinascimento francese. Studi e ricerche*, 1965, p. 7; Louis COURAJOD, *Leçons professées à l'École du Louvre*; II, *Origines de la Renaissance*, Paris, 1901, pp. 25–28. Louis HAUTECŒUR, *Histoire de l'architecture classique en France*; I, *La Renaissance*, Paris, 1943, pp. 77 ff.

[4] Emilio LAVAGNINO, *Gli artisti italiani in Germania*, in *L'Opera del genio italiano all'estero*, III, Rome, 1943, pp. 13 ff.

[5] Giuliano PROCACCI, *Studi sulla fortuna del Machiavelli*, Rome, 1965.

[6] Quoted by José A. MARAVALL, 'Fragmento sobre Maquiavelo y el estado moderno,' in *Boletin informativo de Ciencia Politica*, 2, 1969, p. 5.

[7] Giovanni DELLA CASA, *Oratione a Carlo Quinto imperatore intorno alla restitutione della città di Piacenza*, Florence, 1561, fo. 60 v. Cf. F. MEINECKE, *Die Idee der Staatsräson in der neueren Geschichte*, Munich, 1924.

[8] Jean-Baptiste L'HERMITE DE SOLIERS, known as Tristan L'HERMITE, *La Toscane françoise*, Paris, 1661.

[9] Bibliothèque Nationale, Paris, Italian Collection, 1714, for François I; and for Henri III, Armand BASCHET, *Les Comédiens italiens à la Cour de France sous Charles IX, Henri III, Henri IV et Louis XIII*, Paris, 1882, pp. 66 and 67, note 1.

[10] Gustave ATTINGER, *L'Esprit de la commedia dell'arte dans le théâtre français*, 1969, p. 184.

[11] Henri BAUDIN, 'L'italianisme dans les lettres de Madame de Sévigné,' in *L'Italianisme en France au XVII^e siècle*, suppl. to no. 35 of *Studi francesi*, May/August 1968, p. 113.

[12] 'The foreign merchants and bankers who have long acquaintance with the practices of exchange have amassed . . . large sums of money . . . without having brought to those countries when they arrived anything other than their persons, with a small amount of credit, a pen and paper, and the faculty of knowing . . . how to mix and stir the said exchanges between one country and another, [with] many twists and turns.' Bibliothèque Nationale, Paris, French Collection, 2086, f. 60 v. and 61 r.

[13] Cracow archives, Ital., 382. Cf. F. BRAUDEL, *The Mediterranean and the Mediterranean World in the Age of Philip II*, English ed., 1972, I, p. 201, note 141.

WHAT THE WORLD LOOKED LIKE TO AN ITALIAN IN 1450

[14] The expression is Lujo BRENTANO'S.

[15] D. A ZAKYTINOS, *Crise monétaire et crise économique à Byzance, du XIII^e au XIV^e siècle,* Athens, 1948, p. 40.

[16] Elena C. SKRŽINSKAJA, 'Storia della Tana,' in *Studi veneziani*, X, 1968, p. 2.

[17] Archivio di Stato, Venice, Senato Mar, 4.

[18] ZAKYTINOS, op. cit., p. 37.

[19] Ibid., p. 38.

[20] Ibid., p. 44.

[21] Archivio di Stato, Venice, Senato Mar, 4.

[22] Ibid.

[23] Ibid.

[24] BRAUDEL, *The Mediterranean*, op. cit., I, pp. 467–468.

[25] Ibid., I. p. 471, note 56.

[26] R. HENNIG, *Terrae incognitae*, IV, p. 112.

[27] Ibid., pp. 33 ff. and Niccolò DE' CONTI, Girolamo ADORNO and Girolamo DA SANTO STEFANO, *Viaggi in Persia, India e Giava.*

[28] *Diario da Viagem de Vasco da Gama*, Oporto, I, 1945, pp. 58–59.

[29] F. BRAUDEL, 'Les Espagnols et l'Afrique du Nord,' in *Revue africaine*, 1928.

[30] André CHASTEL's expression.

[31] André CHASTEL, *La Crise de la Renaissance (1520-1600)*, 1968, p. 67. The quotation is from the account by the Portuguese Francesco da Hollanda.

[32] Alexander ROSTOW, *Weg der Freiheit. Ortsbestimmung der Gegenwart*, 1952, II, pp. 248–249.

[33] Renée DOEHAERD, 'Les galères génoises dans la Manche et la mer du Nord à la fin du XIIIe siècle et au début du XIVe,' in *Bulletin de l'Institut historique belge de Rome*, 1938.

[34] Federigo MELIS, 'Firenze,' in *Saggi in memoria di Gino Luzzatto raccolti da A. Fanfani*, pp. 139 ff.

[35] Ibid., p. 143, and Jean-François BERGIER, *Les Foires de Genève et l'économie internationale de la Renaissance*, Paris, 1963, pp. 279 ff.

[36] Alberto TENENTI and Corrado VIVANTI, 'Le film d'un grand système de navigation: les galères marchandes vénitiennes, XIVe–XVIe siècles,' in *Annales, E.S.C.*, 1961, no. 1, pp. 83–86 and map. 37.

[37] Ibid., p. 85.

[38] Frederic C. LANE, *Andrea Barbarigo, Merchant of Venice, 1418–1449*, Baltimore, 1944.

[39] Gino DI NERI CAPPONI, *Commentari dell'acquisto di Pisa e tumulto dei Ciompi*, in *Cronachette antiche di vari autori . . .* ed. D. M. Manni, Milan, 1844.

[40] André CHASTEL, *Le Mythe de la Renaissance, 1420-1520*, Geneva, 1969, p. 30.

[41] R. ZANGHERI, 'Agricoltura e sviluppo del capitalismo, Problemi storiografici,' in *Studi storici*, IX, 1968, pp. 531–563.

[42] Carlo M. CIPOLLA, 'L'economia milanese alla metà del secolo XIV. I movimenti generali (1350-1500),' in *Storia di Milano*, vol. VIII, p. 347.

[43] Federigo MELIS, *Aspetti della vita economica medievale. Studi nell'Archivio Datini*, Siena, 1962.

[44] Federigo MELIS, 'Werner Sombart e i problemi della navigazione nel Medio Evo,' in *L'Opera di Werner Sombart nel centenario della nascita*, Milan, 1964.

[45] *Mémoires de Messire Philippe de Commines*, edited by M. l'Abbé Lenglet de Fresnay, 1747, IV, p. 103.

[46] Henri VAST, *Le Cardinal Bessarion (1403-1472). Étude sur la*

Chrétienté et la Renaissance vers le milieu du XV^e siècle, Paris, 1878, p. viii.

[47] MELIS, *Aspetti*, op. cit.

[48] SIMONE, *Il Rinascimento francese*, op. cit., p. 10.

[49] HAUTECŒUR, op. cit., p. 77.

[50] Léon CAHEN, unpublished debate on the word 'Humanism,' *Centre International de Synthèse*, 13 January 1935.

[51] Ruggiero ROMANO and Alberto TENENTI, 'L'intellectuel dans la société italienne des XV^e et XVI^e siècles,' in *Niveaux de culture et groupes sociaux*, Paris, 1967, p. 56.

[52] André CHASTEL and Robert KLEIN, *L'Europe de la Renaissance. L'Age de l'humanisme*, Paris, 1963, p. 17.

[53] G. OUY, 'Paris, l'un des principaux foyers de l'humanisme en Europe au début du XV^e siècle,' in *Bulletin de la société de l'histoire de Paris et de l'Ile de France*, 1967–1968, pp. 71–98.

[54] Roberto WEISS, 'Italian Humanism in Western Europe, 1460–1520,' in *Italian Renaissance Studies*, ed. E. F. Jacob, 1960, p. 77.

[55] Ibid., p. 78.

[56] Ezio ORNATO, *Jean Muret et ses amis, Nicolas de Clamanges et Jean de Montreuil*, Geneva, 1969, p. 192.

[57] Ruggiero ROMANO and Alberto TENENTI, *Alle origini del mondo moderno, 1350-1550*, Milan, 1967, pp. 144–145.

1450–1650: TWO CENTURIES, THREE ITALIES

[58] Corrado BARBAGALLO, *Storia universale*, IV, 1938, p. 232.

[59] *Autobiografia de Miguel de Castro*, in *Biblioteca de autores espanoles*, vol. XC, 1956, pp. 489 ff.

[60] In *The Economic History Review*, second series, vol. XIV, no. 3, 1962.

[61] Gino LUZZATTO, *Storia economica di Venezia dall'XI al XVI secolo*, Venice, 1961, p. 189.

[62] Heinrich KRETSCHMAYR, *Geschichte von Venedig*, Gotha, 1920, II, p. 385.

[63] LUZZATTO, op. cit., p. 230.

[64] Frederick ANTAL, *Florentine Painting and Its Social Background. The Bourgeois Republic before Cosimo de' Medici's Advent to Power, XIVth and Early XVth Centuries*, London, 1947.

[65] Viviana PAQUES, *Les Sciences occultes d'après les documents littéraires italiens du XVIe siècle*, Paris, 1971.

[66] CHASTEL and KLEIN, *L'Europe de la Renaissance*, op. cit., p. 92.

[67] Yves RENOUARD, *Études d'histoire médiévale*, Paris, 1968, p. 118.

[68] BRAUDEL, *The Mediterranean*, op. cit., I, pp. 615 ff.

[69] Eduard FUETER, *Geschichte des europaischen Staatensystems*, Munich, 1919.

[70] BRAUDEL, *The Mediterranean,* op. cit., I, p. 621.

[71] Federigo MELIS, 'Il commercio transatlantico di una compagnia fiorentina stabilita a Siviglia a pochi anni dalle imprese di Cortes e Pizarro,' in *V Congresso de historia de la Corona de Aragón*, 1954, Zaragoza, pp. 131–206.

[72] Ibid., pp.185–186.

[73] Richard GASCON, *Grand commerce et vie urbaine au XVIe siècle; Lyon et ses marchands*, Paris, SEVPEN, 1971.

[74] The expression is Georges GUSDORF's in *La Révolution galiléenne*, Paris, 1969, I, p. 22.

[75] M. BANDELLO, *Novelle*, London, 1791–1793, II, p 208.

[76] For instance in a little book for the non-specialist by Gonzalo DE REPARAZ (hijo), *La Época de los grandes descubrimientos*, Editorial Labor, 1930, p. 90.

[77] Ibid., p. 90. Cf. the classic study by P. PERAGALLO, *Cenni intorno alla colonia italiana in Portogallo nei secoli XIV, XV e XVI*, 1907, and Charles VERLINDEN, 'La colonie italienne de Lisbonne et le développement de l'économie métropolitaine et coloniale portugaise,' in *Studi in onore di Armando Sapori*, Milan, 1957, I, pp. 615 ff.

[78] Jacques HEERS, 'Les hommes d'affaires italiens en Espagne au Moyen Âge, le marché monétaire,' in *Fremde Kaufleute auf der Iberischen Halbinsel*, ed. H. Kellenbenz, 1970, pp. 74–83.

[79] Henry L. MISBACH, 'Genoese Commerce and the Alleged Flow of Gold to the East,' in *Revue internationale de la banque*, 3, 1970, pp. 67–87.

[80] Archivio di Stato, Venice, Lettere commerciali, XV, 9; and BRAUDEL, *The Mediterranean*, op. cit., I, p. 470.

[81] André SAYOUS, 'Le rôle des Génois lors des premiers mouvements réguliers d'affaires entre l'Espagne et le Nouveau Monde, 1505-1521,' in *Publicaciones de la Sociedad Geográfica Nacional*, 1932.

[82] J. A GORIS, *Étude sur les colonies marchandes méridionales à Anvers de 1488 à 1567*, Louvain, 1925.

[83] GASCON, *Grand commerce*, op. cit., p. 49.

[84] COURAJOD, *Leçons professées*, op. cit., pp. 26 and 647–655.

[85] HAUTECŒUR, op. cit., I, p. 77.

[86] Ibid., p. 83.

[87] Ibid., pp. 84–91.

[88] Ibid., p. 115.

[89] G. ENTZ, 'Nouveaux résultats des recherches poursuivies en Hongrie sur le gothique tardif et la Renaissance,' in *Studia historica Academiae Scientiarum Hungaricae*, 53, 1963, pp. 467–491.

[90] CHASTEL and KLEIN , op. cit., pp. 25–26 .

[91] Ibid., p. 30.

[92] Ibid., p. 30.

[93] For the next paragraph see Zdenek WIRTH, 'Die böhmische Renaissance,' in *Historica*, III, Prague, 1961.

[94] According to Jean GEORGELIN, *Venise au XVIIIe siècle*, Paris, 1978.

[95] On the following pages, see Felipe Ruiz MARTÍN's book, *El Siglo de los Genoveses*, and the same author's 'Les hombres de negocios genoveses,' in *Fremde Kaufleute*, ed. H. Kellenbenz, op. cit., pp. 84–99.

[96] Archivio di Stato, Venice, Cinque Savii, risposte 1602–1606.

[97] Richard EHRENBERG, *Das Zeitalter der Fugger, Geldkapital und Credit-Verkehr im 16. Jahr.*, Frankfurt, 3rd ed., 1922, I, p. 350.

[98] Museo Correr, Venice, Donà delle Rose, 26.

[99] Carlo M. CIPOLLA, 'Note sulla storia del saggio d'interesse. Corso, dividendi a sconto dei dividendi del banco di San Giorgio nel sec. XVI,' in *Economia internazionale*, vol. V, no. 2, 1962.

[100] R. ROMANO, 'Una crisi economica, 1619-1622,' in *Rivista storica italiana*, 1962, pp. 480–532.

[101] Archives Nationales, Paris, A.E., B.I., 511, Correspondence of the French consul Compans, from 1670.

[102] *Jean Nicot, ambassadeur de France au Portugal au XVIe siècle. Sa correspondance inédite*, ed. E. Falgairolle. Paris, 1897, p. 127.

[103] BRAUDEL, *The Mediterranean*, op. cit., I, pp. 558 ff.

[104] Archivo Ruiz, Valladolid, 1591.

[105] KRETSCHMAYR, op. cit., III, p. 179. And Ugo TUCCI, 'Mercanti veneziani in India alla fine del sec. XVI,' in *Studi in onore di Armando Sapori*, 1957, II, p. 1091–1111.

[106] João Carvaho Mascarenhas, who was a prisoner in Algiers in 1627. Cf. Bernard GOMES DE BRITO, *Historia tragico-maritima*, Lisbon, VIII, 1905, p. 74.

[107] Fernando LIUZZI, *I Musicisti in Francia*, vol. I of *L'Opera del genio italiano all'estero*, Rome, 1946, p. 94.

[108] M. SEIDLMAYER, *Geschichte Italiens*, Leipzig, 1942, p. 342.

[109] Armand BASCHET, *Les Comédiens italiens à la Cour de France*, 1882, pp. 105 ff. 110.

[110] Ibid., pp. 232–233.

[111] Germain BAZIN, *Destins du Baroque*, Paris, 1968, p. 8.

[112] Dates from Franco SIMONE, *Umanesimo, Rinascimento, Barocco in Francia*, Milan, 1968.

[113] Quoted by Pierre CHARPENTRAT, in the preface to his book *Baroque. Italie et Europe centrale*, Fribourg, 1964.

[114] Yves BONNEFOY, *Rome, 1630*, Paris, 1970, p. 8.

[115] Eugenio D'ORS, *Du Baroque*, 1935.

[116] BAZIN, *Destins du Baroque*, op. cit., p. 15.

[117] BONNEFOY, *Rome*, op. cit., p. 8.

[118] Lucien FEBVRE, *Le Problème de l'incroyance au XVIᵉ siècle. La religion de Rabelais*, 1942, pp. 461 ff.

[119] CHASTEL, *La Crise de la Renaissance*, op. cit., pp. 34 ff.

[120] D'ORS, *Du Baroque*, op. cit., p. 8.

[121] Leonardo OLSCHKI, *L'Italia e il suo genio*, 1953, II , p. 211.

[122] Ibid., pp. 203 and 207.

[123] Nino PIROTTA, 'L'ars nova italienne,' in *Histoire de la musique, Encyclopédie de la Pléiade*, pp. 799-800, and Nanie BRIDGMAN, 'La frottola et le madrigal en Italie,' ibid., pp. 1087–1088.

[124] On Marino, cf. F. LIUZZI, *I Musicisti*, op. cit., pp. 104 ff.

[125] Gustave ATTINGER, *L'Esprit de la commedia dell'arte dans le théâtre français*, 1969, pp. 14–15.

[126] Vito PANDOLFI, *La commedia dell'arte*, Florence, 1957, I, p. 16.

[127] Giuseppe GALAZZO, in *Storia di Napoli*, VI, p. 320.

[128] LIUZZI, op. cit., p. 111.

[129] BASCHET, op. cit., pp. 243–244.

[130] ATTINGER, op. cit., pp. 432–436.

[131] Archivio di Stato, Genoa, Lettere Consoli, 1/2628, London, October 1675, letter from Carlo Ottone, Genoese consul in London.

[132] Works consulted for the section on music, apart from Fernando LIUZZI'S book: Jacques CHAILLEY, *Cours d'histoire de la musique*, Paris, 1967, vol. I; *Histoire de la musique des origines à Jean-Sebastien Bach*, edited by Roland Manuel; *Encyclopédie de la Pléiade*; OLSCHKI, op. cit.; Maurice ROCHE, *Monteverdi*, Paris, 1960; M. T. JONES-DAVIES, *Inigo Jones, Ben Jonson et le masque*, Paris, 1967.

[133] André VERCHALY, 'Air de Cour, ballet de Cour,' in *Encyclopédie de la Pléiade*, op. cit., pp. 1548–1549.

[134] ROCHE, *Monteverdi*, op. cit., p. 42.

[135] Federico GHISI, 'La reforme mélodramatique,' in *Encyclopédie de la Pléiade*, op. cit., pp. 1429 and 1434.

[136] ROCHE, *Monteverdi*, op. cit., pp. 47 and 71.

[137] Ibid., p. 8.

[138] CHAILLEY, op. cit., pp. 88–89.

[139] ROCHE, op. cit., pp. 40 and 52.

[140] Federico MOMPELIO, 'Monteverdi,' in *Encyclapédie de la Pléiade*, op. cit., pp. 1446–1448.

[141] CHAILLEY, op. cit., p. 109.

[142] Philarète CHASLES, *La France, l'Espagne et l'Italie au XVIe siècle*, Paris, 1877, p. 247.

[143] F. FERRARI, 'Vita del Cavalier Marino,' in G. B. MARINO, *Lettere*, ed. M. Guglielminetti, 1966, p. 631.

[144] Ibid., p. 546.

[145] F. SIMONE, *Umanesimo*, op. cit., pp. 298 ff. See also *L'Italianisme en France au XVIIe siècle*, conference proceedings of the Société française de littérature comparée, supplement to *Studi francesi*, 1968, and A. ADAM, *Histoire de la littérature français e au XVIIe siècle*, 5 vols., 1948.

[146] VENARD, *Les Débuts du monde moderne*, op. cit., VI, 1967, p. 128.

[147] MARINO, *Lettere*, op. cit., p. 607.

[148] Ibid., pp. 553–557.

[149] *La befana* was the fairy who brought children presents on

Twelfth Night, rather like Santa Claus but also an old woman like a witch, whose effigy was paraded during feasts or hung up at windows. *Balloria:* was this the dance, or the ballroom?

[150] BONNEFOY, *Rome*, op. cit., p. 6.

[151] Ibid., p. 157.

[152] Marc VENARD's expression.

[153] François-Georges PARISET, *Georges de la Tour*, 1948, p. 104.

[154] Pierre LAVEDAN, *Histoire de l'Art*, II, 1944, pp. 375–377.

[155] VENARD, op. cit., p. 137.

[156] HAUTECŒUR, op. cit., I, p. 839.

[157] LAVEDAN, op. cit., II, p. 412.

[158] Louis MARIN, 'Signe et représentation: Philippe de Champaigne et Port Royal,' in *Annales, E.S.C.*, 1, 1970, p. 28.

[159] Andreina GRISERI, *Le Metamorfosi del Barocco*, Turin, 1967, pp. 122–123.

[160] V. L. TAPIÉ, *Baroque et classicisme*, 1957, pp. 198-200.

[161] Pierre CHARPENTRAT, *Baroque*, op. cit., 1964, p. 47.

[162] R. LENOBLE, in *La Science moderne*, ed. R. TATON, II, p. 189 and 193.

[163] Wilma FRITSCH, *Galilée ou l'avenir de la science*, Paris, 1971, p. 8.

[164] Alexandre KOYRÉ, *Études d'histoire de la pensée scientifique*, 1966, p. 177.

[165] Alfred North WHITEHEAD, quoted in Fritsch, op. cit., p. 9.

[166] FRITSCH, op. cit., p. 6.

[167] Umberto FORTI, *Storia della scienza nei suoi rapporti con la filosofia, le religioni, la società*, III, 1969, pp. 143–147.

[168] Maurice CLAVELIN, *La Philosophie naturelle de Galilée*, Paris, 1968, p. 462.

[169] Raymond ZOUCKERMANN, *Galilée, penseur libre*, Paris, 1968, p. 1.

[170] FORTI, op. cit., p. 145.

[171] LENOBLE, in *La Science moderne*, op. cit., pp. 191 ff.

[172] 'Dell'oriuolo a pendolo,' in *Antologia della prosa scientifica italiana del Seicento*, Enrico Falqui, ed., Florence, 1943, II, p. 589.

[173] CLAVELIN, *La Philosophie naturelle*, op. cit., p. 416 and note 72.

[174] Louis ROUGIER, 'La lettre de Galilée à la Grande Duchesse de Toscane,' in *La Nouvelle Revue Française*, November 1957, p. 1000.

[175] GUSDORF, *La Révolution galiléenne*, Paris, 1969, I, p. 92.

[176] Pierre COSTABEL and Pierre PIVETEAU, 'Un hommage de Mersenne à Galilée,' in *Galilée, aspects de sa vie et de son œuvre*, Paris, 1968, pp. 360–365.

[177] On 13 December 1650, Colbert, from the camp at Rethel, told Le Tellier about delli Ponti, an Italian famous for siege defences, P. CLÉMEN, *Instructions et Mémoires de Colbert*, Paris, 1861, I, p. 61.

[178] Edizioni Ferro, 1968. See also the paper by U. FORTI at the 3rd Prato conference, in April 1971.

[179] GUSDORF, op. cit., I, p. 18.

LOOKING BACK FROM 1633 OR 1650

[180] Benedetto CROCE, *Storia delle Età barocca in Italia*, 2nd ed., 1946, pp. 41 and 43.

[181] Ibid., p. 51.

[182] GUSDORF, op. cit., I, p. 24.

[183] Ibid., I, p. 23.

[184] Carlo DE FREDE, 'Roghi di libri ereticali nell'Italia del Cinquecento,' in *Ricerche storiche ed economiche in memoria di Corrado Barbagallo*, ed. Luigi di Rosa, Naples, 1970, II, pp. 317–328.

[185] FORTI, *Storia della scienza*, op. cit., III, p. 158.

[186] GUSDORF, op. cit., I, p. 30.

[187] Alberico GENTILI (1552-1608), one of the founding fathers of international law, who became a professor at Oxford, was a refugee for religious reasons and in 1588 had already written *'Silete theologi in munere alieno,'* which could be translated as 'Theologians should mind their own business,' GUSDORF, op. cit., I, p. 19.

[188] Antonio DE MONTALVO to Simón RUIZ, Florence, 23 September 1572, Archivo Ruiz, 17, f. 235, ed. Ruiz Martín, *Lettres marchandes échangées entre Florence et Medina del Campo*, Paris, 1965, p. lxxv.

[189] F. BRAUDEL, *Le Monde actuel*, Paris, 1963, and *The Mediterranean*, op. cit., pp. 312 and 613–624.

[190] Maurice AYMARD, current research on Sicily between the fifteenth and eighteenth century, cf. his paper at the 3rd Prato Conference, 1971.

[191] Emilio SERENI, *Storia del paesaggio agrario italiano*, 1961.

[192] Vincenzo TANARA, *L'Economia del cittadino in villa*, Bologna, 1644.

[193] Jean GEORGELIN, *Venise*, op. cit.

[194] Martin GÖHRING, *Die Ämterkäuflichkeit im Ancien Régime*, 1938.

IS ITALIAN DECADENCE A DISCERNIBLE PROCESS?

[195] ROMANO and TENENTI, 'L'intellectuel dans la société italienne,' art. cit., p. 52.

[196] The Mediterranean, even in the eleventh century, was a Muslim lake on which, according to Ibn Khaldun, the Christians 'could not even float a plank.' But by the end of the century, the situation was reversed. A Muslim poet in Sicily refused to go to Seville, where he had been invited: 'The sea belongs to the Rûm,' he explained, and the risk was too great; cf. Henri PÉRÈS, *La Poésie andalouse en arabe au XIe siècle, ses aspects généraux et sa valeur documentaire*, Paris, 1937, p. 216.

INDEX

OUT OF ITALY · 287

About the Author

French historian Fernand Braudel was a leading figure of the Annales School. His books, including *Out of Italy*, *The Mediterranean*, *A History of Civilizations*, and *Civilization and Capitalism*, are considered to be classics of modern history. His emphasis on the role of large-scale socioeconomic factors in the making and writing of history led to his being named in 2011 the most important historian of the second half of the Twentieth century by *History Today*. He died in 1985.